Grundlagen der Gestaltung

Ulf Jonak

Grundlagen der Gestaltung

2. Aufl. 2012

Prof. Ulf Jonak
Universiät Siegen

ISBN 978-3-8348-1836-2 ISBN 978-3-8348-2256-7 (eBook)
DOI 10.1007/978-3-8348-2256-7

Die Deutsche Nationalbibliothek verzeichnet diese Publikation in der Deutschen Nationalbibliografie; detaillierte bibliografische Daten sind im Internet über http://dnb.d-nb.de abrufbar.

Springer Vieweg
© Vieweg+Teubner Verlag | Springer Fachmedien Wiesbaden 2009, 2012

Lektorat: Dipl.-Ing. Ralf Harms | Annette Prenzer
Einbandentwurf: KünkelLopka GmbH, Heidelberg

Gedruckt auf säurefreiem und chlorfrei gebleichtem Papier

Springer Vieweg ist eine Marke von Springer DE.
Springer DE ist Teil der Fachverlagsgruppe Springer Science+Business Media
www.springer-vieweg.de

Vorwort

*Wer das erste Knopfloch verfehlt,
kommt mit dem Zuknöpfen nicht zu Rande.*
Goethe, Maximen und Reflexionen

Wer den Anfang falsch setzt, dem droht das Weitere zu misslingen. Wem die Grundlagen der Gestaltung fehlen, dem gelingt kein befriedigendes Werk. Dies Buch kann als Protokoll eines über Jahre hinweg sich wiederholenden, aber stets sich verändernden und zugleich neu beginnenden Sehtrainings verstanden werden.

Dies Buch ist kein Rezeptbuch. Dies Buch ist auch kein Reiseführer. Rezepte mindern die Eigeninitiative, Reiseführer machen es uns bequem. Es bahnen sich die wenigsten den mühsamen Weg durch unerforschtes Gelände, wenn ein leicht zu gehender Weg schon nebenan bereitet ist. Schöpferische Gestaltung ist aber zweifellos eine Gratwanderung. Abstürze sind jederzeit möglich, mitunter sogar unvermeidlich. Aus Niederlagen die Kraft zum Durchhalten schöpfen und sich abenteuerlustig auf unbekanntes Terrain begeben, das sind metaphorische Umschreibungen, wie wir uns dem vielschichtigen Vorgang künstlerischen Gestaltens annähern. Unfertiges, Unbeholfenes, Unzugängliches, Irrwege und Stolpersteine gehören zur allmählichen Wegfindung, gehören zum Prozess der Gestaltung dazu.

Mit welchen Mitteln und Techniken der unübersichtliche und steinige Weg zu ,Maß und Ziel' begehbar zu machen ist, davon handelt dieses Buch. Das Wort „Gestaltung" bezieht sich hier nicht nur auf Architektur im weitesten Sinne, nicht nur auf deren Darstellung und Ausformung, sondern auch auf die ,bildhauerische' Gestaltung des Bauwerks und dessen Teilhabe an den anderen Künsten. Allerdings haben die Grundlagen, nämlich das Zeichnerisch-malerisch-skulpturale den Vorrang.

Motivation: Vielfalt der Veranstaltung

Dies Buch gründet auf der ‚Siegener Lehre' im Fach Gestaltung am Fachbereich Architektur und Städtebau. Da es ein Grundlagenfach für die ersten drei Semester ist, müssen sich alle Studierenden des Fachbereichs durch dieses Gebiet hindurcharbeiten. In Siegen herrscht Platzmangel – wie in vielen Hochschulen. Es gibt keinen eigenen Raum für das Fach, so dass nach Ende einer Veranstaltung der Raum aufgeräumt zu hinterlassen ist. Daraus folgt, dass es das beständige, kreative Chaos eines Ateliers nicht gibt, aber auch keine ausufernde Beliebigkeit. Die Beschränkung verlangt Konzentration und Bestimmtheit, was keineswegs Improvisation ausschließt.

Zum Sehen lernen (dem Hauptgeschäft vom Lehrenden und den Lernenden) könnte im Grunde ein unter Anleitung geführtes Skizzenbuch genügen. Der Gesichtssinn ist aber nur einer unter fünfen. Sehen lernen heißt auch Be'greifen'. Deshalb dürfen Malerei und modellhafte Skulpturen nicht unter den Tisch fallen, sind sie doch Verwandte und künstlerische Beiträger zur Architektur. Für das Verstehen räumlich-plastischer Details reicht das Zeichnen nicht aus. Einfühlsam müssen Materialien, deren Fügungen, Verspannungen, Knoten und Kontraste erkundet werden. So gut es geht, muss auch dies in die Lehre aufgenommen werden.

Es gibt ein englisches Sprichwort: Der Zwerg, der auf den Schultern eines Riesen steht, sieht weiter als dieser. Um weiter zu sehen, um zu wissen, was man da eigentlich tut und um sich mit anderen vergleichen zu können, sollten die studentischen Übungen (es ist hier von der Siegener Lehre die Rede) ergänzt werden von Vorlesungen zur Gestaltungstheorie, von Ausstellungen und von Broschüren im Eigenverlag, in denen studentische Arbeiten publiziert werden. Nur von solchen begleitenden Veranstaltungen, die doch immer als Höhepunkte im Semestertrott gesehen werden, werden Begabte, aber auch Lustlose zur Lust am Gestalten motiviert. Motivation geht vom Lehrenden aus. Allerdings gelingt ihm das nicht allein. Ohne die Hilfe der Studierenden wäre all dies nicht möglich.

Eines soll noch festgestellt sein: Im Folgenden wird oft vom Architekten die Rede sein, nie von der Architektin. Sie ist selbstverständlich immer dabei. Die wahltaktische Umständlichkeit, wie sie unsere Politiker pflegen („Bürgerinnen und Bürger draußen im Lande") schien mir auch in diesem Zusammenhang eher heuchlerisch als aufrichtig zu sein, um die oft immer noch mangelnde Gleichstellung der Frauen im Beruf zu verharmlosen. Beiläufige Erwähnung, um umso ungenierter den Status quo beibehalten zu können.

INHALT

1 Sehen lernen

Kreidezeichnungen von Kindern auf dem Straßenasphalt

Zeichnen als Denkakt

To open eyes.
Das war mein Ziel
und ist es noch immer.
Josef Albers, Interaction of Color

Jedes Jahr, jedes Wintersemester vier/fünf/sechs Dutzend neue Studierende, mehr oder weniger gestaltungsresistent, mehr oder weniger erfahren im Freihandzeichnen. Die meisten haben ihre Zeichenkarriere im Grundschulalter aufgeben müssen, denn Alphabetisierung hatte Vorrang. Nun müssen sie die Spanne von anderthalb Jahrzehnten Nichtzeichnen im Geschwindschritt überwinden. Und sie stellen fest, so geschwind lässt sich Verschüttetes nicht ans Tageslicht holen.

Augen öffnen, Sehen lernen, um schließlich Gesehenes mit dem Stift wiedergeben zu können, ist deshalb das hervorstechendste Ziel der Lehre im Fach ‚Grundlagen der Gestaltung' für Architekturstudierende. Wie verkleistert sind anfangs unsere Augen. Wir sehen das, was man uns beigebracht hat zu sehen. Wir sehen das, was wir brauchen. Wenn uns etwas bedroht, beglückt oder innerlich bewegt, färbt das unsere Wahrnehmung der Umwelt. Wie sagt der Volksmund? „Der Furchtsame sieht schwarz" oder „Liebende sehen durch eine rosarote Brille." Der Zeichnende aber braucht klare, ungefärbte Sicht. Er muss sich auf die Klarheit seiner Wahrnehmung verlassen können. Sein Denken beruht auf der fast gleichzeitigen Bewegung von Auge und Hand. Er steuert unbeirrt seinen Kurs durch das unübersichtliche Gewimmel der visuellen Eindrücke.

Der Kunsthistoriker Horst Bredekamp weist nach, dass selbst abstrakt denkenden Wissenschaftlern (Darwin, Hobbes, Leibniz, Galilei u. a.) das Zeichnen zum „zentralen Medium der Weltaneignung"[1] wird. Der Zeichner erklärt sich und anderen die Welt. Schon für Giorgio Vasari (1511-74) war die Zeichenkunst „die Mutter der Malerei" und – darüber hinaus –

2

die notwendige Vorraussetzung für Bildhauerei und Architektur. Der Künstler ist wie der Wissenschaftler ein Welterklärer.

Sehen ist demnach zu recht Gegenstand dieses Lehr- und Lernfachs Gestaltung. Die Lehre des Sehens fängt unspektakulär an, weniger mit der Wiedergabe des Vorhandenen, als mit der Lust am Wiedergeben, spontan und präzis: fast ein Fingertanz (Punktgeschwader, Strichwirbel, Schraffuren, kräftig und sanft, kreuz und quer). Aber die Finger sind nicht nur im Zeichen- und Schreibgestus befangen; sie beschreiben die Dinge nicht nur in der zweiten Dimension, sondern sie verformen auch Material. Das Gedankengespinst auf der Fläche ist zwar äußerst anschaulich, aber in der dritten Dimension gewinnt es noch an Komplexität. Dort erst wird es zum Simulacrum der Welt. Gehirn und Finger, das heißt, Logik, Anschauung und Darstellung sind untrennbar voneinander abhängig, ebenso wie Linie, Fläche und Volumen.

Das eine braucht das andere. Zeichnen ist Gehirntraining. Eine wissenschaftliche Studie an der Berkeley University ergab, dass derjenige Chancen hat, bis ins hohe Alter fit und vital zu bleiben, der sein Leben lang darauf achtet, gelenkige und flinke Finger zu behalten[2]. Vitalität bedeutet auch Gelenkigkeit im Denken, also Phantasie. Sie entsteht nicht allein im Kopf, sondern ist ebenso abhängig von unserem Sechsten Sinn, dem Körpersinn. Jegliche körperliche Tätigkeit, auch wenn es nur das Abtasten von Oberflächen ist, kann zur Entwicklung von komplexen Denken, von Kreativität und Phantasie beitragen.

Am Anfang der Gestaltungslehre steht deshalb auch das ans Licht stellen der eigenen Phantasie: *Ich schmücke mich mit einem gefundenen und kreativ ergänzten Stein. Ich inszeniere das Denkmal eines Bleistifts, ich lasse aus einer Tube etwas Architektonisches herausquellen, ich erfinde einen Eierbecher oder ich erkläre einem Kind an einem handteller-*

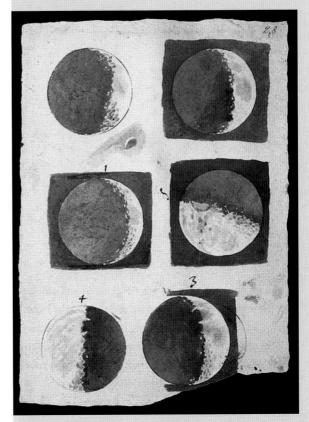

Gallileo Gallilei, Mondphasenzeichnungen

Anfangsübung: Bleistiftmonument

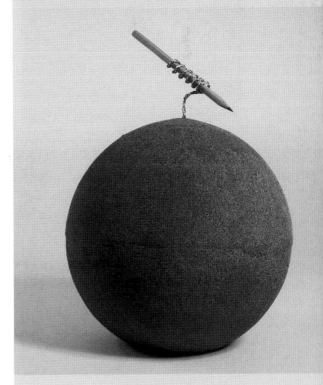

3

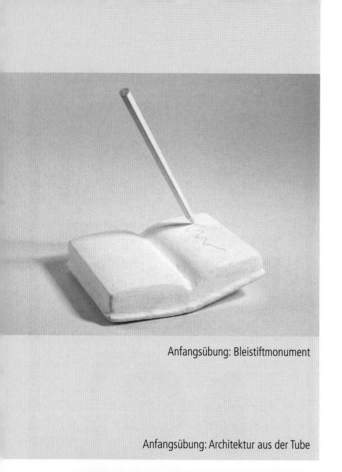

Anfangsübung: Bleistiftmonument

großen Modell, was elektrischer Strom ist usw. Erst danach folgt die aufwendigere Gestaltungslehre, die Techniken der Komposition und Darstellung: Axonometrie und Perspektive, Struktur-, Material-, Natur- und Architekturstudien, Stillebenzeichnen, Farblehre und Aquarellieren. Um den Kontakt zum Handwerk nicht zu verlieren, gehört ein detailliertes Bildwerk, eine thematisch an Architektur erinnernde Skulptur zur Ausbildung.

Ziel der Lehre ist:
– den Vorgang des Sehens als Denkakt, als Navigation in Raum und Zeit zu verstehen,
– das, was wir sehen, als veränderliches Ereignis oder Prozess zu begreifen und wiederzugeben,
– das Gesehene als vergängliches, dreidimensionales Gefüge oder Schichtung wahrzunehmen.
Haben wir das Hintereinander und Nebeneinander unserer Umwelt nicht nur als Abfolge von Bildern im Kopf, sondern als dreidimensionale Struktur (die wiederum unser Denken strukturiert), dann und nur dann entfliehen wir dem visuellen Durcheinander unserer Umgebung und können uns dem Planen zuwenden.

Anfangsübung: Architektur aus der Tube

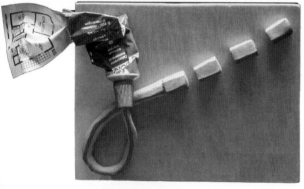

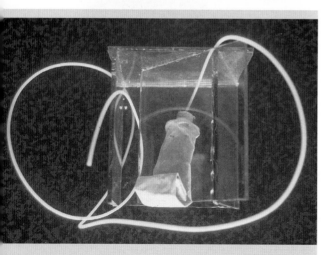

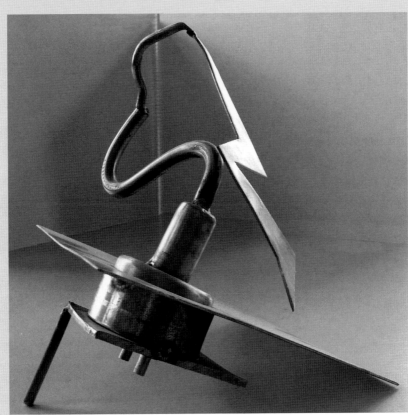

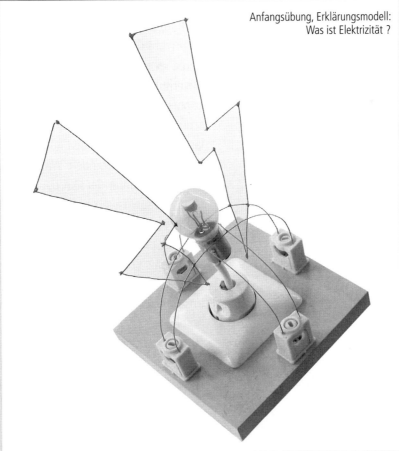

Anfangsübung, Erklärungsmodell:
Was ist Elektrizität ?

Exkurs: Über die Neugier

Wir schauen auf die Dinge und sehen sie nicht. Wir nehmen wahr und hören und schmecken nichts. Im Kopf sind wir mit anderen, existentielleren Dingen beschäftigt. Wir merken nicht einmal, dass wir mit uns selbst sprechen. Erst wenn wir uns einen Ruck geben, befreien wir uns aus dem Innen und können wieder das Außen erkunden. Was hat er gerade gesagt, was habe ich gerade gelesen, wie bin ich gerade von A nach B gekommen? An nichts kann ich mich erinnern. Was wir gewohnt sind, was zur Routine geworden ist, was alltäglich ist, was kontrastlos ist, entgeht allzu leicht unserer Aufmerksamkeit.

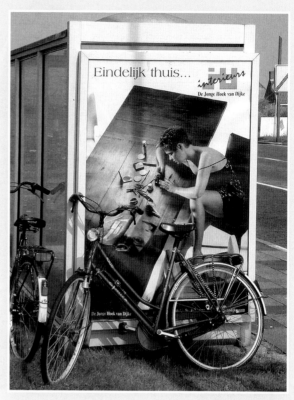

Werbung verlockt

Segmentationsprozess:
Wir wählen das für uns Wichtige aus dem Vorhandenen aus.
A oder B

A

B

Es ist eine Binsenweisheit, dass wir der visuellen Bilderflut in unserer Umgebung kaum standhalten können. Unsere Fähigkeit zur Wahrnehmung ist beschränkt. Unser Gehirn nimmt vieles auf, sortiert und lässt gnädig einen großen Teil des Gesehenen im Unbewussten verschwinden. Wäre dem nicht so, dann brächen wir unter der Flut der Nichtigkeiten zusammen. Bedauernswert sind jene, die nichts, aber auch nichts vergessen können. Sich einen Weg bahnen in der Fülle des Wahrnehmbaren bedeutet, dass wir nur das für uns Brauchbare zur Kenntnis nehmen.

Unser Hirn verordnet uns Blickpausen in der rasanten Abfolge der sich aufdrängenden Bilder. Es unterteilt so die Flut der Erscheinungen in kleine Einheiten, damit wir (dank des so genannten „Segmentationsprozesses"[3]) die uns wichtigen Informationen aus dem Wirrwarr der Ereignisse herausschälen können. Deshalb ist es ein Irrtum zu glauben, dass wir das sehen, was da ist. Wir sehen nur, was wir sehen wol-

len. Wir wählen aus dem Vorhandenen aus, was uns persönlich für den Augenblick notwendig erscheint. Alles andere wird übersehen. Ein Spaziergänger sieht ein Haus anders als ein Feuerwehrmann.

Im Grunde ist das gut so, denn wären wir manisch aufmerksam, gingen wir (alles, jede Kleinigkeit, jedes Detail registrierend) im Stadtlabyrinth unter – hoffnungslos desorientiert. Jedoch wir müssen aufpassen, dass uns das Wichtige, das uns Anrührende im introvertierten in uns Hineindenken nicht entgeht. Zum Glück sind wir neugierig, aber wir müssen unsere Neugier trainieren. Das Seltene, das Ungewöhnliche fällt uns auf: der laute Schrei, der grelle Schein, die Karambolage, der Stürzende, der oder die freizügig Gekleidete.

Wir ahnen es oder sind gar informiert, wie die Werbung sich unsere Neugier zu Nutze macht. Achsen und Diagonalen, Kreuzungspunkte und Gewichts-

Das ‚Urdreieck' aus Augen und Mund

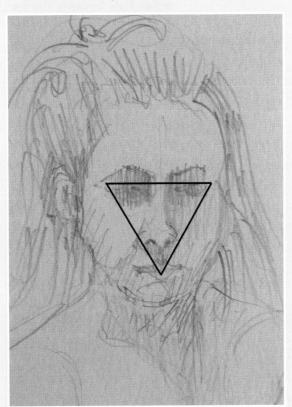

verlagerungen, Vorder-, Mittel- und Hintergrund spielen ihre Rolle wie in der bildenden Kunst. Hinzu kommen aber Verführungstechniken: Autofirmen locken mit graziös platzierten Models, scheinbar ebenso käuflich wie die Ware. Schöne Menschen sind den Produkten beigesellt, als ob Schönsein nur in Gesellschaft dieser Erzeugnisse zu entwickeln sei. Unterschwellig spricht das, was die meisten bewegt, nämlich Sexualität, aus den angepriesenen Dingen. Mit unbewussten Wahrnehmungsrelikten aus der frühen Säuglingszeit werden auch Erwachsene geködert: zum Beispiel mit der Betonung des ‚Urdreiecks', gebildet aus beiden Augen und Mund, welches das frisch geborene Kind, das Sehen noch lernen muss, als erstes, als mütterliches Schutzsignal erkennt. Einem schwellenden Mund und sinnlich verhangenen Augen in Kombination mit einem Luxusgetränk kann deshalb ein unbedarfter Käufer kaum widerstehen. Psychologie spielt nicht nur in der Werbung, sondern auch in den Künsten eine gestaltende Rolle.

Also lohnt es sich selbst für den, der den Inhalt von Werbung nur als Ideologie verachtet, dennoch Werbestrategien zu analysieren und von ihr zu lernen. Gerade von den Techniken seiner Gegner kann man profitieren. Neugier ist für den kreativen Menschen unabdingbar. Er muss gierig sein, im Gewohnten Neues zu entdecken – aufzudecken wie der Detektiv den ungeklärten Fall. Ein Projekt zum guten Ende zu bringen, hat viel mit dem Spürsinn des Detektivs zu tun, hat viel damit zu tun, im Unauffälligen das Spektakuläre aufzufinden. Zwicken wir uns also selbst, schauen wir wie aufgewacht, wie elektrisiert, wie auf Spurensuche in unsere Umgebung. Nur so sehen wir bislang Übersehenes, nur so sehen wir bisher Unentdecktes, scheinbar Neues, das es zu speichern gilt.

Der Anblick einer ruinösen Feldscheune mit zufälligen Lücken in ihren Bretterwänden kann für ein von uns zu entwickelndes Architekturprojekt erhellend wer-

den. Wir entdecken zum Beispiel eine ungewohnte Wechselwirkung zwischen Oberflächenstrukturen und Fensterschlitzen. Wie ein Blitz kommt die kreative Erkenntnis. Die Unordnung eines Gerümpels hat die Ordnung eines Entwurfs zur Folge. Trotzdem bleibt das Gesehene ein subjektiv Gesehenes, andere nehmen anderes wahr.

Doch nur so, durch unvoreingenommenes Registrieren von scheinbaren Belanglosigkeiten schaffen wir uns ein eigenes Repertoire an Formen, Farben, Rhythmen, Strukturen, räumlichen Zusammenhängen, aus dem heraus wir unsere Projekte entwickeln können. Und da wir, was menschlich ist, vergesslich sind, machen wir uns wohlweislich Notizen, das heißt, als Architekten halten wir die Dinge im Skizzenbuch fest. Skizzenbücher sind wie Tagebücher – Archive privater Erinnerungen, Sammlungen von zukünftig verwertbaren Bruchstücken der Realität um uns.

Im Alltäglichen Besonderes entdecken

Im Unauffälligen Spektakuläres entdecken

8

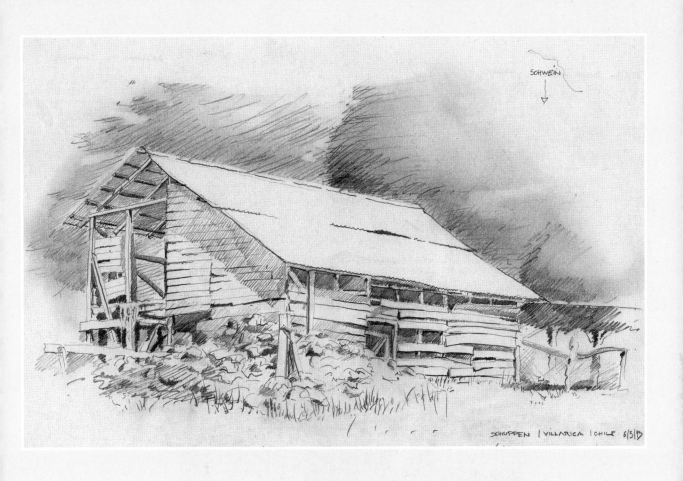

SCHWEIN

SCHUPPEN / VILLARICA / CHILE 6/3/13

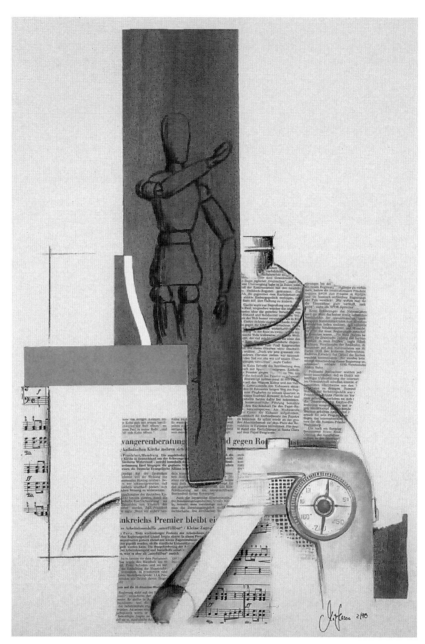

Collage Martin Hassa

2 Komposition

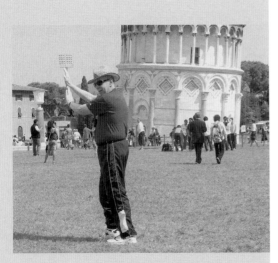

Am schiefen Turm von Pisa:
Die beliebte, kalauernde Negation der
perspektivischen Tiefenwirkung

Mittenbetonte Symmetrie, ein auch dem Laien
zugängliches Kompositionsprinzip:
G. Da Sangallo, Medici-Villa in Poggio a Caiano

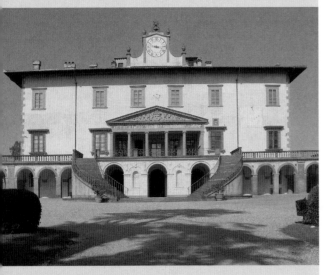

Struktur und Ordnung

Komposition heißt schlicht: Wie ist ein Werk (der Literatur, der Musik, der bildenden Kunst und – nicht zuletzt – der Architektur) gefügt? Es geht um Hierarchien der Einzelbausteine. Es geht um Strukturen und Spannungen. Es geht um Entspannung und Konzentration. Es geht um Ränder und Mittelpunkte. Es geht um Schichtungen, Ebenen (Vorder-, Mittel-, Hintergrund) und Distanzen.

Ein Werk hat einen Mittelpunkt, der aber nur bedingt in der Mitte liegen muss. Dort kreuzen sich Achsen und Diagonalen. Diese Linien verspannen sich mit den Rändern (das Werk ist in sich geschlossen) oder sie tun dies gerade nicht und verweisen über das Werk hinaus (das Werk hat keinen Rahmen). Es scheint nur ein Ausschnitt aus einem größeren Ganzen zu sein. Oder das Werk hat keinen offensichtlichen Mittelpunkt. Es ist getaktet, gerastert und tapetenartig von einem gleichmäßigen Muster („Allover" – im Sinne von Jackson Pollock) bestimmt. Eine Erweiterung, ohne an Konzept und Aussage etwas zu ändern, wäre jederzeit möglich.

Es sind kompositorische Entscheidungen, die zu Beginn der Arbeit am Werk getroffen werden. Entweder – Oder. Jedes Kunstwerk ist von den Neigungen seines Machers geprägt, sei es der Willen zur überlegten Konstruktion, zur Spontanität, zur überschäumenden Fülle oder zur Askese. Er entwickelt intuitiv oder überlegt ein Konzept. Wie auch immer: Es ist in sich schlüssig. Es bleibt konsequent. Es ist strukturiert.

Struktur bedeutet auch Selbstähnlichkeit. Das heißt: Es gibt eine umfassende Aussage, die aus Einzelaussagen gefügt ist, aber jede Einzelaussage ähnelt in ihrer Erscheinung der Gesamtaussage. Ein banales Beispiel: Ich zeichne einen Korb Äpfel. Ich zeichne eine Anzahl Rundungen, die sich zu einer Gesamtrundung aus Korb und gehäuftem Obst ergänzen.

12

Die Gesamtrundung ergibt sich durch eine Häufung von kleinen Rundungen. Die Details ähneln formal dem Ganzen.

Die nachvollziehbare Komposition des Kunstwerks gibt wie ein Textlayout dem Betrachter die Chance der Einfühlung und des Verständnisses. Es ist uns geradezu ein unabdingbares Bedürfnis, Unordnung zu ordnen, das heißt, zu strukturieren, das heißt, im Nachhinein in einem scheinbaren Chaos eine Kompositionsabsicht zu vermuten. Wir können den Sternenhimmel nicht betrachten, ohne nicht in das Gewimmel Figuren (Bären, Drachen usw.) oder Personen (Venus, Mars, Andromeda) hinein zu denken. Nur so orientieren wir uns. Indem wir die Welt strukturieren, strukturieren wir unser Denken. Und umgekehrt: Wir tragen die Struktur unseres Gehirns in die Welt.

Wahrnehmung

Ein Laie sieht ein Bauwerk anders als ein Architekt. Der Laie sieht das respektable Alter, er nimmt die Ehrwürdigkeit des Hauses beifällig wahr. Er sieht den Efeu auf der Fassade, er sieht die Dekorationen, die ihm einen gewissen Reichtum vorgaukeln. Baufälligkeit oder pittoreske Baugestalt erinnern ihn unter Umständen an die Vergänglichkeit der Welt, an das Memento Mori oder an erlebte melancholische oder romantische Gefühle. Der Architekt hingegen übersieht womöglich all diese Merkmale. Für ihn als Fachmann bedeutet Baufälligkeit verloren gegangene Tragfähigkeit. Er sieht Material und Konstruktion. Er versucht das Gebäude stilistisch einzuordnen. Er sieht den Rhythmus der Fenster, er sieht die Plastizität und Proportionen der Bauteile. Er drängt seine Gefühle zurück, denn er archiviert in Gedanken das Gesehene, um es gelegentlich wieder ans Licht holen zu können, und er überlegt, was er anders gemacht hätte. Wenn Laie und Architekt sich unterhalten, stellen sie fest, dass sie Unterschiedliches gesehen haben. War es wirklich das gleiche Haus?

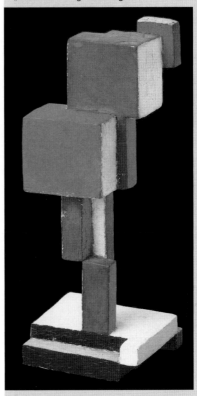

Das kippliche, aber spannende „kontrastbedingte Gleichgewicht".

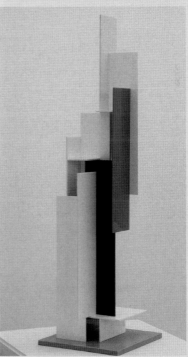

(oben) Geroges Vantongerloo, Komposition aus dem Oval, 1918
(unten) Joost Baljeu, FG-3cd, 1967/69

13

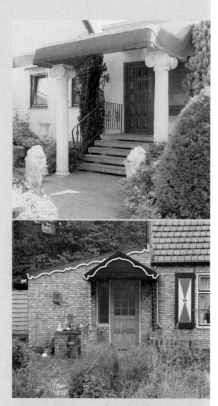

Inszenierung der Schwellen zwischen
Innen und Außen im privaten Raum

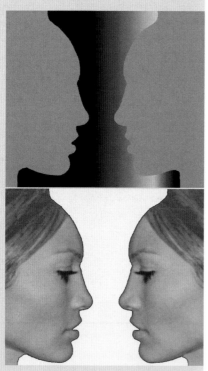

Figur – Grund – Problem: Vase oder Gesichter

Laie oder Fachmann: Es gibt da keinen Vorrang, denn jeder nimmt nur einen Teil des Vorhandenen wahr. Mitunter hat das mehr mit der Gestimmtheit des Betrachters als mit seiner Ausbildung zu tun. Denken wir nur an den wahrnehmungspsychologischen Test des „Figur-Grund-Problems". Je nach Erwartung entsteht vor den Augen die eine oder andere geformte und bedeutungsvolle Figur. Ein Teil des Objekts wird als Gestalt und ein anderer als gestaltloser und grenzenloser Hintergrund wahrgenommen. Genauso aber ist es möglich, den Hintergrund als Figur zu interpretieren, so dass die vordergründige Figur ihre Gestalt scheinbar verliert und vorne und hinten ihre Positionen schlagartig vertauschen. Kippfigur heißt das Fachwort dafür. Jeder kennt die Testzeichnung „Vase oder zwei Gesichter im Profil". Man gerät in Verwirrung, man traut seinen Augen nicht mehr. Die optische Täuschung entlarvt das Subjektive im Objektiven.

Verständnislos schauen sie sich an, der Laie und der Fachmann. Der eine spricht von der Vase, der andere über zwei Gesichter. Also erfordert die Kommunikation zwischen dem Laien und dem Fachmann ein verbindliches Regelwerk, nicht nur eine gemeinsame Sprache; man kann auch sagen, sie erfordert eine schlüssige Theorie, das heißt (im architektonischen Falle), konstruktive, historische, soziale und ästhetische Einordnungen. Das kreative Befolgen des ästhetischen Regelwerks, das Spielen mit seinen Elementen und deren folgerichtige neue Ordnung nennt man Komposition. Über Kompositionsprinzipien zum Beispiel lassen sich Übereinkünfte erzielen. Auch der nicht ausgebildete Laie kann wahrnehmen, ob Gebäudevolumen oder deren Fassaden taktiert, also gleichmäßig gerastert sind, ob sie dem goldenen Schnitt, der mittenbetonten Symmetrie oder dem „kontrastbedingten Gleichgewicht" verpflichtet sind. Allerdings muss er wenigstens die Begriffe kennen.

14

Harmoniesüchtig zu sein, gilt als Charakterschwäche. Andererseits hat jedermann ein Bedürfnis nach „angenehmer Übereinstimmung der Teile eines Ganzen", wie ein Wörterbuch der deutschen Sprache den Begriff etwas umständlich definiert. Wer aber lediglich vom Widerspruch lebt, muss gegenüber dem Harmoniebewussten aus dem Gleichgewicht geraten. „Gleichgewichtsbeziehungen sind es, wodurch die Einheit, die Harmonie, das Universale sich gestalterisch in der Verschiedenheit, in der Mannigfaltigkeit, im Individuellen, im Natürlichen ausdrücken", sagte Piet Mondrian 1917.[4] Er zielte damit auf van Doesburgs „kontrastbedingtes Gleichgewicht", dem Gleichgewicht gegensätzlicher Kräfte. (s. S. 30 f.)

Spannungsaufbau

Wir betreten ein Haus. Zwischen Innenraum und Außenraum hat der Architekt eine Vielzahl von Schwellen und Raum- und Flächenschichten aufgebaut. Umso mehr Zwischenstationen wir überwinden müssen, umso gespannter oder neugieriger erwarten wir das Innere. Das beginnt bereits auf der Straße. Wir durchqueren den Vorgarten, wir steigen eine oder drei Stufen hinauf, wir betreten ein Steinpodest, rechts und links flankiert von zwei Achtung heischenden Figuren. Wenn der Eigentümer sich schon nicht zwei bewaffnete Lakaien leisten kann, so doch deren Symbolisierung, zum Beispiel zwei simple Stützen, die ein Vordach tragen (und damit Privatbesitz demonstrieren), oder – schon anspruchsvoller – zwei steinerne Kugeln auf Sockeln oder zwei grimmig dreinschauende Kunststeinlöwen oder zwei liebliche Blumenbecken. Man umgibt sich, man distanziert sich, man besteht auf Respekt. Was halt den Hausbesitzern dazu einfällt. Auch das drohende Auge einer neben der Haustür installierten Videokamera dient diesem Zweck.

Damit ist ein Eingangsbereich definiert, der schon zum Haus, aber auch noch zum Außenbereich ge-

Inszenierung der Eingangsfronten im öffentlichen Raum

15

Allmählicher Übergang von Außen nach Innen.
Eingang zum Bauhaus in Dessau

Seitlich einfallendes Licht unterstützt die Orientierung

hört. Wir durchschreiten die Eingangstür und sind im Haus. Ein Windfang, danach ein Flur, ein Foyer, eine Garderobe, ein Treppenhaus. Nun endlich betreten wir unser Ziel, ein Wohnzimmer, einen Konferenzraum oder ein Büro. Neun Schwellen haben wir überquert, bis wir dort sind, wo wir hin wollten: Fahrbahn, Trottoir, Vorgarten oder Hof, Stufen, Podest, Windfang, Flur oder Foyer, Treppe, Zimmer. Wenn der Architekt gut ist, inszeniert er jeden einzelnen Bereich. Jeder Abschnitt erhält eine unverwechselbare Atmosphäre. Blühende Natur gegen steinerne Geometrie, enge gegen weite, niedrige gegen hohe, dunkle gegen lichterfüllte, übersichtliche gegen geheimnisvolle Räume. Räume zum Durchschreiten und Räume zum sich Niedersetzen, karg ausgestattete und nobel ausstaffierte Räume. Jedes Mal, von einem Übergang zum nächsten, überrascht uns die Raumfolge aufs Neue.

Die Kunst des Architekten liegt nun darin, diese Überraschungen hierarchisch anzuordnen, das heißt, unsere Aufmerksamkeit und unser Wohlgefühl von Mal zu Mal zu steigern. Die wichtigen Räume im Haus erreichen wir, indem wir weniger wichtige Räume durchqueren. In „dienende und bediente Räume" ordnete Louis Kahn die architektonische Hierarchie im Haus. Deshalb muss sich der Architekt schon im Vorentwurf nicht nur über die Funktionen klar werden, sondern auch über Sinn, Bedeutung und Atmosphäre der Hausteile.

Blickführung

Darsteller vor Zuschauern: Selbstbewusst präsentieren sie sich. Sie offenbaren sich, sie geben sich preis. Noch jeder Architekt, noch jeder Hausbesitzer, hat einen bestimmten Wunsch, wie sein Bauwerk sich darstellen und wie es betrachtet werden soll. Nach Fertigstellung des Hauses, noch ist kein Möbelwagen zu sehen, das Haus steht nackt und leer, denkt der Architekt an die Publikation (auf seiner Homepage oder in der Fachzeitschrift) und weist

den Fotografen ein. Er erklärt ihm kunstvolle Raumverschränkungen, sensible Lichtführungen, wohlüberlegte Materialkontraste und das heikle Spiel der Volumen und Zwischenräume. Im Geheimen träumt der Architekt davon, dass das Haus nie bezogen, keine unvorhergesehene Möblierung es verunstalten würde und es hingegen als hervorstechendes Denkmal eines Geniestreichs im Stadtraum stünde. Der Fotograf soll ihm diese Illusion bieten.

Der Fotograf nimmt den Standpunkt künftiger Betrachter ein. Er spielt für den Architekten das Versuchskaninchen: Wie wird mein Bauwerk wahrgenommen? Ist es makellos oder gibt es vielleicht doch dilettantische Details? Sollte ich, der Planer, deshalb nicht unbedingt verhindern, dass Eindringlinge an den Fehlstellen herumschnüffeln, sondern sollten Besucher nicht besser meinen Blicken folgen? Ängstlich um seinen Ruf (oder Ruhm) bedacht indoktriniert der Architekt kategorisch die Wahrnehmung seiner Mitmenschen.

Selbstverständlich gibt es augenfällige Bauteile: plastischer Fassadenschmuck, Eingangsbereiche, auskragende Dächer, Treppen usw. Sie werden inszeniert auf Kosten zweitrangiger Elemente. Zumeist sind es jene Teile, die eine Schwelle oder einen räumlichen Übergang bezeichnen. Um der Orientierung willen, wird der Blick zu diesen Stellen geführt. Geführt wird er aber auch, weil der Schöpfer des Hauses auf vermeintliche Höhepunkte oder beachtenswerte Raumkompositionen aufmerksam machen will. So werden Ecken, auch Tür- und Fenstergewände profiliert, werden Niveauunterschiede und Gelenke zwischen Raumteilen betont.

Nun ist es allerdings so, dass ein Suchender, der ein ihm unbekanntes Ziel ansteuert, dankbar ist für Hinweise und Zeichen, die ihm das Finden erleichtern. Am simpelsten geschieht das mit Straßenschildern, Hausnummern und Richtungspfeilen. Doch zur ästhetischen Qualität von Wegführungen in Städten,

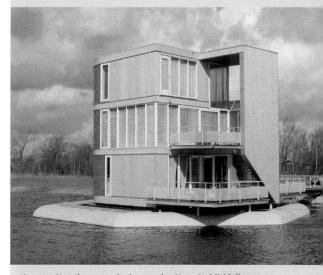

Herman Hertzberger, schwimmendes Haus in Middelburg. Ein Extrem: Isoliert im Stadtraum, aber vielleicht ein Prototyp für die Zukunft (wenn der Meeresspiegel steigt)

Inszenierter Jugendstileingang in Autun

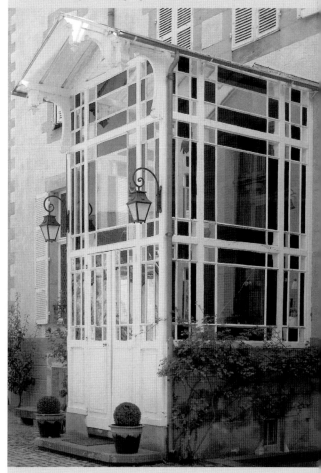

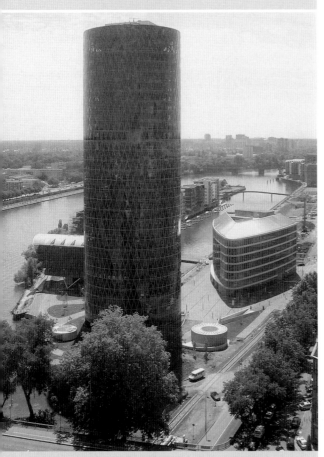

Architekten Schneider+Schumacher, Westhafen Tower (Frankfurt a.M.).
Der Turm als Dominante betont die Kreuzung von Fluß und Brücke

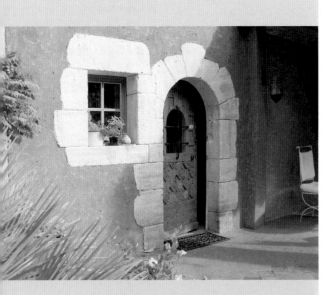

Auch der private Zugang soll aus angemessener Entfernung erkennbar sein. Eingang in Roussillon

Siedlungen oder Gebäuden tragen komplexere (suggestive) Gestaltungselemente bei. Straßen- oder Flurkreuzungen (in großen Bauwerken) werden schon von weitem erkannt, wenn der Schnittpunkt sich verengt oder sich zum Platz erweitert. Seitlich einfallendes Licht in die verschattete Zone unterstützt Wahrnehmung und Orientierung. In der Stadt werden an diese Orte hervorragende (im doppelten Sinne) Bauten platziert, so genannte Dominanten.

Ein Haus muss seine ‚Fangnetze' auswerfen. Es braucht einen einladenden Vorplatz, ein schützendes Vordach und anlockende Leitwände. Das Haus ist den Blicken ausgesetzt. Da es nicht aktiv darauf reagieren kann, auch wenn es manchmal den Anschein hat, muss es auf andere Weise die achtlosen, an ihm vorüberhuschenden Blicke festhalten. Das Haus in der Menge muss sich (bescheiden oder wichtig) hervortun. Wenn kein Haus, keine Stadt auf ihrer Individualität beharrten, würden sie sich zu monotonen oder labyrinthischen Netzen entwickeln, in denen sich kein Außenstehender zurechtfände, da jede Mauer mit der folgenden verwechselt werden könnte.

Der Einheimische im Labyrinth freilich gelangt blindlings ans Ziel. Nur der Fremde braucht Merkzeichen. Er bahnt sich anhand der Zeichen seinen Pfad durch das Dickicht der Stadt. Städte sind keine Zitadellen, Häuser keine Burgen. Menschen wechseln ständig das Außen und Innen. Ihnen muss der Zu- und Ausgang augenfällig angedeutet, das heißt, erleichtert werden. Das Ziel, Schlupfloch oder Portal, privater oder öffentlicher Zutritt, muss aus angemessener Distanz erkennbar sein. Die Begriffe Verschlossenheit und Kommunikation widersprechen sich.

Exkurs: Symmetrie

Die Frage ist nicht, warum Architektur allzu oft symmetrisch ist, sondern – im Gegenteil – warum auch unsymmetrische Bauten errichtet werden. Ist es doch selbstverständlich, dass Gebäude und menschliche Körper sich aufeinander beziehen, folglich die angeborene Symmetrie auch in des Leibes Hülle (auch in der ‚Dritten Haut' des Menschen: der Architektur) wiederkehren müsste. Flurbreiten, Tür- und Fenstermaße, noch eindeutiger Möblierungen, sind den menschlichen Maßen angepasst. Stühle formen unsere Körperhaltung ab, Fassaden werden als Gesichter wahrgenommen. Der Mensch ist symmetrisch, warum nicht seine Hüllen?

Auch wenn sich die Verhältnisse mitunter verkehren, bleibt dennoch der enge Bezug: Dann wird nicht der Bau vermenschlicht, sondern der Mensch wird zum Gehäuse: ein Mann wird zum ‚alten Haus', eine Frau wird zum ‚Frauenzimmer'. Haus und Person ergänzen sich nicht nur, sondern spiegeln offenbar einander. Wir erkennen in der toten Materie das Lebendige und umgekehrt. Wo ist die schmale Schwelle zwischen beiden? Ist die Spiegelsymmetrie Voraussetzung der Schöpfung? Ohne den Klebstoff der Spiegelachse (oder der Spiegelebene im Dreidimensionalen) zerstöben die Hälften – tot und lebendig – im Nichts. Betrachten wir uns frontal im Spiegel: Wo ist der Übergang zwischen links und rechts? Selbstverständlich liegt er in der Mitte. Aber nimmt die ‚Mitte' Raum ein? Wir haben eher das Gefühl, dass es eine hauchdünne, ja substanzlose, aber ungemein feste Scheidewand ist: eben hier noch rechts und schon dort links.

Unser Gehirn besteht aus zwei, in der Form einander spiegelnden Hälften. Dort reflektieren wir den eigenen Leibraum und stellen Symmetrie fest, sich beiderseits der immateriellen Mittelmembran entfaltend. So also steht es mit rechts und links. Anders aber ist es mit vorne und hinten, deutlicher noch mit oben und unten. Diese auf unseren Körper bezogenen Lagebezeichnungen liegen auf Konturlinien. Zwischen den Konturen gibt es Fläche, gibt es Raum. Vorne und hinten berühren sich nicht wie rechts und links, spiegeln sich nicht, sind darum qualitativ verschieden.

Anders als andere Säugetiere nehmen wir Aufrechtgeher die größte Ausdehnung in der vorderen Symmetriefläche ein. Sie ist die Angriffsfläche. Hier müssen wir Eindruck schinden und Abwehr verkünden. Sie ist die Oberfläche der Wahrnehmung, die Fläche der Aufrichtigkeit oder auch von deren Gegenteil. Wir wenden uns demjenigen, dem wir begegnen, misstrauisch, neugierig, freundlich oder boshaft zu. Einer scheint des Anderen Spiegelbild zu sein. Dies Gegeneinander bedeutet Gespräch und Auseinandersetzung. Das Nebeneinander, aneinander vorbeiredend, einander nur aus den Augenwinkeln wahrnehmend, gehört hingegen eher zur Herde.

Wir erforschen den Leib und empfinden ihn als kostbar und verletzlich. Er muss geschützt werden. So erfinden wir künstliche Haut: Kleidung und Architektur. Architektur lässt sich als erweiterter Leibraum beschreiben, Symmetrie als Frontstellung gegenüber dem Anderen, als Ordnungsmittel von Zuneigung und Abneigung, von Liebe, Streit und Selbstdarstellung. Umso ordensgeschmückter die Brust oder umso aufgeblähter die Front des Hauses, umso machtvoller erscheint der Besitzer. Die Angriffsfläche ist zugleich die Kontaktfläche, auch in der Architektur: Bekanntlich werden Fenster und Portal als Augen, Ohren, Nase und Mund wahrgenommen, Seitenflügel als Gliedmaßen. Sie fordern auf, sich dem „Angriff" zu stellen, beziehungsweise zu verhandeln, das heißt, zu kommunizieren. Die Kontaktorgane sind auf Grund ihrer symmetrischen Anordnung am auffälligsten. Symmetrie im Objekt (Haus, Möbel oder Kunstwerk) wirkt identifizierend, ja geht soweit, dass wir Menschliches wieder zu erkennen meinen.

19

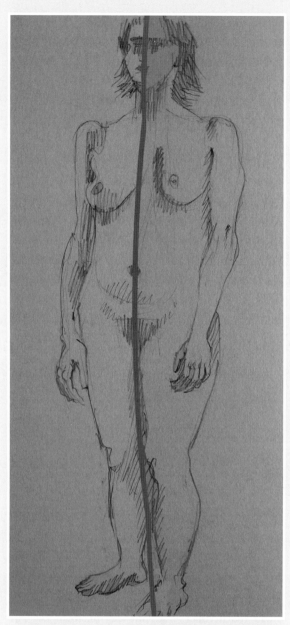

Dagegen erscheinen unsymmetrische Häuser von außen eher als Verpackungen einer ungleichmäßigen Folge von Identifikation stiftenden Innenräumen. Sie erscheinen als Gruppe von unterschiedlichen Raumteilen, von Räumen, deren jeder ein anderes menschliches Organ zu symbolisieren scheint. Das Haus ist auch hier der Spiegel seines Bewohners: Raum für Raum, Spiegelbild für Spiegelbild. Der Benutzer kann gar nicht anders, als – die Raumflucht durchmessend – Schritt für Schritt jeweils die Mitte und den umfassenden Spiegeleffekt zu suchen. So durchschreiten wir im Renaissancepalast die Zimmerflucht: von Symmetrie zu Symmetrie. Die Bewegung gehört dazu, die zeitliche Abfolge ebenso, um das Gesamte zu erfahren. Wir begegnen einer Raumfigur nach der anderen. Es ist wie eine Kamerafahrt im Film. Das Haus erscheint als Vorgang, als Wegenetz. Von Standort zu Standort gehend spiegeln wir uns im Dargestellten, fühlen uns bestätigt oder nicht, werden letztlich von den Symmetriefiguren eingefangen.

Der spiegelsymmetrische Mensch
Das spiegelsymmetrische Haus

Haus mit menschlichem Antlitz

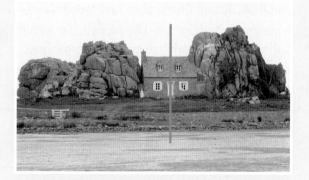

Spiegelsymmetrie wirkt als vorübergehende Konfrontation, Rundumsymmetrie verstellt uns den Weg. Palladios Villa Rotonda als kreuzsymmetrisches Gebilde erscheint deshalb manieristisch und künstlich, ein Ort weniger des Lebens als des Rituals. Inmitten des Hauses stehend, in welche Himmelsrichtung auch blickend, erscheint jedes Blickfeld als Wiederholung des bereits zuvor Gesehenen. Zwar kommt der Bau dank seiner rigorosen Konsequenz dem platonischen Schönheitsideal näher, wird aber zugleich zum Käfig aufgrund seiner punktartigen Mitte im Zentrum des Kreuzes. Dort ist Stillstand, dort endet die Bewegung. Dort begänne die Erstarrung, wenn es nicht innen ein Beobachtungsritual gäbe. Denn das Gebäude steht auf sanfter Anhöhe inmitten eines im Dunst der Ferne ausschwingenden Landstrichs. So steht es da wie ein Leucht- oder Beobachtungsturm, von dem sich nach allen Seiten die Tätigkeiten der Gärtner und Bauern in Augenschein nehmen und überwachen lassen. Ein Totaltheater, in dem man lauert und ins Auge fasst, nur ab und zu die Logenplätze wechselnd.

Bewegungen und Veränderungen – quirliges Dasein – aber gehören zum kreatürlichen Tagesablauf. Zu Palladios Konzept gab es epigonale Varianten, allesamt zum Scheitern verurteilt, wenn man lebendiges Wohnen zur Richtschnur nimmt: Grabarchitektur – wie Boullées rundum symmetrisches Kenotaph für Newton.

Offenbart sich Architektur erst als lebendige, wenn sie aus der Symmetrie ausbricht, wenn ihre Asymmetrie Unvorhersehbarkeit – wie das Leben – andeutet? Vom Zwang des Korsetts befreit, entblößt der Bau sein Innenleben. Ein Anschein von Natürlichkeit entsteht. Prototypischstes Produkt dieser Ideologie ist Mies van der Rohes Backsteinvilla von 1923, ein mit tentakelhaften Mauern in die umgebenden Wiesen ausgreifendes Bauwerk, ein großzügiges Überlappen von Außen- und Innenraum, so dass die Grenzen fließend und die Bedeutungen der Räume vielfältig werden. Die Wohltat des fließenden Grundrisses genießt allerdings nur der, der umhergeht und sich dem Fluss anvertraut.

Wir folgen den Raumfluchten und gleichen unsere Tätigkeiten, unsere Spiele und unser Kommunikationsverhalten den an uns vorbeiziehenden Raumsequenzen an. Schwer ist es, selbstgewiss und selbstgenügsam zu bleiben angesichts des lockenden Angebots von Spiegelbildern. Einer zeitgenössischen Architektur mag die herkömmliche Symmetrie nicht mehr anstehen, aber im Verborgenen wirkt eine unbändige Kraft des Ausgleichs, die auf die Realität des Irrealen mit gegengewichtigem Anspruch antwortet: High-Tec contra Low-Bric.

Andrea Palladio, Villa Rotonda 1567

Mies van der Rohe, Backsteinvilla, Projekt 1923

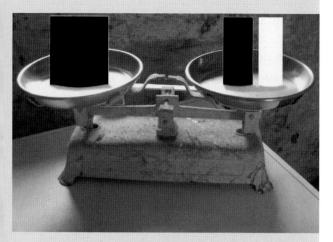

Tafelwaage:
Auf der einen Seite das zu Wiegende, auf der anderen Seite
die Gewichte, zwei als Lasten vergleichbar schwere, aber in der
Gestalt unterschiedliche Dinge

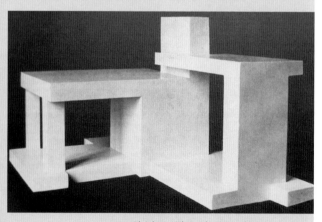

Gleichgewichtige horizontale Baumassen,
Betonung der Senkrechtachse
Georges Vantongerloo, Geometrischer Ort, 1931

Kontrastbedingtes Gleichgewicht

Jetzt kommt van Doesburgs „kontrastbedingtes Gleichgewicht" ins Spiel. Er definiert es als „ausgewogenes Verhältnis ungleicher Teile, das heißt solcher Teile, die auf Grund ihrer Funktionseigentümlichkeiten sich durch Position, Größe, Proportion und Lage voneinander unterscheiden. Die Gleichwertigkeit dieser Teile beruht auf dem Gleichgewicht ihrer Ungleichheit und nicht auf ihrer Gleichheit."[5] In anderem Zusammenhang formuliert er es so: „Das Leben ist ein Agglomerat gegensätzlicher Kräfte, die sich […] in ewig währendem Gleichgewicht befinden."[6] Offenbar handelt es sich für van Doesburg um ein grundlegendes und nicht nur formales Prinzip. In diesem Zusammenhang aber interessiert uns vor allem die gestalterische Anwendung.

Stellen wir uns eine Tafelwaage vor: auf der einen Seite das zu Wiegende, auf der anderen Seite die Gewichte, zwei als Lasten vergleichbar schwere, aber in der Gestalt unterschiedliche Dinge. Im übertragenen Sinne bedeutet das, dass Ausgewogenheit (rechts und links einer Vertikalachse, über und unter einer Horizontalachse) durch zwei oder mehrere kleine Objekte konträr zu einem großen Objekt erzeugt werden kann, dass unter Umständen eine große, blasse durch eine zwar winzige, aber stark farbige Fläche ins Lot gebracht wird, ja, dass sogar eine Farbe einer Form bedeutsam, das heißt gleichgewichtig gegenüber steht (usw.). Ausgewogenheit meint also keinesfalls Symmetrie, wenn sie auch annähernd mit ihr verwandt ist.

Das Prinzip lässt sich natürlich sowohl auf die Skulptur wie auf Architektur übertragen: glatte gegenüber rauen Oberflächen, kleinteilige gegenüber ungegliederten Volumen, vertikale gegenüber horizontalen Baumassen. Aufregend ist, wenn eine Komposition scheinbar zu kippen droht, aber durch eine Gegenmaßnahme aufgehalten wird. Der schwankende Bauklötzchenturm lässt das Kind den Atem anhal-

ten, erzeugt eine Art von Angstlust. Ebenso erregt geregelte Labilität des Betrachters Aufmerksamkeit. Und Beachtung möchte das Kind genauso wie der Kreative erzielen.

Die Vielfalt der Möglichkeiten, kontrastbedingtes Gleichgewicht zu erzeugen, ist enorm. Schlichte (eindeutig standfeste) Symmetrie dagegen wird oft nur aus Gewohnheit, Gedankenlosigkeit oder in der Scheu vor dem Experiment angewandt. Kreativität aber besteht darin, dass wir uns in der Weite des Denkbaren und Undenkbaren vergnügt und risikofreudig unseren Weg bahnen.

Licht und Schatten

Als Natur noch nicht zur Idylle verklärt worden, sondern noch feindliche Umwelt war, gehörte es zum sich Verteidigen dazu, Entfernungen und Zwischenräume schätzen zu können. Aber auch wir, selbst wenn wir die längste Zeit des Tages an den Büroschreibtisch, den Zeichentisch und den Computer gefesselt sind, müssen notwendigerweise die Tiefe zwischen Gegenständen beurteilen. Wer das nicht kann, warum auch immer, stößt an, greift und tastet daneben, tritt ins Leere oder stürzt. Dreidimensionales Sehen ist eine Qualität, ohne die wir in unserer Umgebung nur mühsam zurechtkämen. Unsere Augen sind unser Navigationswerkzeug im Umfeld. Licht und Schatten sind unsere Navigationshilfen. Die Tiefe zwischen hintereinander liegenden Kulissen wird durch den Schattenwurf der einen Fläche auf die andere deutlich. Vorsprünge und Rücksprünge auf architektonischen Volumen, ihr plastisches Relief, werden von schräg einfallendem Licht hervorgehoben. Das im Tagesverlauf wandernde Sonnenlicht verändert kontinuierlich die Oberflächen und weckt die Illusion von Lebendigkeit. Selbst ein Rauputz verfärbt sich im Streiflicht dank seines sandigen Korns.

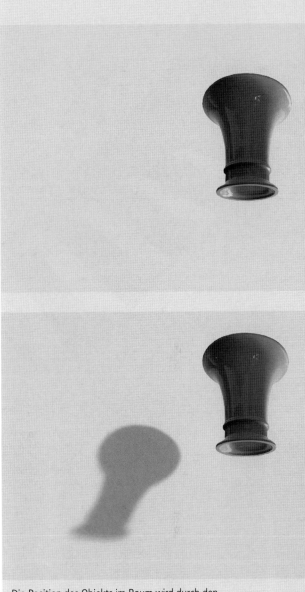

Die Position des Objekts im Raum wird durch den Schattenwurf deutlich.

Le Corbusier: „Unsere Augen sind geschaffen, die Formen unter dem Licht zu sehen: Licht und Schatten enthüllen die Formen."

Symmetrie wird nicht nur verstärkt, wenn die Spiegelachse hervorgehoben ist, sondern auch wenn Bauteile sichtbar in verschiedenen Vertikalebenen liegen. Der Betrachter sieht die plastischen Qualitäten, das heißt, die gegeneinander versetzten Volumen und das fein differenzierte Relief der Oberflächen. Am deutlichsten sieht er dies, wenn er das wechselnde Spiel von Licht und Schatten auf den Fassaden beobachtet, denn „Architektur ist", wie Le Corbusier formulierte, „das kunstvolle, korrekte und großartige Spiel der unter dem Licht versammelten Baukörper. Unsere Augen sind geschaffen, die Formen unter dem Licht zu sehen: Licht und Schatten enthüllen die Formen."[7]

Der Laie sieht, was der Architekt bedachte: schmale vertikale Schattenstreifen, die die Volumen trennen und ihre Ausbreitung rhythmisieren; horizontale Schattenstreifen, die die Staffelung der Baumassen in der Höhe unterstreichen, gar den Baukörper schlanker erscheinen lassen. Reihung, Rhythmus und Takt sind musikalische Kategorien, jedoch zugleich anwendbar in allen Künsten, auch in der Architektur. Licht auf reliefartigen Vor- und Rücksprüngen erzeugt Schatten, die sowohl die Plastizität verstärken, als auch die Taktierung des Baus betonen. Beleuchtung hebt einen Bauteil hervor, Schatten lässt ihn in scheinbare Bedeutungslosigkeit versinken. Ein Hintergrund kann so als das Eigentliche inszeniert, ein Vordergrund in seiner Bedeutung gemindert werden. Durch Illuminationen werden unsere Blicke manipuliert, das heißt, wir werden geführt, wir lassen uns verführen.

Auch hier gilt das Motto: Sehen lernen und Strategien entwickeln. Da der Lichtschattenkontrast im Tagesverlauf eher zufällig, sich stetig ändernd und unvorhersehbar auftritt, können wir dem entgegensteuern, indem zurückliegende Flächen im Fassadenrelief farblich verdunkelt werden. Filmregisseure haben es längst vorgemacht: Robert Wiene (Das Kabinett des Dr. Caligari) oder Alain Resnais (Letztes

Entwerfen mit Licht und Schatten, Studienprojekt von Thilo Specht

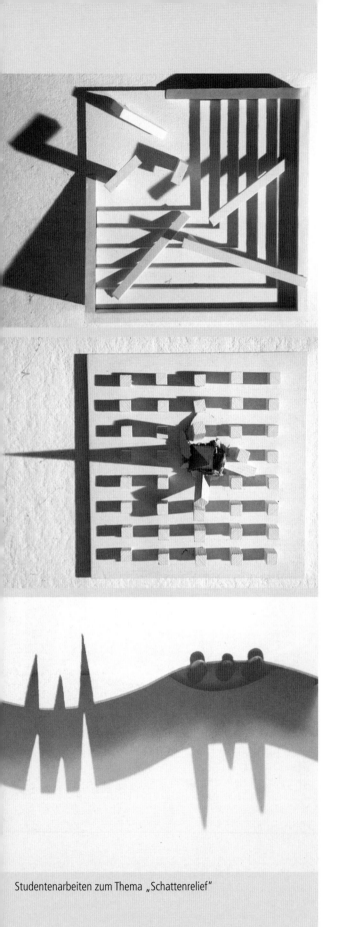

Studentenarbeiten zum Thema „Schattenrelief"

Jahr in Marienbad) haben für bestimmte Szenen Schlagschatten mit schwarzer Farbe auf den Boden malen lassen. Die durch Kontrastverstärkung erzeugte expressionistische Wirkung weist in ihrer dramatischen Rigorosität auf körperlich-psychische Grenzerfahrungen hin.

So weit wird man in der Architektur nicht gehen, aber auch dort kann man mit Kontrastverstärkungen eine gewünschte Atmosphäre erzeugen. Gerade das Prinzip ‚Entwerfen mit Licht und Schatten' ist mehr als nur eine vage Möglichkeit, Bauvolumen zu strukturieren. Es macht Oberflächen scheinbar wandlungsfähig und verleiht ihnen eine charakteristische Gestik. Tiefliegende Einschnitte, senkrecht scharrierte Oberflächen, eingelassene Plattenfugen, Fenster- und Türgewände, hervorstehende Gesimse, auskragende Konstruktionsteile, ornamentaler Flächenschmuck, Rankgitter und Jalousien, all das verschattet strukturierend Mauern im Sonnenlicht.

Probehalber kann man das in kleinen skulpturalen Übungen testen, zum Beispiel an der *Aufgabe „Schattenrelief". An Hand von griffigen Modellen, nicht größer als 30 x 30 cm, mit leicht zu schneidenden Materialien (Pappen, Blechen, Drähten, Fäden, Glas- oder Kunststoffscheiben), lässt sich die Vielfalt der Möglichkeiten erproben. Die Erzeugung von farbigen Lichtflecken sind ein ergänzendes Thema.* Auf der Baustelle werden später in der Praxis mit probeweise aufgestellten Teilfassaden nicht nur Materialstudien, sondern auch Licht- und Schattentests durchgeführt.

Tiefe

„Elemente, die in einer Szene gleich weit entfernt sind, erscheinen mit zunehmendem Abstand als immer dichter gepackt"[8] Derart lässt sich der so genannte Texturgradient definieren. Das Phänomen beruht auf der Erfahrung, dass in Form und Ausdehnung gleiche Objekte mit zunehmender Entfernung – ebenso ihre

26

Zwischenräume – scheinbar kleiner werden. Da wir um die gleiche Größe der Objekte wissen, schließen wir aus dem Wahrgenommenen (auf einem Foto oder einem Gemälde), dass auf Grund des kontinuierlichen kleiner Werdens der Volumen und ihrer Abstände die Objekte in Wirklichkeit räumlich weit auseinander liegen Mit dem Texturgradienten holen wir die dritte Dimension auf unser Skizzenpapier. Neben der Perspektive ist er wie das Sfumato (Luftperspektive, s. S. 109) eine weitere Möglichkeit, auf der Fläche den Eindruck eines tiefen Raums zu erzeugen.

Wie der Bildhauer ist der Architekt ein Tiefengestalter. Die Fläche ist ihm zwar nicht gleichgültig, aber zweitrangig. Die dritte Dimension ist die entscheidende: Volumen und Hohlräume. Raumerfahrung ist Grenzerfahrung, ist die Begegnung mit Widerständen – mögen sie sich auch als dünne Wände oder gar Membrane darstellen. Durchbreche ich den Widerstand, verlasse ich den Raum und gerate in einen anderen.

Wir können uns in die Materie nicht hineinwühlen: In die Tiefe vorstoßend stoßen wir auf eine Oberfläche nach der anderen. Sind wir durch eine Raumgrenze gedrungen, schauen wir wiederum nur auf die Sicht versperrende Hülle eines angrenzenden Raums. In der Distanz zwischen den Häuten wird uns der Raum bewusst. Außen und innen: überall Fassaden, Fassaden in alle Himmelsrichtungen. Aber mehrere Fassaden ergeben einen Körper, der dem Außenstehenden ein erfülltes Inneres verspricht, mag die Fülle in Wahrheit auch hohl sein.

Texturgradient, Sfumato, Licht und Schatten, Perspektive und Axonometrie erzeugen auf dem Papier die Illusion von Lebensumwelt. Leben heißt sich verändern, auch den Standpunkt. Wir bewegen uns, weil wir den endgültigen Stillstand fürchten. Wir durchmessen den Raum. Darum zeichnen wir die Tiefe, zeichnen keine flachen Welten. Zeichnend machen wir uns klar, dass wir den Raum bewohnen, dass wir da sind.

Luftperspektive (Sfumato)

Texturgradient: Wir schließen aus dem Kleinerwerden der Objekte und ihrer Abstände auf die räumliche Tiefe.

Paul Cézanne: Sein Stilleben ist reduziert auf geometrische Grundformen

Carlo Scarpa, Treppenmotiv

Motivwiederholung

Motivwiederholung und Echo spielen nicht nur in der Musik eine Rolle. Auch in den anderen Künsten verstärken sie den Geist des in sich Schlüssigen, das dann wie aus einem Holz geschnitzt, wie aus dem Korb des miteinander Verträglichen geholt erscheint. Wenn Paul Cézanne darauf bestand, dass die Formen der Natur sich aus den Primärformen der Geometrie (Kugel, Würfel, Pyramide, Zylinder, s. a. S. 83) zusammensetzen, so meinte er damit nicht die wahre Existenz der Objekte, sondern die Tatsache ihrer Wahrnehmung und deren Wiedergabe im Gemälde. Der selbst auferlegte Zwang, das Gesehene zu geometrisieren, macht die Dinge nicht nur vergleichbar, sondern lässt sie aus dem gleichen Geist erschaffen erscheinen. Eine Allegorie des Glaubens an den göttlichen Ursprung der Welt.

Die Kunstrichtung ‚Kubismus' heißt so, weil der Kubus (aber auch Kugel, Pyramide und Zylinder) als sich wiederholendes Element Struktur und Form der Bildgegenstände prägt. Eine Baum- und Felslandschaft wird zum Eckigen hin stilisiert, als gäbe es keine geschwungenen Linien, als stünde alles im innigsten Verwandtschaftsverhältnis. Ein Gleiches nehmen wir in architektonischen Ensembles wahr: Die Dreiecksform des Hausgiebels kehrt oberhalb von Tür und Fenster wieder. Oder das Motiv der Eingangsstufen wiederholt sich in der Stufung des Giebels und zugleich im Detail der gestuften Säulenbasis. Das Treppenmotiv zum Beispiel findet sich im Werk des Architekten Carlo Scarpa geradezu exzessiv ausgebreitet.

Die hervorragende Stellung des intelligenten Lebewesens Mensch in der Welt äußert sich darin, dass er mit einem einfachen Werkzeug, dem Messer zum Beispiel, die vielfältigsten Tätigkeiten verrichten kann. Schneiden oder Schnitzen, einmal eingeübt, gibt Sicherheit auch im Umgang mit ungewohnten Materialien. Die Tätigkeit des Schnitzens erzeugt

ein gleichartiges Erscheinungsbild (anders als das Sägen, anders als das Meißeln) auf unterschiedlichen Oberflächen. So entsteht die unverwechselbare Handschrift des Handwerkers oder Künstlers. Für den Konsumenten, ebenso wie für den Handwerker, zufrieden stellend ist das wieder Auffinden einer einmal erkannten Einzelform im Ganzen, eines einmal erkannten Motivs im Gesamtwerk. Die Wiederholung erzeugt ein befriedigendes Gefühl von Beständigkeit und Vertrautheit. Die Mannigfaltigkeit im Gleichartigen, die Einheit in der Vielfalt ist das Kunstvolle.

Wie ein Trommelschlag wiederholt das Motiv eine Aussage. Es soll sich einprägen. Die Einzelform eines Bild- oder Bauwerks bildet die Gesamtform ab. Selbstähnlichkeit heißt das in der Chaosforschung oder der Theorie der Fraktale (s.a. im Kapitel Komposition). Motive wiederholen sich also. Wir wollen sie vom „Echo" unterscheiden.

Das Echo ist nicht auf die sichtbare Nähe angewiesen. Es kann der Widerhall aus anderen Räumen, anderen Zeiten sein. Nur ein Zitat. Anders als das auditive scheint das visuelle Echo beständig zu sein. Vielleicht verblasst es allmählich. Es ist reduziert, es erinnert nur bescheiden an etwas Bedeutenderes, aber es bleibt wahrnehmbar, es bekräftigt die voran gegangene Aussage. Wie der Gehilfe den Meister unterstützt. Ein Beispiel: Das Grundstück des im 2. Weltkrieg zerstörten Dessauer ‚Meisterbaus', des Wohnhauses Walter Gropius', wurde in den 50er Jahren wieder bebaut. Im Zuge der musealen Restaurierung aller Meisterbauten wurden dem kaum noch zu erkennenden Gropiushaus Metallrahmen in den Maßen der ursprünglichen Fenster vor die Fassade gesetzt. Eine intelligente Art und Weise, an den Vorgängerbau zu erinnern.

Das visuelle Echo verweist auf ein vergangenes Bild; jeder neuzeitliche Dreiecksgiebel zum Beispiel kann auch als Echo auf ein fernes antikes Vorbild gese-

Motivwiederholung: Redentore-Prinzip

Walter Gropius, eigenes Haus in Dessau, im 2. Weltkrieg zerstört und wieder aufgebaut. Die ehemaligen Öffnungen sind als Rahmen vor die Fassade gesetzt.

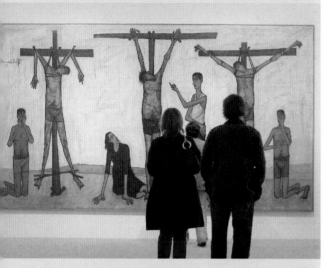

Betrachter und Gemälde (Bernard Buffet, Kreuzigung)

Bildachsen und Diagonalen:
Jusepe de Ribera, Martyrium des heiligen Bartholomäus

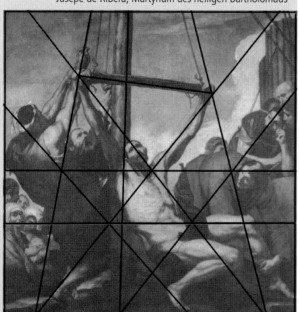

hen werden. Das Echo gleicht unter Umständen nur einem Hauch des Vorbilds. Mancher übersieht es, manchem aber bestätigt es seinen Scharfsinn. Es ist ein Anreiz zur Interpretation. Das Gespräch zwischen Werk und Betrachter wird in Gang gesetzt.

Bildanalyse

Um in der Welt zu bestehen, gehörte einst – zu Zeiten der Jäger und Sammler – die nervös gespannte Ausspähung des Umfeldes dazu. Zwar ist die beobachtende Wachsamkeit nicht mehr unabdingbarer Bestandteil des Lebenskampfes, bleibt aber ein kreatives und intellektuelles Spiel, notwendig für den klaren Kopf und für künstlerisches Tun.

Es wurde bereits die kreative Neugier (Exkurs im Kapitel 1) verteidigt. Gehen wir in eine Gemäldegalerie und hören dem Raunen der anwesenden Besucher zu: „An Dürers ‚Hasen' lässt sich jedes Härchen erkennen" oder „das Elend der geschundenen Körper ist ergreifend dargestellt" oder auch nur „das ist erstaunlich, das gefällt". Diese Bemerkungen lassen zwar etwas über Neigung und Geschmack des Betrachters erkennen, sagen aber nichts aus über den Kunstgehalt des Kunstwerks.

„Kunst ist schön, macht aber viel Arbeit", sagte einst Karl Valentin in seiner schlichten, unnachahmlich hintersinnigen und scheinbar naiv-komischen Art. Er meinte damit nicht nur die Tätigkeit des Künstlers, sondern auch die des Rezipienten, also des Betrachters. Der Vergleich mit anderen Werken, das Bewusstsein des eigenen Wissens, das Erkennen von Strukturen, Kompositionsprinzipien und Arbeitstechniken strengt an, befriedigt aber, weil wir mehr erkennen als beim flüchtigen oder gar begriffsstutzigen Schauen.

Befriedigend ist das Betrachten, wenn wir uns zuvor das dafür nötige geistige Handwerkszeug angeeignet haben. Denn zum Betrachten gehört das

Nachdenken. Nicht nur, dass wir etwas über die Zeitumstände oder die Techniken des Malens, vielleicht auch über die gesellschaftlichen Umstände des Malers wissen sollten, wir sollten auch über die abendländischen Kompositionsgewohnheiten und Farbkombinationen Bescheid wissen.

Da gibt es die Bildfläche, die eindeutig durch ihre Kanten und darüber hinaus durch den Rahmen begrenzt ist. Es gibt einige Senkrecht- und Waagrechtachsen, die die Bildränder miteinander verspannen. Wir erkennen, dass eine Vielzahl von Linien rechts und links, oben und unten scheinbar an den Bildrahmen geheftet sind, was mitunter einem Spinnennetz gleicht. Einige Linien fahren offenbar weit über die Bildfläche hinaus und einige Volumen quetschen sich ins Bildgeviert, als wollten sie den Rahmen sprengen. Wenn aber eine Zeichnung in der Bildfläche schwimmt und keinen Halt an den Bildrändern findet, dann ist dies ein Zeichen dafür, dass ein Zeichner sich seiner Mittel nicht sicher ist.

Weiterhin erkennen wir Bilddiagonalen, die (so wie der gegen den Sturm gebeugte Mensch geht) eine fortschreitende scheinbare Bewegung ins Bild holen. Wir sind gewohnt, von links nach rechts zu lesen: Demnach gibt die von links unten nach rechts oben zielende Diagonale den Eindruck von Fortschritt (sich gegen den Sturm stemmen) und die von rechts unten nach links oben den Eindruck von Rückläufigkeit (vor einem Ereignis zurückweichen). Die eine erscheint forsch und hoffnungsvoll, die andere haltlos oder resignativ. Das gilt natürlich nur für Diagonalen in senkrecht stehenden Flächen. Auf einer Bodenfläche im Raum neutralisieren sich die Deutungen. Es gibt dort naturgemäß keine aufsteigende und keine absteigende Diagonale. Jedoch erscheinen sie auch hier, weil sie zwei gegenüber liegende Ecken stracks miteinander verknüpfen, bedeutungsvoller als jede andere Linie.

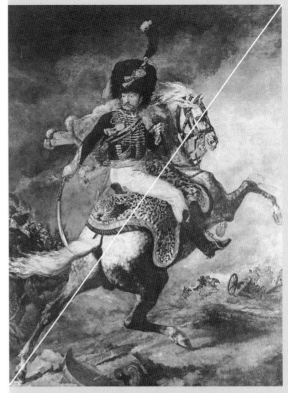

Bilddiagonale von links unten nach rechts oben:
Theodoré Géricault, Gardejäger beim Angriff

Bilddiagonale von links oben nach rechts unten:
Peter Bruegel, Parabel von den Blinden

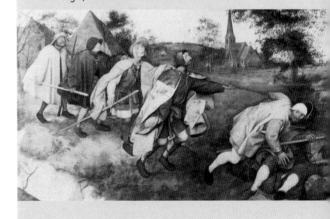

Exkurs: Diagonale

Die Diagonale wird als die Strecke definiert, die im Polygon zwei nicht benachbarte Ecken verbindet. Daraus folgt, dass ein Kreis oder eine Dreiecksfläche keine Diagonale haben können. Es sei denn, ich verspiegele eine Seite eines dreieckigen Raums, der sich dann scheinbar zum viereckigen erweitert und somit die Spiegelseite zur queren, diagonalen Verbindungsfläche erhebt.

Die Diagonale gilt als die hervorstechende Verknüpfung im Raum. Wie die Achse ist sie deutlich wahrnehmbar und zugleich unsichtbar. Sie symbolisiert die Linie, auf der zielbewusste Bewegung stattfindet, losgelöst von schützenden Wänden. Die diagonale Linie, eine Kette von Mittelpunkten, auf der voranschreitend jeder sich selbst im Mittelpunkt wähnen darf. Jedoch gehört ein bestimmtes Maß an Selbstbewusstsein dazu, ein gewisses Vergnügen, sich zur Schau zu stellen. Scheu Veranlagte wählen eher den Umweg an Wänden entlang, in Tastnähe

zu deren Oberflächen. Von ihnen wird der Raum wie im Kartenhaus als Stecksystem von Flächen begriffen, eine gezügelte Reduktion auf bildhafte Ebenen. Anders der diagonal Schreitende; denn nur jener Schreitende, der seiltänzerisch auf Achsen und Diagonalen wandelt, erfährt ahnungsvoll das, was Raum tatsächlich bedeuten kann: eine den eigenen Körper durchdringende Atmosphäre und eine erst in angemessener Ferne begrenzte, aber prägnant geformte Umgebung.

Der Weg in Tastnähe an Wänden entlang führt sicher zum Ziel, die Diagonale quer durch den Raum führt schnell zum Ziel, schnell auch deshalb, weil der Gehende wie auf schmalem Grat wandelt. ‚Der kürzeste Weg ist nicht immer der beste‘, belehrt Volkes Mund. Der Umweg, der dem Spaziergang ähnelt, falls er nicht auf einem Irrtum beruht, schafft Nähe und erlaubt Detailerkundungen, ermuntert zu sinnlichen Erfahrungen taktiler und olfaktorischer Art. Der Umweg lässt den direkten Weg als Sehne eines Bogens oder als Hypothenuse eines Dreiecks erscheinen und erzeugt, wenn die Neugier überhand nimmt, den Wunsch, das Gegenstück auf der anderen Seite des direkten Weges zu erforschen. Dann wird der direkte Weg zur Diagonale eines Feldes. Der aufrecht gehende Mensch, den diagonalen Weg verfolgend, wird unbewusst navigatorisch tätig. Er gibt sich selbst leibbezogene Ortszuweisungen: oben – unten, vorne – hinten, rechts – links. Er erschafft sich seinen Raum als sichtbaren Raum, als Randerscheinung des Weges.

Auf der Diagonalen einen bevölkerten Innenraum querend, vermeintlich alle Blicke auf sich ziehend, empfindet er den Weg als Laufsteg, verlockend und einschüchternd. Ein angespanntes, ungemütliches, aber auch erfüllendes Tun, zugleich die Menge teilend und von ihr bedrängt. Befreiter, erhabener und theatralischer wird die Bewegung, wenn die Diagonale zur Höhendiagonalen im Architekturkubus erweitert wird. Auf der Treppe oder Rampe herab-

steigend, langsam und kerzengerade, wird ihm die Würde des aufrechten Ganges bewusst. Himmel und Erdboden verbindend stieg Gott Marduk die babylonische Zikkurat herab zu den Menschen. Ein Klischee, auch ein dramatisches: Der Würdenträger erscheint – Achtung gebietend – auf dem obersten Treppenabsatz, um nach vollendeter Ansprache aus den höheren Regionen in die unteren herabzusteigen.

Auch die Showbiz-Göttinnen, ob im Filmstudio oder Kabarett, tänzeln die Freitreppen herab, als schwebten sie diagonal in den Saal hinunter. Nicht blitzartig, nicht wie deus ex machina erscheinen sie, sondern die Szene des Auftritts und des genussvollen Schauens wird so lange wie möglich ausgekostet. Verlängert wird der Auftritt des Stars, indem er auf achsial gestellten, breiten Treppen diagonal die Stufen herabsteigt. Der deus ex machina hingegen schwebt wie im Fahrstuhl herab, eventuell mit Blitz und Donner, jedoch bewegungslos im auf- oder absteigenden Stillstand befangen. Hier

ist der Augenblick des Erscheinens belangvoll und nicht die pompöse Entfaltung der Person. Derart ist der Fahrstuhl zur Selbstinszenierung untauglich, ja im Gegenteil eher ein Instrument des inneren Rückzugs, mag auch ein unerwartetes in der Türe Stehen eindrucksvoll wirken.

Die Achse entspricht dem langsamen, feierlichen Schreiten. Auf der Diagonalen geht es bewegter, wenn auch nicht weniger wirkungsvoll zu. Steif und herrscherlich dort, animiert und geschäftig hier. Auf der Diagonalen entsteht Öffentlichkeit. Nicht ohne Grund werden in zeitgenössischen Stadtentwürfen Passagen oft schräg ins sonst konsequent gerasterte Raumgefüge geschnitten. Um der inszenatorischen Wirkung willen nimmt der Entwerfer Unregelmässigkeiten und kaum brauchbare Raumzwickel in Kauf. Der New Yorker ‚Broadway' macht es deutlich: Die nicht ins System passende Linie (die Erinnerungsspur eines ehemaligen Indianerpfads) wird zur Lebensader. Hier findet Austausch statt, hier werden die aufmüpfigen Ideen zu Markte getragen. Tiefsinn und Leichtsinn.

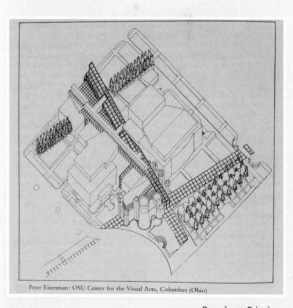

Broadway-Prinzip
Peter Eisenman, OSU-Center for the Visual Arts,
Columbus (Ohio)

Madonnenauge im Mittelpunkt des Bildes
Jan Gossaert, Madonnenbild um 1516

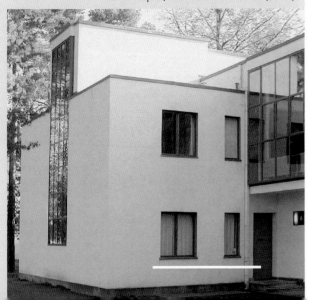

Die Eingänge liegen abseits der Symmetrieachse
Carlo Scarpa, Projekt (oben),
Walter Gropius, Meisterhaus in Dessau (unten)

Mittelpunkt

Die Diagonalen und die eventuell mittige Senkrechtachse haben einen gemeinsamen Kreuzungspunkt, der (wenn wir ihn wahrnehmungspsychologisch untersuchen) zuerst unsere Aufmerksamkeit hervorruft. So wird dort in der Mitte oft das Belangvollste, das Augenfälligste, das, worauf der Betrachter gestoßen werden soll, platziert. In Jan Gossaerts symmetrisch gebauten Madonnenbild gehen die senkrechte Mittelachse und die Waagrechtachse durch jenes Auge Mariens, mit dem sie Blickkontakt mit ihrem Kind sucht. Der verehrungsvolle Abstand zum Gottessohn und zugleich die mütterliche Zuneigung hat Gossaert so auf subtile Art auszudrücken gewusst.

In weniger bedeutsamen Zusammenhängen wirkt die Mittenbetonung jedoch auf Dauer zu routiniert und wird in der Wiederholung zum Gähnen langweilig. Deshalb findet sich in der Mitte (seit der späten Renaissance) oft – ausgerechnet nichts. Eine Provokation, die dem Betrachter zu denken geben soll. Es ist des Malers verblümte Aussage zum Zustand der Welt: Wir geraten aus dem Gleichgewicht, weil wir unseren Mittelpunkt verloren. „Der Verlust der Mitte" heißt das bezeichnende Buch des konservativen Kunsthistorikers Hans Sedlmayr, in dem er das allmähliche Verschwinden jeglicher Autorität und den Zerfall der Gesellschaft beklagt.

Der Maler verrückt den zentralen Punkt, er verschiebt die Horizontalachse, er betont die Diagonale oder vernachlässigt sie. Mit diesen (versteckten) Kompositionslinien und -punkten gelingt es dem Maler, unsere Blicke nach seinem Willen zu lenken und das ihm Bedeutungsvolle wie auch das hintergründig Verborgene hervorzuheben. Das Gleiche lässt sich auf Architektur übertragen. Bei einem symmetrisch komponierten Gebäude zum Beispiel erwarten wir in der Spiegelachse den Eingang. Wenn es dort aber verschlossen, der Eingang hingegen in einer Neben-

34

fassade zu finden ist, dann vermuten wir des Besitzers Hang zum Rückzug oder zur stillen Abwehr von Besuchern. Wir können nicht anders: Hinter jedem ‚Versprecher' (Sigmund Freud erörterte dies unter dem Begriff „Fehlleistung"), hinter jedem Planungs- oder Kompositionsfehler vermuten wir eine Absicht oder einen Einblick in des Urhebers Psyche.

Goldener Schnitt

Einen Einblick in den Willen der Götter erhoffte sich schon der antike Mensch, indem er das, was ihn umgab, zu erfassen und vor allem zu vermessen suchte. Die Entdeckung des goldenen Schnitts war der Versuch, Universum und Mensch, die großen und die kleinen Dinge zueinander in ein harmonisches Verhältnis zu bringen, gleichsam eine ästhetische Weltformel zu finden. Göttliche Teilung nannte der Franziskanermönch Luca Pacioli diese ausgewogene Asymmetrie in seinem Werk „De divina proportione" (1509). Die Konstruktion des Verhältnismaßes ist einfach (s. Zeichnung), mathematisch gesehen entspricht das Verhältnis SB : SA den Zahlen 1 : 1,618. Seit Vitruv gibt es zahllose Versuche, in der Natur, in den menschlichen Kreationen (seinen Kunst- und Bauwerken) und vor allem am Menschen selbst ein ewig gültiges Proportionsgesetz, das harmonische Maß, nachzuweisen.

Am bekanntesten ist sicher Leonardo da Vincis Proportionsstudie, die wiederum sich auf Vitruvs Architekturtraktat bezog. Aber auch seine Idee, den Menschen sowohl in ein Quadrat als in einen Kreis einzuzeichnen, hatte bereits Vorstufen. Leonardo schreibt:

„Wenn du deine Beine so weit auseinander stellst, dass du um ein Vierzehntel kleiner wirst, und wenn du deine Arme so hochhebst, dass du mit den Mittelfingern die vom Scheitel ausgehende Linie berührst, wisse, dass der Mittelpunkt deiner ausgestreckten Gliedmaßen dein Nabel ist und dass der Raum zwi-

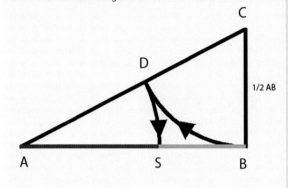

Zwei Strecken stehen im Verhältnis des goldenen Schnittes, wenn sich die größere zur kleineren Strecke verhält wie die Summe aus beiden zur größeren.

Konstruktionsanweisung:

Errichte auf der Strecke AB im Punkt B eine Senkrechte mit der halben Länge von AB und dem Endpunkt C. Schlage einen Kreis um C mit dem Radius CB. Er schneidet die Strecke AC im Punkt D. Ziehe dann einen Kreis um A mit dem Radius AD. Dieser teilt die Strecke AB im Verhältnis des Goldenen Schnittes.

Leonardo da Vinci, Proportionsstudie

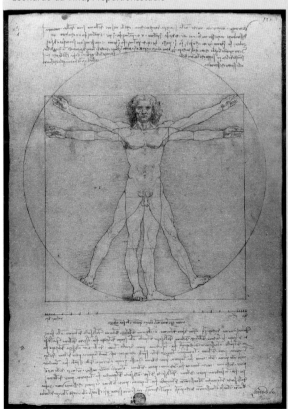

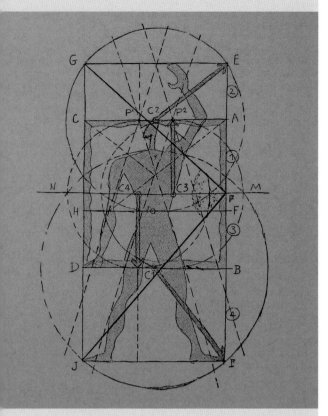

Le Corbusier, Proportionsstudie Modulor

Zeitungscollage

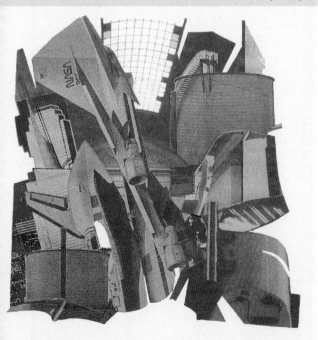

schen deinen Beinen ein gleichschenkliges Dreieck ist. Der Mensch kann seine Arme so weit ausbreiten, wie er groß ist."[9]

Allerdings gehört ein gehöriges Maß an Gutgläubigkeit dazu, denn die Messpunkte sind nie eindeutig. Auch Le Corbusier musste sich in seiner Maßlehre „Der Modulor" den Idealmenschen zurechtbiegen: „Ein Mensch mit erhobenem Arm liefert in den Hauptpunkten der Raumverdrängung – Fuß, Solarplexus, Kopf, Fingerspitze des erhobenen Arms – drei Intervalle, die eine Reihe von goldenen Schnitten ergeben, die man nach Fibonacci benennt. Die Mathematik andererseits bietet sowohl die einfachste wie die stärkste Variationsmöglichkeit eines Wertes: die Einheit, das Doppel, die beiden goldenen Schnitte."[10]

Collagen

Das Ende des 18. Jahrhunderts (dem Zeitalter der Aufklärung und der französischen Revolution) zeichnet Skepsis über die „beste aller möglichen Welten" (Voltaire, Candide) aus. Auch das anerkannt Schöne wird nun skeptisch gesehen und zugleich dem Hässlichen ästhetische Attraktion zugestanden (Karl Rosenkranz, Ästhetik des Hässlichen, Königsberg 1853). Die Fundamente der Gesellschaft geraten ins Schwanken, Disharmonien und Disproportionen gelangen zunehmend ins Blickfeld. Der Zustand der Welt – von Menschen gemacht – erscheint im Verlauf der Neuzeit immer bedenklicher, erschüttert und sensibilisiert zunehmend die dafür empfänglichen Geister.

Das bislang Unbeachtete, das schamhaft Verdrängte, das leichthin Verworfene wird Kunst. Im 19. Jahrhundert werden die Bildgattungen erweitert. Die grafischen Techniken vervollkommnen sich, die Fotografie wird erfunden. Die Kunst verlässt ihr Piedestal. Im 20. Jahrhundert vervielfachen sich die Bildmittel: Abfälle aller Art, Schrott, Prospekte, Zeitschriften, Textilien werden gesammelt, zerschnitten, auseinander gerissen und wieder neu gefügt.

Müll ist nur, was dazu erklärt wird. Im Augenblick hat der Werbebrief noch seine Wichtigkeit, wenig später landet er jedoch im Papierkorb. Er hat sich zwar nicht verändert, wird aber urplötzlich zu Abfall. Wird er wieder aus dem Korb gezogen, zerschnitten (zerstört) und vom Künstler neu gefügt, hat sich sein Wert sensationell vervielfacht. Minderwertige Materialien erhalten durch die Kunstfertigkeit des Täters unvermutet neue Bedeutung. Das macht den Reiz der Collage aus. Collagieren ist ein subversiver Akt. Der allgemeinen Übereinkunft, was denn gut und was schlecht sei, wird widersprochen. Die „Umwertung aller Werte" gehört zu den Provokationen des Kunstgeschehens im 20. Jahrhundert. Sie zielten auf eine ‚neue Zeit' und einen ‚neuen Menschen', unabhängig von Hierarchien und alten Machtstrukturen.

Aus Bruchstücken wird ein Ganzes, ein sinnvolles Ganzes – eine Collage. Die Collage, indem sie verknüpft, was nicht zusammen gehört, erstaunt und verblüfft. An der Schnittstelle des nicht Zusammengehörigen blitzt vage etwas Unergründliches auf. Die Collage weist offenbar auf etwas Mehrdeutiges, gar Unerklärliches hin.

Besser als Max Ernst es tat, lässt sich die Collage kaum definieren: „Collage-Technik ist die systematische Ausbeutung des zufälligen oder künstlich provozierten Zusammentreffens von zwei oder mehr wesensfremden Realitäten auf einer augenscheinlich dazu ungeeigneten Ebene – und der Funke Poesie, welcher bei der Annäherung dieser Realitäten überspringt."[11]

So wandelt sich unser Erstaunen zur Ahnung, dass die Welt vielleicht nicht so ist, wie wir sie sehen, dass hinter unserer geordneten Umgebung womöglich Tiefen und Abgründe lauern. Konkret verheimlicht die Collage nicht, dass Fugen, Lücken, Spalten, Schnitte und Risse zwischen den miteinander verklebten Einzelteilen aufklaffen. Sie lässt Kontraste

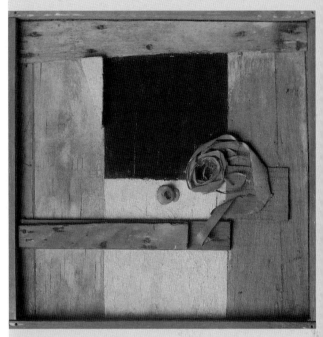

Kurt Schwitters, Materialcollage, Merzbild mit Kerze, ca. 1925-28

Bildanalyse (siehen oben)

37

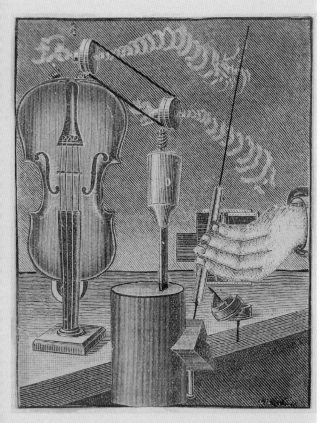

Max Ernst, Holzstichcollage, Violon renversé, 1921

Bildanalyse (siehe oben)

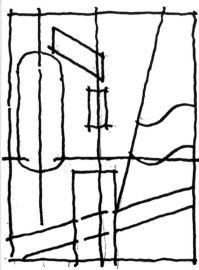

hart aufeinander stoßen und verbirgt Brüche nicht hinter einem Schleier von Illusionen. Das gilt für das flächige Werk auf Papier wie für das dreidimensionale Relief oder die Skulptur. Das kunstvoll Klaffende mögen wir als Zugang zum geheimnisvollen Hintergrund oder als Metapher für eine beschädigte Welt oder zerrissene Zeit lesen. Was aber durch die Ritzen der Rissränder hindurch scheint, bleibt unbestimmt und öffnet unterschiedlichen Interpretationen Tor und Tür. Die Collage deutet nämlich im Grunde nur demonstrativ auf die Binsenweisheit hin, dass Kunst, wenn sie nicht Propagandakunst ist, immer mehrdeutig bleibt.

Konfrontation und Widerspruch wurden zum Inhalt der Kunst schon im späten 19. Jahrhundert, vor allem aber in der des 20. Jahrhunderts. Sie rückte nun ihr Handwerk, ihre Machart ins Licht. Sie verwies auf ihr Material, indem sie den Malvorgang (Tupfen, Kratzen, pastose Farben usw.) stilisierte und indem sie Oberflächenstrukturen (grobe Leinwand, Holzmaserungen usw.) deutlich sichtbar ließ. Malerische Kunst wurde so nicht als Abbild (wie ein Blick durch ein Fenster oder in einen Spiegel), also als vorgetäuschte Wirklichkeit vorgeführt, sondern als originäre Schöpfung, als Geburt von etwas ganz Neuem, von etwas vorher nicht Sichtbarem. Damit wurde die platonische Hoffnung genährt, dass eine unsichtbare Welt hinter der sichtbaren vorscheine.

Das gilt denn auch für die Collage. Ihre zusammen geklebten Einzelteile aus unterschiedlichen Substanzen haben unterschiedliche Stärken, was ein feines, (im Schatten werfenden Streiflicht) deutlich erkennbares Relief erzeugt. Darüber hinaus verweisen raue, glatte, vergilbte, bedruckte oder zerschlissene Oberflächen auf ihre Herkunft (erzählen also Geschichten), verweisen aber vor allem auf ihre Materialität. Eine Collage ist ungeachtet ihrer tiefsinnigen Aussage auch eine Komposition aus Materialfetzen. Das macht sie zum ästhetischen Vergnügen. Dass sie aber Widersprüche in unserem

38

Dasein aufzeigt und artikuliert, macht sie zur vielleicht folgenreichsten künstlerischen Erfindung der Moderne.

Was bringt die Handhabung der Collage dem Architekten? Sie sensibilisiert ihn für Kontraste, für alltägliche Erscheinungen wie abblätternde Oberflächen, abgerissene Plakatwände und bröckelnde Putzflächen. Sie sensibilisiert ihn für Oberflächenstrukturen, die die Haut seiner Bauten lebendig erscheinen lassen. Sie ermuntert ihn aber auch, Ungewohntes zu kombinieren und der Phantasie neue Nahrung zu geben. Sie gibt dem funktionalen Anlass des Gebäudes zusätzliche tiefere Bedeutung.

Schon Leonardo da Vinci empfahl seinen Malgehilfen, sich „manches Gemäuer mit verschiedenen Flecken oder mit einem Gemisch aus verschiedenartigen Steinen" anzuschauen: „Wenn du dir gerade eine Landschaft ausdenken sollst, so kannst du dort Bilder verschiedener Landschaften mit Bergen, Flüssen, Felsen, Bäumen, großen Ebenen, Tälern und Hügeln verschiedener Arten sehen; ebenso kannst du dort verschiedene Schlachten und Gestalten mit lebhaften Gebärden, seltsame Gesichter und Gewänder und unendlich viele Dinge sehen, die du dann in vollendeter Form und guter Gestalt wiedergeben kannst."[12] Und wir fügen hinzu: „Du wirst Mauern, Dächer, Podeste, Galerien, Treppen, Höhlen und organische oder geometrische Volumen sehen, die dir über die kreative Erstarrung angesichts des vor dir liegenden, leeren Blattes hinweghelfen und zum Gelingen deines Entwurfs beitragen."

Abfallprodukte, dem Müll entrissen, in neue Zusammenhänge eingefügt, ergeben nicht nur ein poetisches Nebeneinander, sondern sprechen von unerwarteten, befremdlichen, die Augen öffnenden, neugierig machenden Einblicken in eine neue Welt. Nur ein Beispiel: Wir entfalten eine Faltschachtel, die sich in allen Haushalten zuhauf in Medizin- und Vorratsschränken finden lassen. Dieser Karton hat

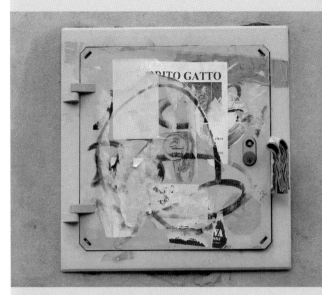

Durch Verunstaltung gestaltete Fläche

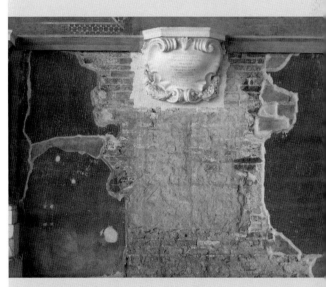

„Wenn du dir gerade eine Landschaft ausdenken sollst, so kannst du dort Bilder verschiedener Landschaften mit Bergen, Flüssen, Felsen, Bäumen, großen Ebenen, Tälern und Hügeln verschiedener Arten sehen", Leonardo da Vinci

Die Zeichnung verdichtet sich dort, wo Tiefe dargestellt werden soll. An den Rändern bleibt sie unfertig

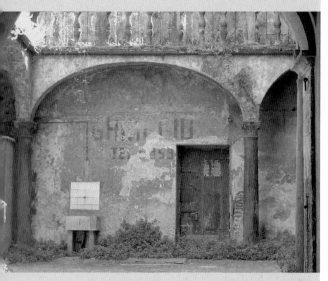

Den Ruinen der Vergangenheit stehen wir nicht teilnahmslos gegenüber

jetzt keine kubische, sondern eher eine bizarre Umrissform. Er hat kräftige Farben, schräge Logos und nunmehr kaum verständliche Aufschriften. Wir kleben ihn auf einen Untergrund, interpretieren ihn als Bild einer Bauruine und bauen diese zeichnerisch oder malerisch wieder auf. Die Phantasie sprudelt und veranlasst uns, vorher unvorstellbare Architekturcapriccios zu erfinden. Unsere Kreativität ist ein Stück weit gewachsen.

Über das Fragment

Warum sind Zeichnungen, Gemälde, Skulpturen mitunter trotzdem fertig, obwohl sie scheinbar nicht zu Ende gebracht sind? Sie sind nicht perfekt, ihr konstruktives Gerüst, ihre Machart ist entblößt und das ist gut so. Denn das Unfertige verweist auf ihr Entstehen, der Arbeitsvorgang wird durchsichtig. Wir sehen, die Zeichnung ist während der dahinfließenden Zeit geschaffen, indes offensichtlich vor dem endgültigen Ziel beendet worden. Vielleicht gab es umständehalber Probleme, Probleme vielleicht bei der Bildproduktion. Diese bleiben sichtbar und verraten die Intensität der Rätsellösung, die jedem Kunstwerk als unlösbare Aufgabe aufgebürdet ist.

Manches lässt sich beiläufig lösen, zum Beispiel die Grundierung der Bildfläche oder die Wahl des Bildzentrums; anderes offenbart die Qual des Produzenten, zum Beispiel die Darstellung der Körperlichkeit von Mensch und Architektur. Verhältnisse zueinander, atmosphärische Stimmungen sind unter Umständen nur angedeutet. Der Grund ist oft Zurückhaltung und das Bemühen, nicht in unnötiges Pathos zu verfallen. Des Zeichners scheinbare Lässigkeit lässt sich mit der vorgeblichen Leichtigkeit von Artisten in der Zirkuskuppel vergleichen.

So werden Bildteile sorgfältig ausgeführt, andere aber bleiben im Rohzustand stehen. Die Frage ist, welcher der beiden Zustände mehr Emotionen weckt. Vielleicht ist es eher die Spannung zwischen Ausge-

40

führtem und Unfertigem, die sich auf den Betrachter überträgt. Im Grunde sind es rhetorische Mittel: so wie der Vortragskünstler sein Publikum aufpeitscht durch immer lautstärkere Sentenzen und dann durch urplötzliches, wie im Nebenbei Gesprochenem wieder beruhigt.

Fragment heißt aber auch, dass von einem Vorhergehenden ein Rest, der bewahrenswert schien, übrig geblieben ist. Wir möchten in der Vergangenheit verankert sein, wir wollen uns vergewissern, dass es ein Zuvor gab, eine frühere Zeit, die scheinbar folgerichtig auf unsere Existenz zusteuerte. Deshalb finden wir in alten Bauten eingebaute ältere Fundstücke (Spolien), die sorgfältig gefasst, wie antiker Schmuck uns an jene Ahnen erinnern, mit denen wir uns identifizieren können.

Den Ruinen der Vergangenheit stehen wir nicht teilnahmslos gegenüber. Sie sind im weitesten Sinne Bestandteile unserer eigenen Geschichte. Wir binden sie ein in unser Dasein. Mitunter gelingt es, sie wiederzubeleben. Um den Betrachter nicht gleichgültig zu lassen, sondern ihn zu veranlassen, an den Bauten oder Bildwerken in Gedanken weiter zu arbeiten, zeigen Architekten und Künstler ihre Mittel und ihr Handwerk. Die Offenlegung der Konstruktion, die Materialschichten der Wände, die Alterungsspuren geben den Bauwerken erst die eigentliche Substanz.

Die Bildfläche, die ersten skizzierenden Striche, die Hilfslinien und verschiedenen Malschichten, aber auch die heftige oder verhaltene Linienführung, der Pinselstrich, die wässrige oder pastose Farbe: Sichtbar belassen trägt all dies zum „Wechselbad der Gefühle" beim Betrachten von Flächenkunst bei. Der Betrachter kann nicht anders, er muss interpretieren, also mitdenken. Und Denken können wir durchaus als Arbeit ansehen. Arbeit, deren Ergebnisse mitunter Erschöpfung, mitunter Ratlosigkeit, aber bei gutem Gelingen Befriedigung nach sich zieht. Doch nicht nur der Schaulustige sucht das Gespräch, auch der

Von einem Vorhergehenden ist ein Rest, der bewahrenswert schien, übrig geblieben

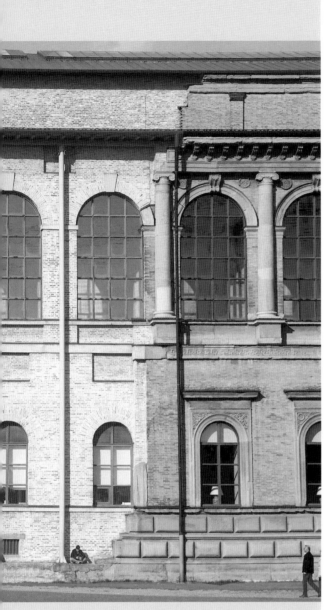

Leo Klenzes Alte Pinakothek, von Hans Döllgast restauriert
Foto: Hanns M. Sauter

Produzent eines Kunstwerks wendet sich an sein Gegenüber. In sein Produkt fließen strategische Überlegungen mit ein, von wem denn sein Werk beachtet und wie es wirksam werden soll. Der zeichnende Architekt braucht den kritischen Bauherrn, der Bauherr braucht den beratenden Architekten. „Der Betrachter ist im Bild" nannte Wolfgang Kemp seinen Sammelband zum Thema.

„Das offene Kunstwerk", ein Titel von Umberto Eco, dem Literaturwissenschaftler, Philosophen und Romancier, ist ein anderes Buch, das sich mit dem schwierigen Verhältnis zwischen Rezipienten, Werk und Künstler befasst (Architektur ist eines seiner breit ausgeführten Themen). Das bewusst unfertig Gelassene, das offen Gebliebene kann eine Qualität in der Gestaltung – von was auch immer sein –, sei es in der Musik, im Drama, in den bildenden Künsten oder in der Architektur. Dass ein Objekt seine Geschichte hat, ob sie dramatisch, tragisch, komödiantisch oder auch unspektakulär war, färbt Inhalt und Oberflächen.

In Carlo Scarpas Umbau des Castelvecchio in Verona zum Museum (1958-1964) werden bewusst die vielfältigen Eingriffe in den Gebäudekomplex stilisiert, einschließlich seiner eigenen. Der Bau wird gleichsam seziert, Verborgenes freigelegt und die entstandenen Wunden demonstrativ versorgt. Auf die gleiche Weise ist Hans Döllgast mit Leo von Klenzes Alter Pinakothek (erbaut 1826-1836) in München umgesprungen. Die Lücken der kriegszerstörten Fassade wurden von ihm nicht rekonstruierend, sondern geradezu ärmlich und schmucklos geschlossen (1952-1955). Die Tatsache des zweiten Weltkriegs sollte nicht vertuscht werden, sondern der Bau sollte mahnend an das Überstandene erinnern. „Zeige deine Wunde" hieß 1976 eine Ausstellung von Joseph Beuys in einer Münchener Fußgängerunterführung. Man kann sagen: Das Verletzliche, das Verletzte wurde zum signifikanten Thema in den Künsten, auch auf Grund der erfahrenen Schrecknisse im 20. Jahrhundert.

42

ZWINGER 26/05

3 Freies Zeichnen

Freihandskizze und digitale Umsetzung
Studienprojekt

Interpretierendes Zeichnen

Das Bauhausmanifest (1919) von Walter Gropius beginnt mit der Feststellung: „Das Endziel aller bildnerischen Tätigkeit ist der Bau."[13] Ebenso apodiktisch behauptete schon Giorgio Vasari (1511–1574), dass die Zeichenkunst die Grundlage aller künstlerischen Tätigkeit sei – auch die der Architektur. Wenn es nur um die Bestandsaufnahme ginge, dann wäre das Zeichnen – das Zeichnen des Architekten – nutzlos vergeudete Zeit, bestenfalls eigenwillige Liebhaberei. Leistet doch die digitale Kamera im Verein mit ‚Photoshop' in wenigen Momenten mehr oder weniger wahrheitsgetreu das, was andernfalls im Skizzenbuch zeitaufwändig und dennoch (mitunter) tadelnswert unvollkommen festzuhalten wäre.

Aber die Zeichnung vermittelt nicht weniger als das digitale Bild, sondern mehr und anderes: Sie verzerrt, das heißt, sie fokussiert, weil sie Interpretation ist, sie beleuchtet Details, sie vernachlässigt oder vernebelt störende Randerscheinungen, sie röntgt den zu zeichnenden Gegenstand und entblößt Innewohnendes. Zudem hält sie im Gegensatz zum Dokumentarfoto niemals nur einen Moment fest, sondern eine Folge von Augenblicken. Das Auge des Zeichners blickt abwechselnd auf Gegenstand und entstehende Zeichnung.

Der Bildhauer und Zeichner Alfred Hrdlicka (1928–2009) sagte dazu im Interview: „Ein Foto kann ja nur abbilden, man kann damit nichts entwerfen, sich nichts ausdenken, auch keine Erinnerung hervorholen. Da ist eine Zeichnung doch hundertmal überlegen. Wenn ich zeichne, dann kann ich etwas abbilden, aber ich kann auch etwas erfinden oder etwas zeigen, das ich nur im Gedächtnis habe."[14] Die Zeichnung hat einen Anfang und ein Ende; es verrinnt Zeit während ihres Entstehens, und diese Zeit verläuft synchron zur subjektiven Zeit des Zeichners. Ja, sie kann verschiedene Ansichten eines Gegenstandes oder einer Figur (die sie nacheinander beleuchtete) auf dem Zeichenblatt miteinander verschmelzen.

46

Des Zeichnenden Hand fährt, wischt, tastet, streichelt über das Papier, äfft Konturen eines Gegenübers nach, folgt aber auch den Empfindungen, Windungen, Vorbehalten, Qualen und Obsessionen des zeichnenden Ichs. Der Beginn war anders als der Schluss, erst vielleicht holprig-mürrisch, dann im kreativen Rausch hastig und erregt. Der Ausdruck der Zeichnung verändert sich mit den Stimmungslagen des Zeichners. Papier, Stift und Pinsel verlangen Zeit, denn der Charakter, die Laune einer Zeichnung formt sich beim Machen. Während das Foto als Produkt eines chemisch-optischen Prozesses unter Umständen unabhängig von Akteuren entstehen kann, ist das Zeichnen als Vorgang eine zutiefst menschliche Reaktion, ein stellvertretender Akt der Besitznahme, eine sublime Verwandlung kreatürlichen Verhaltens in eine sinnstiftende Deutung über den Anlass hinaus. Professionelle Fotografen sehen das natürlich anders. Gemeint ist hier auch nur der knipsende Laie.

Des Zeichnenden Hand tastet und streichelt über das Papier, äfft Konturen eines Gegenübers nach.

Notiz, Skizze, Gedankensplitter

Zeichnen ist meine Waffe gegen das Endenwollen,
gegen das Versiegen und gegen das Eingewickeltwerden
in die flauen Übereinkünfte.
Schreiben, Zeichnen, Malen, das ist der Weg
in die Tiefe, wo die Bilder wohnen.
Martin Disler

Unsere Gehirne suchen als kleine, denkende Energiezentralen mit allen möglichen Mitteln Kontakt zum umgebenden Raum und zu anderen Hirnen. Diese Mittel sind tentakelhaft ausgeformt: Hände, Füße, Zunge, Augen und Ohren. Sie sind wahrhaft Tentakeln, mit denen ein Gegenüber wahrgenommen, geprüft und vereinnahmt wird. Eine Handbewegung ist nur im Zusammenhang mit einem denkenden Gehirn sinnvoll oder nützlich. Entweder führt die Hand einen Befehl des Gehirns aus oder das Gehirn gewinnt eine Erkenntnis auf Grund der tastenden Hand. Es ist also durchaus eine Wechselwirkung, die zu wechselstromartig schnellem Hin und Her verstärkt werden kann: Die Hand denkt mit. Unerlässlich ist dies für

Liederliche Notizen stützen die Erinnerung

Eine Zeichnung muss nicht schön sein

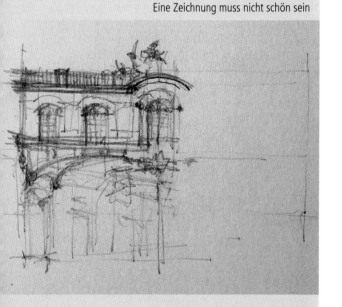

den Handwerker, für den Chirurgen oder den Pianisten und – für den zeichnenden Architekten.

„Die Gedanken sind frei", allerdings so frei, dass im Schädel alles möglich zu sein scheint, fließend und unbegrenzt. Das Gedankenexperiment im luftigen Äther des Gehirns muss in der rauen Wirklichkeit überprüft werden, wenn es denn jemals in die Realität überführt werden soll. Das Korn des Papiers, die Härte des Stifts, die Kratzigkeit der Feder usw., kurz, der Widerstand des Materials simulieren im Kleinen, was uns im Großen in der Welt ständig geschieht: Anecken und Ausweichen, Zusammenstoßen und sich Durchschlängeln, Kämpfen und Stürzen. Im Großen mag sich so Lebenserfahrung entwickeln, das Gefühl für Machbares und Vergleichbares. Im Kleinen entsteht so Projekterfahrung und ebenso das Gefühl für Realitäten. Der Widerstand seines Handwerkszeuges führt den Zeichner zu neuen Erkenntnissen, die auf Grund der Widerborstigkeit des Materials seiner Lebenssphäre verhaftet bleiben und nicht in nebulösen Phantasien entschwinden.

Betrachten wir die Hand und jedes in der Hand gehaltene Werkzeug als Filiale des Gehirns. Der Bleistift in der Hand ist wahrlich eine Verlängerung des Denkapparates. Indem er über das Papier gleitet, rutscht, fegt, stolpert, indem er zittert, auf der Zeichenfläche herumirrt, forsch und großzügig Spuren verknüpft, sein Tempo mindert oder erhöht, stille Pausen macht oder hastig übers Papier fährt, so ahmt er (strukturell verwandt) auf symbolische Weise die Vertracktheit und Vielfalt menschlichen Lebens nach. Man sieht dem Produkt des „denkenden Bleistifts" an, ob Glut oder Langeweile, Temperament oder Blutleere, Verbohrtheit oder Forschergeist die Hand führten. Dieses von Gedanken und Emotionen erfüllte Sein, pralle Lebendigkeit, gehört zum Wesen der bedeutenden Zeichnung und sei es nur eine flüchtig hingeworfene Skizze. Die Zeichnung muss nicht schön sein im landläufigen Sinne von Schönheit, eher charaktervoll, das heißt, sie spiegelt

auch all die Widersprüche, Unzulänglichkeiten und vielschichtigen Eigenarten ihres Produzenten.

Populärästhetik bedeutet Stilisieren, Trends Akzeptieren, Zurechtstutzen, Eindämmen, das heißt, die Welt so sehen, wie die Gesellschaft sie sich in stiller Übereinkunft zurechtgelegt hat. Was nicht ins Bild passt, wird übersehen oder unter den Teppich gekehrt. Durch derartige Reduzierung der wahrgenommenen Phänomene allerdings ist menschliches Zusammenleben erst erträglich. Der Gang durch eine Großstadtstraße lässt uns über Vieles hinwegsehen: Adressensuche oder Kaufwunsch verändern die Wahrnehmung der Umgebung. Wir können nicht anders: Wir müssen das uns Willkommene aus der Flut der Angebote oder Reize auswählen. Das ist notwendig, doch so entstehen auch Scheuklappen.

Im Gegensatz zur gängigen Ästhetik haben Künstler es stets als ihre Aufgabe betrachtet, „wider den Stachel zu löcken", Scheuklappen als Scheuklappen zu bezeichnen und nicht als physiologisch bedingte Sehweise. Immer versuchen sie dann einzugreifen, wenn sich Ansichten zu Klischees einzuschleifen beginnen. So erweitert sich das Sichtfeld, zugleich aber wird der gerade gültige Schönheitsbegriff in Frage gestellt. Normen lösen sich auf, neue Regelwerke entwickeln sich, bis auch diese wieder abgegriffen zu sein scheinen. Wenn es auch Fortschritte in der Kunst nicht gibt, so ist sie doch einem ständigen Prozess unterworfen und immer am Rande des Skandals.

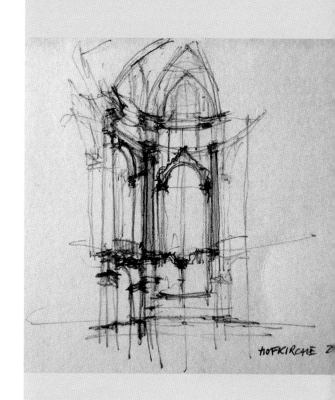

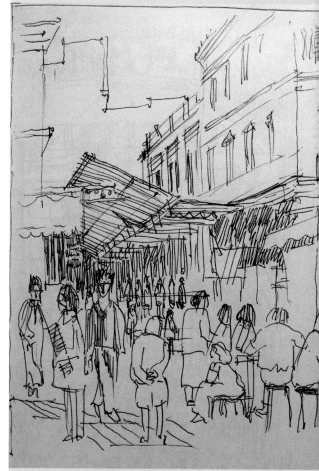

Kapitol in Rom, Skizze von Diedrich Praeckel

Zeichnen im Skizzenbuch

Ich habe mein Leben lang gezeichnet. Die Zeichnung ist das Knochengerüst meiner Kunst. Ich habe mich selbst durch Schauen erzogen und das hat ein gutes Maß an Konzentration gekostet. Zu lernen, scharf genug zu beobachten, wirklich zu „sehen", was ich gerade zeichne, ist immer meine Absicht. Ich empfinde, dass das Zeichnen die wesentlichste Art und Weise des Sprechens ist.

Jim Dine

Jedem sei empfohlen, ständig ein handliches Skizzenbuch in der Jackentasche mit sich zu führen. Es hat Postkartenformat (vielleicht ist es auch etwas größer), es hat unliniertes, mattes Papier. Es sollte Wasserfarben aushalten können, ohne dass diese die nachfolgende Seite durchtränken. Immer gibt es etwas zu notieren, nicht nur auf Reisen, sondern auch beim Warten an der Haltestelle, am Kneipentisch, am Picknickplatz, zu Besuch bei den Eltern oder Freunden, zu Hause in der Küche oder im Atelier.

Es sind nicht immer ausgefeilte Zeichnungen, sondern eher liederliche Notizen (so wie man schreibt), die aber die Erinnerung und irgendwann die Weiterverarbeitung stützen. Deshalb sollte man auch jede Skizze datieren. So hat man am Jahresende ein Tagebuch des Wahrgenommenen, ein ‚Storyboard' des Jahresablaufs und eine Sammlung von Gedanken- und Bildsplittern, deren einige (nicht vorsehbare) später die Vorlage zu kreativen Ideen geben. Kreativität entsteht nicht aus dem Nichts, denn auch sie braucht ein Archiv (im Kopf, im Skizzenbuch), aus dem sie ihre Einfälle ableitet.

Was zeichnen wir? Oft sind es die kleinen Dinge: eine Baumwurzel, ein Weinglas neben einem Papierstapel, die Basis eines gotischen Bündelpfeilers, ein Fensterbankdetail, Stufen und Geländer, ein Schuh im Regal, das Ohr der oder des Liebsten oder ein selbstvergessenes Gekritzel während eines Telefonats. Irgendwann vielleicht werden wir die Skizze eines Ohrs zeichnerisch in eine Gartenlandschaft oder eine Baumwurzel in einen Brückenkopf transformieren.

50

Natürlich zeichnen wir auch Außen- und Innenräume, Baumalleen und Stadtsilhouetten, Menschen und Tiere. Dies aber meist nur so weit, wie uns Flächen, Volumen und deren Zwischenräume, wie uns Proportionen und Rhythmen interessieren. Eine Skizze ist nie fertig, ist von Hilfslinien durchzogen, ist spontan und scheinbar im Vorübergehen geschaffen. Sie lässt Unwesentliches aus. Sie vereinfacht.

Erinnert sei dabei an Cézannes Maxime, dass alle Naturformen sich auf geometrische zurückführen lassen. Diese Geometrisierung ist für den Architekten eine Erleichterung, weil sie ihm als Konstrukteur vertraut ist, ist aber zugleich eine Komplikation, weil sie einen analytischen Denkakt erfordert. Bilden wir uns also nicht ein, dass Kreativität nur aus dem Bauch kommt, Kreativität kommt ebenso aus dem Hirn. Wir informieren uns, wir untersuchen, was es Neues in den Bildenden Künsten, in der Musik, in der Literatur, in der Werbung gibt und wie es nutzbringend in der Architektur zu verwenden oder zu verwerten wäre. Wir entdecken in den anderen Künsten Rhythmen, Takte, Echos, Stimmungen und Färbungen, die wir in unsere dreidimensionalen, materiellen Vorstellungen transformieren.

Womit zeichnen wir? Alles ist erlaubt und sei es der Daumen oder ein abgebranntes Streichholz. Die Unvollkommenheit oder der Widerstand des Materials, der uns quält oder ärgert, erhitzt uns emotional und überträgt die Erleichterung und die Freude am Gelingen auf den Betrachter, ja, hat sogar therapeutische Wirkung auf den Zeichner. Eine gelungene Zeichnung gleicht einem Befreiungsakt. Wir probieren die Artikulationsfähigkeit unserer Hand aus:
– Lässt sich ein Baum nur mit Punkten wiedergeben?
– Menschen im Cafe: Können wir sie ohne Kontur, nur mit Schraffuren darstellen?
– Wie zeichne ich das Relief einer Felswand, wie Schatten im Sand und wie auf Holz?
... usw.

51

Flüchtige in wenigen Minuten gezeichnete Notizen

Allerdings sollte man das Experimentieren nicht übertreiben. Nach und nach entwickelt sich ein Darstellungsrepertoire. Nach und nach stellt jeder seine bevorzugten Zeichenutensilien zusammen.

Empfohlen aber für die schnelle Architekturzeichnung sei der Bleistift (Stärke: HB), der leicht über das Blatt geführt (leicht wie ein Hauch: weil so mit stärkerm Strich leicht Korrekturen ohne Radiergummi auszuführen sind) und nur an den uns wichtig erscheinenden Partien verdichtet und mit festerem Druck über das Papier gezogen wird. Auch Kugelschreiber und Füllfederhalter sind bestens zum Skizzieren geeignet. Filzschreiber und Tintenroller dagegen sind zu vermeiden, weil sie den wechselnden Druck der Hand nicht weitergeben und einen an- und abschwellenden Strich nicht zulassen. Der Strich wird mit diesen Stiften allzu gleichmäßig und kann unsere Nervosität oder den (pulsierenden oder stolpernden) Rhythmus unseres augenblicklichen Geisteszustands nicht widerspiegeln. Die Zeichnung wirkt leblos. Wir werden feststellen, dass jedes Zeichenmittel seine Eigenart hat und dass, je nachdem mit welchem Mittel wir zeichnen, sich Darstellung und Ausdruck verändern.

Bestandsaufnahme

Hirn und Hand wirken miteinand'.
Anonym

Hat also die Zeichnung des Architekten kommunikativen Charakter, nämlich den, ein Gebilde aus dem Dunst privater Phantasie in die Klarheit allgemeiner Anschauung zu heben, so spielt dennoch das „Wie", die Machart eine bedeutende Rolle. Ebenso wie ich einen urbanen Platz im flüchtigen Vorübergehen erfahren kann, im stummen Stillestehen oder im ausmessenden Durchschreiten, ebenso kann die Zeichnung auf analoge Weise das weiße Blatt Papier ausfüllen: flüchtig in Minutenschnelle skizziert oder beharrlich gestrichelt (abwechselnd aufs Blatt

52

schauen und vor Ort sich vergewissern) oder introspektiv aus dem Inneren heraus übertragen. Jedes Herangehen hat seine unvergleichliche Eigenheit. Manchmal jedoch – wenn der Zeichner Glück hat – wird dies alles zusammen die Qualität einer Zeichnung ausmachen.

Was auch immer der Inhalt der Zeichnung sein mag, ob es um die „Stimmung" eines Baus geht, um raumgreifende oder Volumen aufbauende Maßnahmen, ob es das Erlebnis von Kulissen ist oder die Gestalt von Zwischenräumen oder ob es um das raumbildende Spiel von Licht und Schatten geht: Das Repertoire der Darstellungsmittel kann nicht vielfältig genug sein, weil sonst allzu schnell das Dilemma des gedankenlosen, schmissigen „Stempelns" von Skizzen entsteht. Hilfe bietet dann nur ein Hort von Papieren, Blöcken, Tinten, Farben, Stiften, Pinseln und Federn und vor allem eine kontinuierlich sich weitende Bandbreite von Techniken: Stricheln, Pünkteln, Pinseln, Spritzen, Kratzen, Collagieren usw. Die Rhetorik des Zeichners gilt es zu begreifen, denn sie ist auch des Architekten Rhetorik.

Sequenz (Storyboard)

Mit der Illusion von Geschwindigkeit sind wir (dank des Kinos) derart vertraut, dass wir die schnelle Abfolge stehender Bilder mit Bewegung verwechseln. Im Kino sehen wir aber nur, was uns der Kameramann sehen lässt. Wir sitzen starr und verfolgen den Ablauf der fiktiven Ereignisse. Doch wer bequem im Kinosessel versunken sich nicht bewegt, erfährt visuell nur die Oberflächen der Bildräume. Nur indem wir uns selbst bewegen, erfahren wir die Objekte umfassend – von allen Seiten, in allen Dimensionen, in allen Veränderungen: durchlässig – undurchlässig, außen – innen, oben – unten, vorn – hinten, fließend – starr.

Erfahrung bedeutet Kenntnis, bedeutet, etwas von allen Seiten betrachtet zu haben, es hin und her gewendet, es geschält und seziert zu haben. Daher

Sequenz:
die gleiche Situation aus drei übereinander liegenden Fenstern betrachtet

Portrait in fünf Schritten

begreifen wir Architektur nur im Umschreiten oder Durchdringen. Wollen wir unsere Erfahrungen, die wir im und vor dem Haus gewannen, weitergeben, genügt deshalb nicht ein Hinweis oder ein Bild. Unsere „promenade architecturale" (wie Le Corbusier es nannte) als Folge von Blicken und Einsichten kann nur als Folge von mehreren Bildern vermittelt werden. Die gemeinsame „Begehung" eines Objekts oder eines Projekts ist notwendig. Kann sie nicht real stattfinden, so muss es denn wenigstens fiktiv sein. Wollen wir unsere Einsichten vermitteln, gilt es, eine Sequenz unserer Erkenntnisse zu erarbeiten und dem Interessenten vorzuführen.

Architekten sind es gewohnt, Projekte prozesshaft darzustellen. Die Folge der Geschosspläne und Schnitte, das Nebeneinander der Ansichten ergeben ein schrittweises Eindringen und Begreifen des Gesamtgebäudes. Wer ein Projekt nicht kennt, ist erst einmal begriffsstutzig und versteht das Vorliegende nur langsam und in sparsamen Portionen. Allmählich taucht er ein in die Vielzahl der Bilder. Von einem schließt er auf das andere. Im Rückblick auf das vorher Gesehene fängt er an zu begreifen. So dient die Sequenz der Pläne der Erläuterung des Projekts.

Aber die Sequenz dient nicht nur der Belehrung, sondern sie kann zur selbständigen Qualität werden. Sie kann wie eine Partitur gelesen werden. Sie verhilft dem Planer einerseits zur Rhythmisierung und Musikalisierung seines Projekts und reflektiert andererseits den Mechanismus seines Denkens. Sie schleust in den Entwurf all die Zweifel und Widersprüche, kurz gesagt, das Mehrstimmige, das Widersprüchliche und die Vielfalt seiner Überlegungen ein, die das Unergründliche, Geheimnisvolle und letztlich Kunstvolle seines Werks ausmachen. Gedanke folgt auf Gedanke, Zeichnung folgt auf Zeichnung, Arbeitsmodell folgt auf Arbeitsmodell. Das schließlich beendete Projekt ist nun dennoch kein fertiges, sondern enthält Spuren aller Entwicklungsschritte. Es zeigt sein Beginnen, sein Fortschreiten und dessen Richtung.

54

„Das offene Kunstwerk" (ein Buchtitel Umberto Ecos), das Kunstwerk als nie endender Prozess gehört zu den kreativen Grundsätzen im 20. Jahrhundert. Das Entwurfsmittel ‚sequentielles Entwerfen' gibt daher keinen fest gegründeten Zustand wieder, sondern ein schillerndes sich Verwandeln des Augenscheins, die metamorphotische Verformung eines Gedankengebäudes. Immer aber sind die einzelnen Elemente der Sequenz einander verwandt, ähnlich und aufeinander bezogen. Sie sind voneinander abhängig und ergeben im Zusammenklang einen sich verfestigenden Eindruck. Der Entwerfer geht schrittweise voran. Jeder vorhergehende Schritt entscheidet über den nächsten. Die Sequenz hat folgerichtig zu sein, das heißt, nach jedem Schritt muss eine stimmige Entscheidung getroffen werden. So funktioniert Erkenntnis.

Die Produktion eines Kinofilms ist ohne Storyboard kaum denkbar. Das Storyboard ist eine comicartige Sequenz von Zeichnungen, mit der ein Regisseur Kameraeinstellungen, Handlungsabläufe und Ausstattung einer Filmerzählung festlegt. Zeichner und Architekten könnten einiges davon lernen. Da ein Bauwerk kein Standbild, sondern die Aufforderung ist, sich darin und davor zu bewegen, unter Umständen auch dessen stetige Veränderung nachzuvollziehen, gar mit zu gestalten, ist die Wiedergabe der in Einzelschritte unterteilten Promenade um das Haus und durch dessen Räume eine notwendige Vorraussetzung des Begreifens.

Es ist Hirnarbeit zu verstehen, wie ein Haus sich fügt: die Ausmaße und Funktionen seiner Räume, die Dimensionen der Einzelteile, die Materialien, die Farben. All das bezieht sich aufeinander und fügt sich zu einem Ganzen. Bewunderung allein reicht für das Begreifen nicht aus. Eine vage Gestimmtheit kann so nur das Ergebnis sein. Erfüllender für den Betrachter und für den Planer ist es hingegen, wenn er Analysetechniken zur Verfügung hat, Erfahrungen, die er aus Plankonvoluten, Storyboards oder Modellen gewonnen hat. Erfahrungen, die ihm helfen, den

Maschinenbauhalle, comicartig in sequentielle Zeichnungen übersetzt

55

Panorama eines griechischen Platzes (1-6)

Augenschein zu interpretieren, zu strukturieren und damit verständlich zu machen. Natürlich ist auch die geschriebene Erläuterung nützlich. Dennoch scheuen viele auf Grund der Abstraktion der Fachsprache deren Lektüre und vertrauen auf offenbar eingängigere Einsichten durch Bilder.

Sequenzen oder die Mehrfachbelichtung von Bildern kennen wir nicht nur von der Fotografie und vom Film. Früh haben Kubismus und Futurismus sich diese Techniken der visuellen Simultanität angeeignet. In der Malerei haben mit vergleichbaren Überlagerungen zum Beispiel Georges Grosz, Francis Picabia oder später Sigmar Polke experimentiert. Sie konnten so die Gleichzeitigkeit von Ereignissen oder Situationen verdeutlichen, ebenso all die Schichten und Widersprüche des Daseins. Das gelänge allerdings auch durch simples nebeneinander Stellen der Bilder. Die Überlagerungen jedoch zeigen, dass die Darstellungen etwas miteinander zu tun haben, dass sie gleichzeitig auftreten, dass das eine aus dem anderen hervorgeht, dass sie verflochten und voneinander abhängig sind. Sie zeigen die Mehrschichtigkeit oder Doppelsinnigkeit, die den alltäglichen ‚Wahnsinn‘, also im Grunde das Wesen des Menschen und seiner Hervorbringungen ausmachen.

Es ist zu empfehlen, sich nicht mit einer Situationsskizze zu begnügen, sondern wie ein zeichnender Flaneur den Raum, die Räume zu durchmessen. Oder von Stockwerk zu Stockwerk nach oben zu steigen, um von übereinander liegenden Fenstern aus die perspektivischen Veränderungen des Straßenbildes zu prüfen. Immer wieder still stehen, die gerade gezeichnete Skizze noch vor Augen und im Kopf und ergänzend die nächste beginnen. **Der Lohn wird ein inniges Begreifen und die Erfahrung einer derart intensiven Betrachtung sein, wie man sie sonst selten erlebt.**

Transparenz der Ebenen nährt die Illusion, hinter Oberflächen schauen zu können, weckt aber auch

56

das Bewusstsein, tiefer in Situationen eintauchen zu wollen. Wem aus seiner Schulzeit die mathematische Mengenlehre noch in Erinnerung ist, dem wird Durchdringung und Überlagerung verschiedener Ebenen ein durchaus vertrautes Verfahren sein. Wir können damit Identisches (die so genannte Schnittmenge) hervorheben. Aber wir können auch das Gleichlautende oder Zeitgleiche wiedergeben und wir können ebenso den Zeitablauf eines Ereignisses darstellen. Das heißt: Die Bewegung eines Gegenstandes oder des Zeichners im Raum wird nachvollziehbar. Unser Gedankenfluss wird offenbar. Dreidimensionale Sequenzen als Übungsaufgabe findet man im Kapitel ‚Bildnerisches Gestalten'.

Exkurs: Empathie

Wir wollen zwischen angespanntem und meditativ entspanntem Zeichnen unterscheiden: Zum einen will der Architekt jemandem ein Detail oder eine Raumfolge, die er bereits im Kopfe hat, verdeutlichen. Schnell, fast wie er spricht, skizziert er das Wesentliche (auf der Papierserviette, auf dem Bierdeckel). Zum anderen versucht er, Erkenntnis für sich zu gewinnen. Dazu braucht er Ruhe. In sich versunken gräbt er in tieferen als den offenkundigen Schichten: Assoziationen und verborgene Strukturen evozieren den Genius Loci, bzw. die geheimnisvolle Innenwelt der vor den Augen sich präsentierenden Außenwelt.

„Es gibt eine zarte Empirie, die sich mit dem Gegenstand innigst identisch macht und damit zur eigentlichen Theorie wird"[15], schrieb Goethe an seinen Brieffreund Zelter (1828). Goethe, der bekanntlich ein hervorragender Skizzierer war, sagte dies womöglich auch aus der Perspektive des sich einfühlenden Zeichners heraus. Nur wer sich einfühlen kann, begreift ein wenig von den verborgenen Strukturen des Daseins.
Dass Empathie (= Einfühlung) die Entwicklung der menschlichen Kultur voran getrieben habe, lassen

auch Ergebnisse der jüngsten Hirnforschung vermuten. Wir lernen, indem wir mitfühlen. Die Neuronen unseres Gehirns feuern nämlich gleich heftig, ob wir mit der Hand ein Werkzeug ergreifen oder ob wir dies nur bei anderen beobachten. Es sind so genannte Spiegelneuronen, die eine Handlung oder Geste, die wir bei einer anderen Person sehen, uns im eigenen Kopf nacherleben lassen. Die speziellen Hirnregionen werden jedoch ebenso aktiv, wenn wir uns im Kino von dem Geschehen mitreißen lassen oder wenn wir ein Gegenüber lachen oder weinen sehen.[16]

Es gibt Räume, in denen wir uns von einem Nicht-Geschehen mitreißen lassen, Räume, die uns in ihrer Großartigkeit und Leere überwältigen. Der Architekt Louis Kahn schildert seine Begegnung mit dem Pantheon in Rom: „Das Licht kommt von oben, du kannst dich ihm nicht nähern. Du kannst darunter stehen; es schneidet dich wie ein Messer… du möchtest fern bleiben."[17] Entweder man widersetzt sich dem im unbeeindruckten Vorübergehen und mit fotografischen Schnappschüssen (bleibt begrifflos, bleibt emotional gepanzert mit Hilfe seiner digitalen ‚Schusswaffe') oder aber man lässt sich übermannen: stillstehend, kauernd, beobachtend – und skizzierend (auf das Begreifen wartend).

Johann Wolfgang von Goethe, Männer am Feuer, 1776

58

Axonometrische Darstellung (objektiver Blick):

Für den Architekten bedeutet die Zeichnung nicht nur Wiedergabe von Welt und Emotion. Sie hat eindeutig auch Werkstattcharakter. Sie gibt Anweisungen und erläutert den Entwurfsprozess. Im Laufe der Jahrhunderte wurden zum freien, spontanen Zeichnen eine Vielfalt von Varianten geschaffen, deren Fülle man kennen und teilweise auch beherrschen sollte.

Das Technische Zeichnen gehört weniger in diesen Zusammenhang, aber die Axonometrie (als eine seiner Unterabteilungen) ist nicht grundlos eine beliebte Weise des architektonischen Skizzierens. Mit ihr lassen sich Raumfolgen und die sonst unübersichtliche Komplexität eines Baukörpers auf einfachste Weise darstellen und kontrollieren. Axonometrie ist der Oberbegriff für mehrere sich einander unterscheidende Ausdrucksweisen der räumlichen Darstellung. Das sind Planometrie, Kabinettprojektion und Isometrie (um der Vollständigkeit willen: es gibt noch die Dimetrie, die aber für die architektonische Darstellung kaum zu empfehlen ist).

Planometrie
Die Planometrie (früher Militärperspektive genannt) ist unter Architekten am beliebtesten. Wir legen einen Grundriss (einen Horizontalschnitt) ungefähr diagonal auf den Tisch und ergänzen die senkrecht nach oben führenden Kanten, zeichnen darüber das nächste Geschoss, ergänzen die weiter in die Höhe führenden Kanten usw. Der Vorteil ist, die Horizontalflächen bleiben unverzerrt und darum messbar. In den Höhen allerdings, in den Ansichts- und Schnittflächen verändern sich die Winkel. Zudem bemerken wir eine optische Täuschung. Alle Höhen erscheinen leicht gedehnt. Empfehlenswert ist deshalb, sie um ungefähr ein Drittel zu kürzen. Der abgebildete Kubus (rechts) erscheint als Würfel trotz reduzierter Senkrechten. Wer es weiß, kann später beim Messen der vertikalen Kanten den Kürzungsfaktor wieder dazu rechnen.

Planometrie

59

Kabinettprojektion

Kabinettprojektion

Für die Kabinettprojektion (früher Kavalierperspektive) gilt im Grunde das Gleiche. Nur wird hier der Schnitt (ein Vertikalschnitt) durch ein Gebäude oder Möbel oder eine Ansicht zur Grundlage genommen. Der Schnitt wird blattparallel auf den Tisch gelegt, bleibt also unverzerrt und messbar. Die Tiefen werden von den Eckpunkten her unter 30, 60 oder 45 Grad (im Grunde wären alle Winkel möglich, aber es gibt nun mal eine Tradition) parallel zueinander gezeichnet – bis die nächste unverzerrte Senkrechtfläche die Länge begrenzt. Auch hier verzerren sich die Winkel (der Parallelen zur Schnittfläche). Auch hier macht sich eine optische Täuschung bemerkbar: Die Tiefenlinien scheinen gedehnt zu sein, so dass wir sie am besten ebenfalls um ungefähr ein Drittel kürzen.

Unser eingeprägtes Wissen um optische Täuschungen spielt uns hier einen Streich: Wir können nicht anders, als den umgebenden Raum perspektivisch zu sehen. Das heißt, wir vermuten, dass alle Distanzen kontinuierlich kleiner werden, also sich mit zunehmender Entfernung verkürzen. Wenn wir Höhen- oder Tiefenlinien unverkürzt zeichnen, melden unsere Gehirne eine angeblich perspektivische Verkürzung. Wir gehen irrtümlich von einer längeren Distanz aus. So erscheint das wahre Maß als zu lang und fälschlich das gekürzte als das wahre Maß.

Isometrie

Die Isometrie ist schwieriger zu handhaben, da sie anders als Planometrie und Kabinettprojektion nicht direkt von einer vorhandenen Entwurfszeichnung ausgehen kann. Hier sind alle Ebenen verzerrt, das heißt, wir zeichnen eine ursprünglich rechteckige Fläche um 30 Grad gekippt auf das Blatt und verzerren deren rechte Winkel auf 120 und 60 Grad (Im Rechteck haben wir dann statt vier 90-Grad-Winkeln zwei 120-Grad-Winkel und zwei 60-Grad-Winkel; die Winkelsumme bleibt also erhalten). Parallelen bleiben auch hier parallel. Wir zeichnen die Kanten senkrecht nach oben und ergänzen die nächste Horizontalfläche. Da

60

nun alle Flächen gleichmäßig verzerrt werden, es auch keine Hierarchie der Flächen gibt, tritt auch keine optische Täuschung auf. Beim Messen müssen wir zwar alle Winkel umrechnen, haben aber den Vorteil, dass alle Höhen-, Längen- und Tiefenmaße nicht verkürzt werden. Die Isometrie ist die am umständlichsten zu zeichnende, aber dafür anschaulichste aller Axonometrien.

Axonometrien sind einfacher als Perspektiven zu zeichnen, geben aber ebenso wie diese den dreidimensionalen Eindruck wieder. Bruno Reichlin zitiert in einem Katalogbeitrag Alberto Sartoris, einer der italienischen Heroen der modernen Architektur, der meinte, dass die Axonometrie eine synthetische Darstellung der Architektur leiste. „Zwei Axonometrien, von beiden Ecken aus aufgenommen, stellen einen Entwurf umfassend dar."[18] Der Zeichner und später auch die ausführenden Handwerker haben so von Beginn an eine Vorstellung der komplizierten Raumverschränkungen im Gebäude.

Anders als die Perspektive kommt die Axonometrie ohne festen Blickpunkt aus, entspricht also nicht unserem gewohnten Sehen (Parallelen bleiben parallel und bündeln sich nicht in Fluchtpunkten wie in der Perspektive). Das macht sie etwas unanschaulicher für den Laien, anschaulicher jedoch für den Fachmann. Alle Kanten bleiben maßgenau. Maße sind für den Handwerker ablesbar.

Natürlich ist es einfacher und sicher nicht zu verachten, wenn man die Axonometrie am Computer vorkonstruiert, da sie sich dort mit wenigen Mausbewegungen drehen und wenden lässt. Skizzenhaft aber dann den Ausdruck der Zeichnung mit der Hand verändern und ergänzen, bedeutet, dass sie einem wieder selbst gehört und nicht dem Computer. Der wie ein Seismograph zwischen den Fingern zitternde Stift als Mittler zwischen Gehirn und Darstellung ist unumgänglich für das emotionale Bewusstwerden einer kreativen Leistung.

Themenübung: Rekonstruierendes Zeichnen

Das rekonstruierende Zeichnen ist eine hilfreiche Methode, mit der sich das architektonische Projektieren einüben lässt. In der Anschaulichkeit gleicht es dem aufwendigeren Arbeiten am Arbeitsmodell. Wer es beherrscht, skizziert damit schnell seine Ideen, schneller als es entsprechende Programme im Computer leisten. Es ist eine Methode, die das Projekt nicht in Grundrisse, Schnitte und Ansichten zerlegt, sondern mit der wir von Anfang an den Überblick über alle Dimensionen der Gestalt behalten – ihre Räume und Volumen.

Um sich mit dem Verfahren vertraut zu machen, ist es zu empfehlen, es an Hand eines Gebrauchsgegenstandes zu trainieren. Am Brauchbarsten sind ältere Apparate, denen man ansieht, wie sie zusammengesetzt sind, deren Verschraubungen ihrer Einzelteile deutlich und verständlich macht, wie sie hergestellt wurden. Die Abbildung der Schreibmaschine aus den dreißiger Jahren zeigt ein besonders lohnendes Beispiel.

Der Gegenstand wird zeichnerisch auf seine stereometrischen Grundformen reduziert. Es entsteht so kein fotografisches Abbild, sondern die Analyse eines Gefüges. Die innere Mechanik und Konstruktion sollen dabei keine Rolle spielen. Der Gegenstand wird in Gedanken auseinander genommen (um ihn als Ensemble von Grundformen zu verstehen) und anschließend zeichnerisch wieder zusammengesetzt – so zu sagen rekonstruiert. Er wird gezeichnet, als sei er hohl und seiner Funktionsweise beraubt, aber als sei er durchsichtig – mit durchscheinenden, sonst verborgenen Kanten. Da dies analytische Verfahren komplexes und anschauliches Vorstellungsvermögen erfordert, ist es notwendig, es am einfachen Objekt zu üben (Schraubstock, Wasserhahn, Papierlocher, Schreibmaschine, Eierbehälter).

Eine Handlungsanweisung sieht dann so aus: Das Objekt wird in der Schrägaufsicht gezeichnet. Es wird von

oben und im schiefen Winkel (ca. 30, 45 oder 60 Grad) zu den Blattkanten angelegt. Senkrechte Linien werden unserem optischen und ebenso dem statischen Gefühl entsprechend als senkrechte Parallelen dargestellt. Da die räumliche Verkürzung der relativ kleinen Dinge sich nur wenig auf die Darstellung auswirken würde, wird die Perspektive vernachlässigt, stattdessen das Objekt axonometrisch gezeichnet. Zur Veranschaulichung der Zusammenhänge und zur Kontrolle

das Verfahren:

1

2

3

von Winkel und Proportionen werden alle verdeckten Kanten und Teile ebenfalls gezeichnet, ebenso Hilfslinien wie Achsen, Diagonalen und Tangenten.

Die Zeichnung wird ‚rekonstruierend' entwickelt: Mit der Bodenplatte wird begonnen und darüber werden die einfachen Primärformen aufgebaut. Erst wenn die Gesamtform entstanden ist, werden sparsam die notwendigen Details eingesetzt. Wichtig ist die prägnante, klare Linie. Auf das Einsetzen von Licht und Schatten wird verzichtet.

Axonometrien sind im Falle des rekonstruierenden Zeichnens die einzigen Erfolg versprechenden Darstellungsverfahren. In einem weiteren, die Einbildungskraft anregenden Schritt kann das rekonstruierte Gebilde dann variiert, das heißt, in eine Phantasiearchitektur verwandelt werden. Dies ist auch ein Hinweis, wie scheinbar entwurfsfremde Fundstücke unsere Gehirnzellen zum beschleunigten Interagieren anregen können.

Verwandlung in Phantasiearchitektur

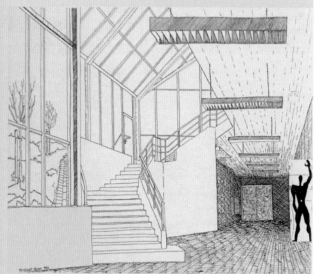

Perspektivische Darstellung (subjektiver Blick):

Die Axonometrie gibt die Geometrie des darzustellenden Gegenstandes und seine Maße objektiv wieder. Die Perspektive dagegen vermittelt einen verzerrten, subjektiven Blick des Betrachters von seinem Standpunkt aus (denken wir nur an die in Wirklichkeit parallelen, scheinbar aber in der Ferne im Fluchtpunkt zusammenlaufenden Eisenbahnschienen). Die Axonometrie ist Werkzeichnung (Parallelen bleiben parallel) und gehört als Hilfsmittel in den inneren Werkstattbetrieb. Die Perspektive wendet sich hingegen nach außen zur Kundschaft. Sie gehört zur Rhetorik der Architekturdarstellung. Sie „ist eine Ordnung der visuellen Erscheinung". Man kann ihr vorwerfen, „dass sie das ‚wahre Sein' zu einer Erscheinung gesehener Dinge verflüchtige", oder „dass sie die freie und gleichsam spirituelle Formvorstellung auf eine Erscheinung gesehener Dinge festlege"[19]. So schrieb es der bedeutende Kunsthistoriker Erwin Panofsky der Perspektive zu.

Aber auch für die Wiedergabe des in Gedanken Gesehenen, einer räumlichen Vorstellung, ist die Perspektive unumgängliches Hilfsmittel. Sie illustriert Idee und Plan des Zeichners, sie versucht den Klienten, den Bauherren oder eine Jury zu überzeugen. Die mit der Hand gezeichnete Perspektive vermittelt das Einzigartige, das Unvergleichliche, das Persönliche, das Individuelle, das dem Bauherren auf den Leib Geschnittene. Dem Betrachter soll schnappschussartig und möglichst realistisch der Anblick eines Bauwerks geboten werden, so wie er ihn künftig an seinem Ort, inmitten eines vorhandenen Baubestands wahrnehmen wird. Irgendwie leisten dies auch die Perspektivprogramme im Computer. Aber ihren Zeichnungen ist alles Persönliche ausgetrieben. Sie sind perfekt, anonym und glatt. Sie sind photorealistische Täuschungen und sprechen weder vom Zeichner, noch vom Auftraggeber. Das Anderssein von Computer- und Handzeichnung lässt sich mit dem Unterschied zwischen Industrie und Handwerk vergleichen.

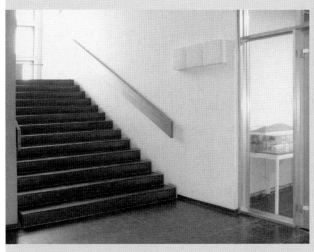

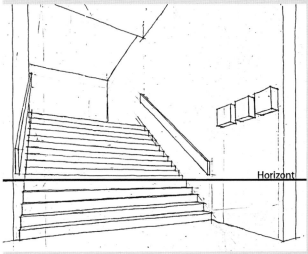

Wie der Fotograf kann der Perspektivzeichner unterschiedlichste Standpunkte wählen: Nah- und Fernsicht, Frosch- und Vogelperspektive. Anders als der Fotograf aber wird der Zeichner nie von störendem Beiwerk wie Strommasten oder Verkehrszeichen irritiert. Im Gegenteil: Mitunter setzt er Beiwerk zur Vertuschung unliebsamer Schwachstellen im Entwurf ein. Der verzerrenden Manipulationen sind kaum Grenzen gesetzt – bis hin zur Täuschung. Diese Machenschaften sind Gefahren, denen sich Zeichner und Betrachter bewusst sein müssen.

Nie werden so viele Darstellungsfehler gemacht wie beim perspektivischen Zeichnen. Das liegt daran, dass die Perspektive eine Ansammlung von optischen Täuschungen ist (Parallelen werden nicht parallel wiedergegeben, gleiche Distanzen werden ungleich usw.). Unser Gehirn aber beharrt hartnäckig auf unserem Wissen, dass Parallelen parallel zu zeichnen sind oder dass der zu zeichnende Gegenstand auch oberhalb unseres Auges eine Oberfläche hat. So streiten sich Auge und Gehirn um das Gesehene und um das Vorwissen und manchmal behält dummerweise das Gehirn die Oberhand.

Grundlagen der Perspektive

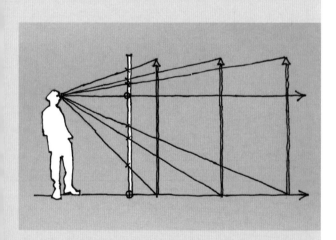

Versuchen wir, uns klar zu machen, warum wir perspektivisch sehen. Stellen wir uns vor, wir stünden im freien, ebenen Gelände auf einer Landstraße. Den Weg begleitend baut sich vor uns eine lange Reihe von hohen Masten oder Pfählen auf. Um die Masten zu zeichnen, haben wir quer zur Straße zwischen sie und uns eine senkrecht stehende, transparente Bildfläche gespannt. Nun denken wir uns selbst einäugig und fixieren mit dem Auge den uns zunächst stehenden Pfahl: zum einen den Fußpunkt, zum anderen die Spitze. Der Sehstrahl zwischen Auge und Fußpunkt durchstößt unsere Bildfläche und hinterlässt dort eine punktförmige Markierung. Das Gleiche geschieht mit dem Sehstrahl zwischen Auge und Pfahlspitze: eine zweite Markierung entsteht auf der Bildfläche. Ver-

66

binden wir nun auf der Fläche die beiden Markierungspunkte, dann entsteht dort ein verkleinertes Abbild des Pfahls (eine vage Annäherung, denn natürlich müssen wir noch weitere Punkte fixieren, den Blick zwischen den beiden Punkten hin- und herwandern lassen, um ein realistisches Bild zu erzielen).

Wenn wir dies mit entfernter stehenden Masten wiederholen, erhalten wir nicht nur kleinere Abbilder der gleich großen Masten, sondern wir nehmen auch wahr, dass allmählich die Schenkel der Winkel zwischen Fußpunkt und Spitze immer enger werden, bis sie endlich über dem fiktiv zum Punkt geschrumpften, im Unendlichen stehenden Mast zusammenklappen (s. Abb. S. 74). Der Winkel beträgt nun Null Grad. Wir schauen nun weder hoch noch nach unten, sondern parallel zum Boden, auf dem wir stehen.

Dieser Nullwinkel, der kein Winkel mehr, sondern eine Linie ist, ist uns besonders wichtig. Wir können den Kopf im Halbkreis drehen. Solange unsere Sehstrahlen parallel zu unserer Standebene verlaufen, bestreichen sie eine Fläche, die wir Horizontfläche nennen wollen. Da sie in Höhe unseres Auges sich erstreckt, können wir sie nur als Linie wahrnehmen. Es ist die so genannte Horizontlinie, die lineare Abbildung der Horizontfläche. Wir nehmen sie als Band punktförmiger (aneinander stoßender) Markierungen auf der transparenten Bildfläche wahr.

Wir stehen und drehen unseren Kopf hin und her um zu beobachten. Dabei läuft der Sehstrahl unseres Auges parallel zum Boden bis hin zum im Unendlichen stehenden Objekt. Dasselbe (die Parallelität) ist der Fall, falls wir knien oder liegen oder über der Landschaft schweben. Immer liegt der zum Punkt geschrumpfte Mast im Unendlichen auf dem Horizont. Obwohl er im Unendlichen liegt, können wir diesen Mast als Punkt (wir nennen ihn schon mal Fluchtpunkt) genau fixieren, das heißt, zeichnen. Das zeigt uns, dass unser perspektivisches Sehen ein subjektives ist. Das sich vor uns aufbauende Bild ist im Augenblick (!) ein nur von

67

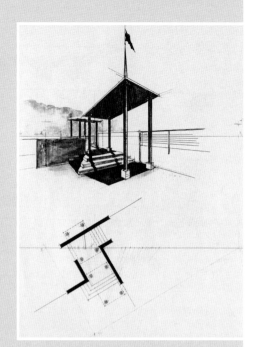

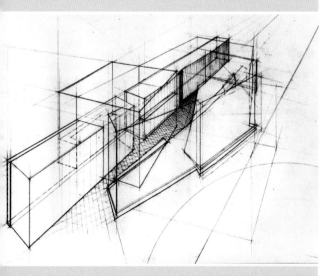

uns selbst sichtbares, ist also von unserem Standort abhängig. Selbst wer sich neben uns befindet, sieht ein anderes (nur ein annähernd gleiches) Bild als wir. Jedoch es gibt allgemeine Gesetzmäßigkeiten.

Schauen wir uns den gleichen Versuch von oben, das heißt, in der Aufsicht an:

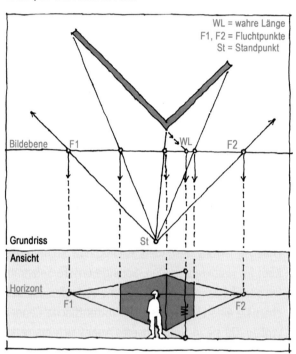

Wieder haben wir einen Standort festgelegt. Wieder haben wir zwischen uns und die Mastenreihe eine transparente Bildfläche gestellt und wieder schauen wir uns die Masten (die von oben gesehen nur noch als Punkte, in der Zeichnung als Kreuze dargestellt, erscheinen) einen nach dem anderen an. Der Winkel unseres Sehstrahls zur Bildfläche wird vom vorderen Pfahl zu den dahinter liegenden von Mal zu Mal flacher. Bis der Sehstrahl auf den im Unendlichen Liegenden (auch in der Ansicht Punktförmigen) trifft. Der Winkel ist nun ebenfalls kein Winkel mehr, sondern eine Parallele zur Mastenreihe (wir erinnern uns an den Lehrsatz: Parallelen treffen sich im Unendlichen). Trotzdem können wir diesen im Unendlichen liegenden letzten Pfahl feststellen: Er liegt dort, wo unser Sehstrahl parallel zur Reihe und parallel zum Boden (also auf der Horizontlinie)

68

unsere Bildfläche quert. Diesen Punkt nennen wir Fluchtpunkt. Folgerichtig hat eine zweite Reihe, die mit Abstand, aber parallel zur ersten verläuft, den gleichen Fluchtpunkt.

Wir können selbstverständlich die Reihen auch durch unendlich lange Mauern ersetzen (s. Abb. gegenüber). Das ist im Prinzip dasselbe. Wie sieht es nun aus, wenn zwei Mauern nicht parallel zueinander verlaufen? Dann haben die Mauern je einen eigenen Fluchtpunkt. Wenn sie im rechten Winkel zueinander stehen und alle anderen Mauern parallel dazu, wie das bei Häusern meist der Fall ist, dann müssen wir demnach mit zwei Fluchtpunkten hantieren. Es handelt sich dann um die so genannte, meist gebräuchliche Übereckperspektive. Unsere Bildebene haben wir dabei geschickterweise schräg zu den Mauern gelegt.

Wie also konstruieren wir? Wir zeichnen zuerst den Mauerwinkel im Grundriss, legen dann unseren Standort fest und platzieren die Bildebene (sie bildet sich im Grundriss, von oben betrachtet, als Linie ab) zwischen Standort und Mauern. Bildebene und Standort lassen sich beliebig festlegen, aber bei einiger Routine stellen sich im Laufe der Zeit günstigere oder ungünstigere Positionen heraus. Vom Standort zu den Mauern parallele Sehstrahlen durchstoßen die Bildebene. Diese Durchstoßpunkte nennen wir Fluchtpunkte (denn wir wissen ja, dass Parallelen sich im Unendlichen, im Fluchtpunkt treffen).

Nun beginnen wir eine Ansichtszeichnung der Bildebene, die eigentliche Perspektive. Wir zeichnen die Standfläche und in Augenhöhe den Horizont (falls wir uns stehend denken: maßstäblich ungefähr 1,70 m, im Falle des Sitzens: ungefähr 1,20 m). Standfläche und Horizont liegen senkrecht zur Bildebene und erscheinen deshalb als Linien).

Nächster Schritt: Wir übertragen die Distanz der Fluchtpunkte aus dem Grundriss in die Ansicht und

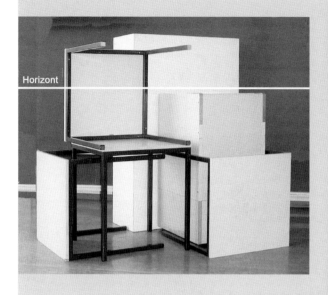

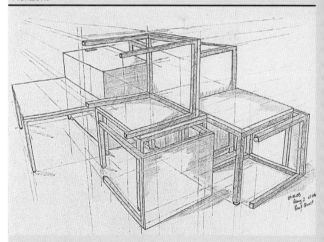

Perspektivübung im Seminarraum

69

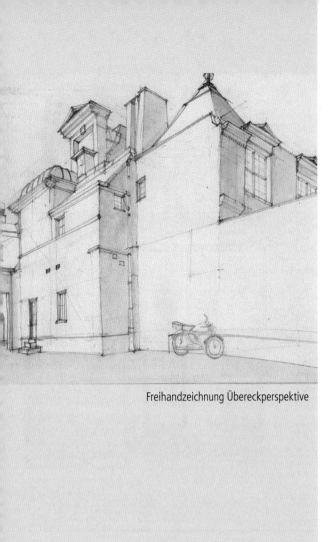

Freihandzeichnung Übereckperspektive

Freihandzeichnung Zentralperspektive

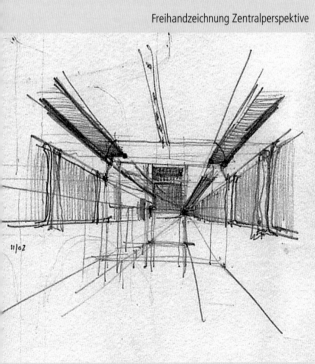

dort auf die Horizontlinie. Die Konstruktion kann beginnen: Im Grundriss ist der Abstand zwischen Mauern und Bildebene beliebig gewählt. Das hat Einfluss auf die Ausdehnung der entstehenden Perspektive. Deshalb müssen wir noch die gewünschte Höhe der Mauern festlegen. Dazu ziehen wir eine der beiden Mauerstücke (siehe Zeichnung) über ihre Ecke hinaus bis zur Bildebene. Da sie dort die Fläche berührt, bildet sie sich im wahren Maß (WL) ab. Das können wir nun aus dem Grundriss als Senkrechte in die Ansicht übertragen.

Die Mauerecke in wahrer Länge steht auf der Standlinie (da sie ja nicht schwebt). Wir verbinden ihre Endpunkte mit dem zur herausgezogenen Mauer gehörenden Fluchtpunkt F1. Danach projizieren wir im Grundriss die ursprüngliche Mauerecke (Sehstrahl vom Standort dahin) auf die Bildebenenlinie und übertragen die Position als Senkrechte in die Ansicht. Sie schneidet die beiden schon vorhandenen Fluchtstrahlen (zu F1). Jetzt haben wir endlich die perspektivische Erscheinung der Ecke erhalten. Von deren Endpunkten aus (und keinesfalls von der wahren Länge aus, was häufig verwechselt wird) können wir nun die beiden Fluchtlinien zum Fluchtpunkt F2 ziehen. Wie man die Endkanten der Mauern findet, dürfte nun kein Problem mehr sein. Ein mühsamer Weg, der aber leichter ist, als er zunächst aussieht.

Es gibt noch den speziellen (für Innen- oder Straßenräume gebräuchlichen) Fall, dass wir die Bildebene parallel zu einer der beiden Mauern setzen. Auch unser Horizont und der ins Unendliche laufende Sehstrahl bleiben dann parallel zu dieser parallel stehenden Mauer. Bleiben sie aber parallel, dann können sie sich auch nicht im Fluchtpunkt in unserer Zeichnung treffen, das heißt, die Mauerkanten verlaufen parallel zum Horizont. Die andere, senkrecht zur Bildebene stehende Mauer hat allerdings einen Fluchtpunkt auf dem Horizont. Diesen speziellen Fall der Perspektive nennen wir Zentralperspektive.

70

Freihandperspektive

Wollen wir (auf Reisen: im Gelände, im städtischen Raum) eine perspektivische Zeichnung verfertigen, so gilt es, locker und dem Augenschein nach zu skizzieren. Wir suchen uns zuerst einen Standpunkt, klären die Augenhöhe (ob sitzend, ob stehend usw.), die, wie wir nun wissen, identisch ist mit dem Horizont. Die Horizontlinie zeichnen wir deutlich aufs Blatt (von Blattrand zu Blattrand). Ihre Position, ob unten, mittig oder oben auf dem Blatt, ist davon abhängig, wie viel Zeichenwertes wir oberhalb oder unterhalb des Horizontes sehen. Dann versuchen wir festzustellen, wo die Fluchtpunkte (leider selten auf dem Papier) liegen. Wenn wir die von uns wegstrebenden Kanten des Raumes oder Volumens, die ja scheinbar abwärts oder aufwärts steigen, mit dem in gleiche Richtung gehaltenen Bleistift über ihre Enden hinaus verfolgen, stoßen wir irgendwo auf unsere vorher festgelegte Augenhöhe. Dort erhalten wir die Fluchtpunkte. Zur Kontrolle können wir mehrere Kanten mit dem von uns weg gehaltenen Bleistift überprüfen: Alle zueinander parallelen Kanten kreuzen sich in fiktiver Verlängerung in einem der Fluchtpunkte (auf dem Horizont), mit Ausnahme der senkrechten parallelen Kanten, die parallel bleiben.

Nun suchen wir uns noch eine unser Bild bestimmende Senkrechte (eine für die Zeichnung bedeutungsvolle Kante, die ins Auge springend einen Richtungswechsel angibt) und kreuzen sie mit dem Horizont. Damit dürfte der Vollendung der Zeichnung nichts mehr im Wege stehen.

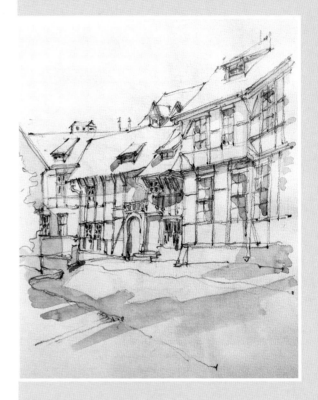

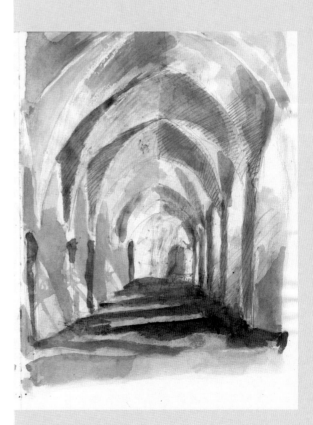

Wir schämen uns nicht der Hilfslinien (Horizont, Fluchtlinien, Achsen). Übertreiben wir eher, spannen wir die Zeichnung in ein Netzwerk erklärender Linien! Sie sind eine Bereicherung unserer Zeichnung und gehören deshalb nicht ausradiert. Sie erläutern die Struktur der Räume und Volumen vor uns und geben unsere eigene Analyse des Gesehenen wieder.

Noch einmal sei gesagt: Nie werden so viele Darstellungsfehler gemacht wie beim perspektivischen Zeichnen. Perspektivisches Sehen muss trainiert werden. Deshalb ist es unabdingbar, so oft wie möglich, räumliche Situationen zu skizzieren (und seien es nur ein paar gestapelte Kisten). Nicht immer wird man im Freien zeichnen. Für Architekten sind Innenräume ebenso wichtig. Um zu üben genügen banale Situationen. Ein paar zusammen gerückte Möbelstücke lassen sich mit ein wenig Phantasie als stadträumliches Ensemble interpretieren.

Figürliches Zeichnen

Bekleidete Personen

Die Maße der Architektur sind auf den Menschen bezogen. Jede Tür, jede Fensterbrüstung, jedes Möbelstück führt uns das vor Augen. Die meisten kennen ihre Körperlänge, ihre Kleidungsmaße oder ihre Schuhgröße, diese jeweils jedoch nur in Zahlen. Präzise gefühlt sind sie selten. Dennoch vergleichen wir uns ständig mit dem, was uns umgibt: Passen wir in diesen Schlupfwinkel hinein; können wir diesen Zwischenraum durchqueren; können wir dieses Mäuerchen überspringen, können wir uns hinter dieser Säule verbergen usw.?

„Unsere leibliche Organisation ist die Form, unter der wir alles Körperliche auffassen"[20], befand der Kunsthistoriker Heinrich Wölfflin und meinte, „dass die Grundelemente der Architektur [...] sich bestimmen nach den Erfahrungen, die wir an uns gemacht haben."[21] Am deutlichsten aber wird diese Erfah-

rung, wenn wir einer Person gegenübersitzen, die stille hält und die wir zeichnen wollen. Dann bemerken wir allmählich, dass wir uns in den fremden Körper hineinfühlen. Beschäftigen wir uns zeichnend mit der Schulter des anderen, so spüren wir unsere eigene Schulter. Im Fortgang der Zeichnung erfahren wir so nach und nach den fremden und damit auch unseren eigenen Körper.

Der bekleidete Körper allerdings verschleiert einiges. Halsansatz, Arm- und Beingelenke, hervortretende Muskeln, all diese Partien können unter ihrer textilen Verpackung nur erahnt werden. Fließende und gefältelte oder weit geschnittene Kleidungsstücke verändern und vergröbern das Verhältnis der Körperteile zueinander. Andererseits ist das Zeichnen von Leib und Leibeshülle für den Architekturzeichner ein Akt der dreidimensionalen Erkenntnis, weil er hier am deutlichsten das Zueinander, aber auch die Schichtungen von Stoff, Luft und Haut (analog zu Leib, Leerraum und Mauerwerk) nachvollziehen kann.

Der Zeichner befasst sich nicht mit der nackten Oberfläche eines Körpers, sondern mit dessen Verpackung, also mit unterschiedlichen Materialien, mit Textur und Faktur, mit Falten und geometrisierten Formteilen, zugleich aber auch mit den Reibungsflächen und Zwischenräumen zwischen Leib und zweiter Haut (der Kleidung). Nichts anderes findet im Architekturentwurf (zwischen Leib und dritter Haut, dem Gebäude) statt. Deshalb führt das kontinuierliche Skizzieren von Menschen in ihren Hüllen und ihrer Umgebung zur allmählichen Verschärfung der architektonischen Sensibilität.

Aktzeichnen

Warum aber dann auch Aktzeichnen? Nur am unbekleideten Körper können wir menschliche Proportionen präzise erkennen, können wir zum Beispiel genau das Verhältnis von Oberarm zu Unterarm (vom Schultergelenk zum Ellenbogen und zum Handge-

73

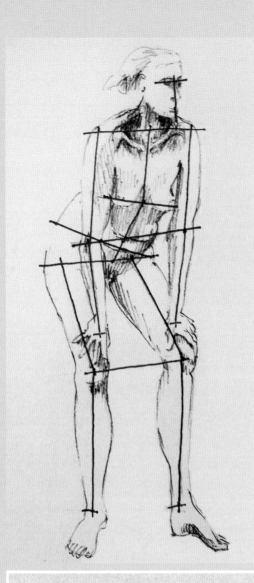

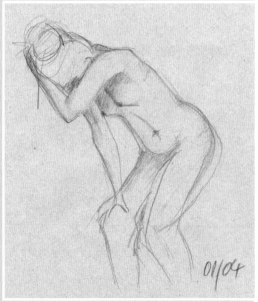

01/04

lenk) oder von Oberarm zu Oberschenkel (usw.) erkunden. Nackt vor dem Spiegel vergleichen wir uns mit der Idealfigur, die uns die Gesellschaft vorgibt. Angesichts des anderen nackten Körpers, den wir zeichnen, sind wir gehalten, uns mit Proportionen auseinander zu setzen. Uns werden Maßverhältnisse gewärtig, nach denen wir dann Gebäude formen. Denn unterschiedliche Menschen – groß und klein, dick oder schmal – müssen hineinpassen. Aus der Fülle der von mir gezeichneten Aktfiguren ergibt sich die Durchschnittsfigur (von Mann oder Frau).

Kleidung verschiebt die Proportionen, verschiebt auch die dem Leib immanente Symmetrie. Nur der nackte Körper offenbart deutlich die Längssymmetrie. Eine Mittelachse verläuft zwischen den Augen, den Nasenlöchern, mittig des Kinns, des Halses, zwischen den Brustwarzen, über den Nabel und die Scham. Es ist ratsam diese Achse (ratsam auch bei verbogenem, bei gebeugtem Körper) einzuzeichnen. Genauso anzuraten ist es, Querachsen (Schulter, Hüfte, Becken, Knie) erkennbar wiederzugeben, ebenso die Mittelachsen von Armen und gespreizten Beinen. Da Horizontalachsen und Vertikalachsen im Winkel von 90 Grad zueinander stehen, werden Verschiebungen und Abweichungen der Körperteile zueinander deutlicher fasslich.

Auch hier gilt wie bei jeder Skizze: Hilfslinien strukturieren die Zeichnung, verweisen auf den Zeichenvorgang und analysieren nachvollziehbar für den Betrachter die Figur. Die Intelligenz des Zeichners zeigt sich weniger in der sentimentalen Wiedergabe des Gesehenen als in dessen zeichnerischer Verarbeitung. Dazu gehört, dass sich der Zeichner jener Achsen bewusst wird, die sich mit der Drehung oder Krümmung des Körpers und seiner Glieder mit bewegen. Die Festlegung der Achsen zu Beginn der Zeichnung hilft uns, grobe Missverhältnisse zu vermeiden. Wir können leichter die Winkel der zueinander geneigten Gliedmaßen abwägen.

74

Ebenso fordert die Skizze, soll sie denn erfolgreich beendet werden, ein unaufhörliches Abschätzen der Binnenmaße des Körpers. Wie in der Architektur sind Höhen, Breiten und Tiefen der einzelnen Glieder oder Rumpfabschnitte miteinander zu vergleichen. Genauso wichtig sind uns aber Negativvolumen, also Zwischenräume, zum Beispiel zwischen abgespreiztem Arm und Oberkörper. Ihre Konturen und Flächeninhalte müssen ständig überprüft und proportionsgerecht wiedergegeben werden.

Zur intelligenten Zeichnung gehört auch die Ausmerzung alles Überflüssigen. Auch die Trennung von Wichtigem und Unwichtigem ist ein Denkvorgang, der Entscheidungen verlangt. Der Anfänger tut gut daran, nach Betrachtung seiner eigenen fertigen Skizze testend die eine oder andere Linie wieder auszuradieren. Er wird feststellen, dass die Zeichnung (wenn er die richtigen Linien entfernte) nicht nur genauso fertig erscheint wie vorher, sondern zusätzlich Leichtigkeit und scheinbar souveräne Bestimmtheit ausstrahlt. Das hängt damit zusammen, dass unser Gehirn unbewusst jede unvollkommene Form zur vollkommenen ergänzt. Es ist aber auch so zu verstehen, dass wir in der Realität vielfach erfahren haben, dass Sonnenlicht Kanten, ja sogar Flächen bis zur Unsichtbarkeit überstrahlen kann.

Zur Reduktion der Fülle des Wahrgenommenen gehört auch die Geometrisierung der einzelnen Körperpartien. Denn zur menschlichen Natur gehört es, Ähnlichkeiten in unterschiedlichen Objekten und ihren Teilen aufzudecken und sie sodann zu systematisieren. Was Paul Cézanne zu Beginn des 20. Jahrhunderts meinte, gilt auch heute: „Man behandle die Natur gemäß dem Zylinder, der Kugel und dem Kegel und bringe das Ganze in die richtige Perspektive."[22]

Das Gesehene auf die geometrischen Grundformen zurückzuführen, ist ebenfalls ein analytischer Denk-

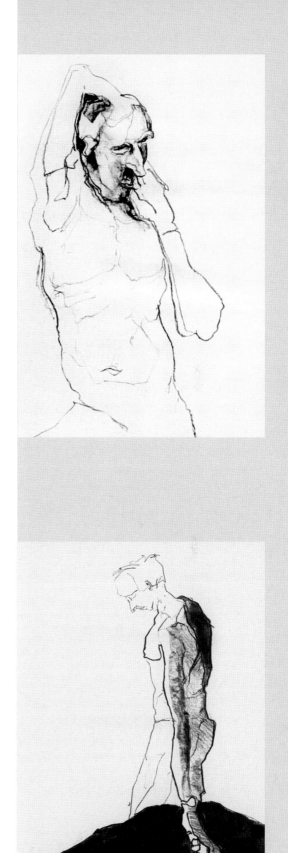

75

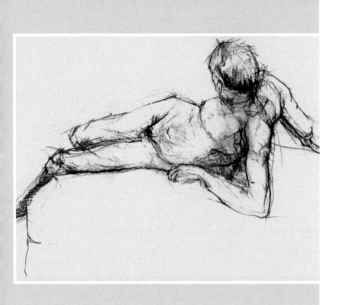

vorgang, der der Verdeutlichung der innewohnenden Struktur dient. Wir verzetteln uns dann nicht in Nebensächlichkeiten, sondern behandeln das Grundlegende. Das Überragende der Zeichnung gegenüber der Fotografie ist eben, dass sie ohne heimliche oder retuschierende Manipulationen das Unsichtbare sichtbar machen kann. Das Sichtbare wird geformt von des Betrachters subjektiver Wahrnehmung des Betrachteten.

Das Aktmodell, sein Körper wird von jedem Zeichner in Gedanken aufs Neue geformt. Der Zeichner identifiziert sich, sein eigener Körper wird ihm vertrauter. Die körperliche Gesamtform entwickelt sich auf dem Zeichenblatt aus Einzelformen – raumhaltigen Einzelelementen, die am Anschaulichsten mit dem Cézanne-Prinzip dargestellt werden. Die Wiedergabe und Analyse des fremden Körpers führt unbewusst zur Selbsterkenntnis.

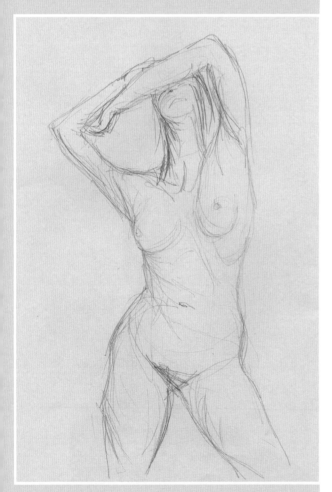

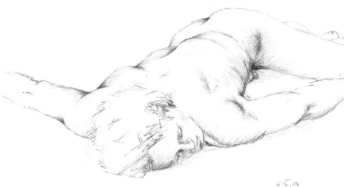

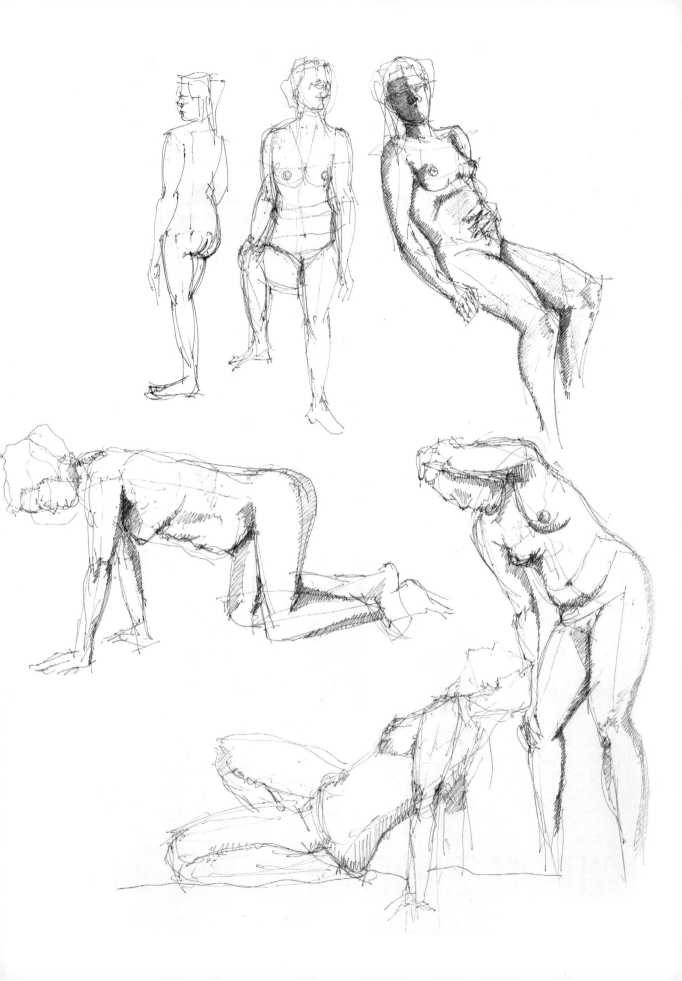

Themenübung: Lebende Skulpturen

Selbsterkenntnis bereitet den Weg zu authentischer Selbstdarstellung. Aufrichtigkeit und Glaubwürdigkeit (Authentizität) gehören zu den Grundmaximen der Moderne, vor allem der modernen Architektur (erinnert sei an Louis Sullivans „form follows function"). Wie aber gelangen wir zu der dazu gehörenden Klarsichtigkeit? Die künstlerische Avantgarde fand dafür den Ausbruch, die Befreiung von den bürgerlichen Normen. Wer aber den Rahmen sprengt, löst sich aus der ihn stützenden Gemeinschaft, muss sich auf sich selbst besinnen, kann kaum Klischees verfallen, muss den Dingen ins Auge schauen. Dies unverfrorene Schauen ist eine Voraussetzung für Kreativität.

Als Augen öffnende Gestaltungsaufgabe hat sich folgende Übung erwiesen. *Eine Skulptur wird gefordert, die ein wenig die gewohnten Grenzen sprengt und dennoch mitten im eigentlichen Aufgabenfeld des Berufs angesiedelt ist: eine individuell geprägte Formbestimmung der „zweiten Haut" des Menschen als Modell für die Gestaltung der „dritten Haut", dem Haus. Die Skulptur sei identisch mit dem Skulpteur.*

Die bildhauerische Beschäftigung mit der lebensgroßen, menschlichen Figur wäre zweifellos eine Überforderung für jene, die mit dem skulpturalen Handwerk nicht vertraut sind. Der menschliche Körper war für den Bildhauer stets Urerlebnis und vorrangiges Thema zugleich (übrigens auch für den Architekten), weil einfühlend sich hinein Begeben in den Fremden oder das Fremdartige hier am eindringlichsten zu vollbringen ist. Nicht nur, dass wir die räumlichen Koordinaten im eigenen Körper spüren (oben – unten, rechts – links, vorne – hinten), auch

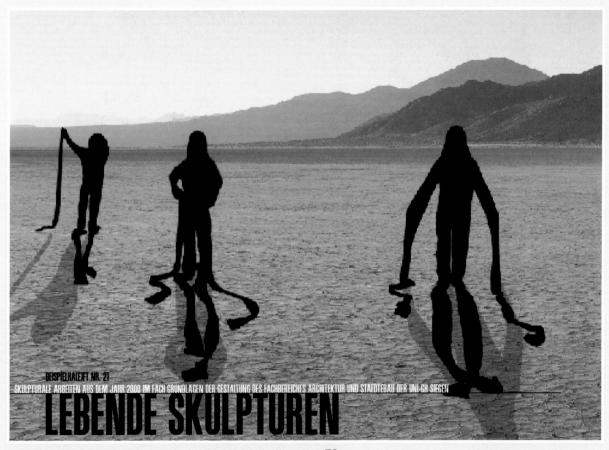

BEISPIELHALELFT NR. 21
SKULPTURALE ARBEITEN AUS DEM JAHR 2000 IM FACH GRUNDLAGEN DER GESTALTUNG DES FACHBEREICHES ARCHITEKTUR UND STAEDTEBAU DER UNI-GH SIEGEN

LEBENDE SKULPTUREN

geistige oder emotionale Vorgänge wie soziales Miteinander, kollektive oder singuläre Leidenschaften lassen sich in der Übersetzung vom Fleisch in Stein/Holz/Metall mitteilen. Das lässt sich gut vermitteln, weil der Betrachter sich ebenso einfühlend in die verwandte Form hineindenken kann wie der Bildhauer.

In diesem Falle, in dieser Aufgabe allerdings ist die menschliche Figur (die eigene nämlich) bereits gegeben. Doch das bislang eher unbewusste Raumgreifen kann nun zu einem bewussten werden: Arm strecken, Fuß heben, in der Hüfte drehen usw. Jedenfalls ist das Gebärdenballett auch ein Hintersinn der Aufgabenstellung. Hinzu kommt eine zusätzliche, zu erfindende Haut, die das Volumen verändern, neue Tentakeln und Gliedmaßen kreieren, kurz, den eigenen Körper befremdlich und zugleich die Sensibilisierung für Differenzen und Übergänge, für das

Verbindende und Trennende von Innenwelt und Außenwelt vertiefen soll. Hauptsächlich dies sollten Architekten im Sinn haben, wenn sie Häuser planen. Skulptur und Architektur sind gleichartig ablaufende Prozesse trotz aller Unterschiede.

Die Aufgabe wurde einem zweiten Semester erfolgreich gestellt und dann im dritten Semester öffentlich präsentiert (Siegen 1999). Erinnerungen an das „triadische Ballett" (1922) Oskar Schlemmers, an opernhafte Phantasiegestalten, Rüstungen, geometrische Primärkörperhüllen und Architekturen der Baugeschichte sind vielleicht den Lösungsbeispielen anzusehen. Auch dies ist ein Hintersinn der Aufgabenstellung: Sich die richtigen Vorbilder suchen, aber über sie hinauswachsen, gehört zu den ehrgeizigen Vorhaben und wünschenswerten Erkenntnissen angehender Architekten.

Bäume zeichnen

„Einen alten Baum versetzt man nicht" und „der Apfel fällt nicht weit vom Stamm". Ein Baum gleicht einem Menschen: Der eine ist des anderen Doppelgänger. Zur Geburt eines Kindes wird ein Baum gepflanzt. Festliche Anlässe werden mit Bäumen ‚überhöht' (Weihnachten, Richtfest, Maifeier). Für die meisten Lebenssituationen lassen sich Baum-Sprichwörter finden: „Er steht zwischen Baum und Borke", sagt man über jenen, der sich in einem kaum lösbaren Dilemma befindet. Der Baum hat Charakter, er hat seine besonderen Eigenheiten, er ist dem Menschen nahe, er gehört zum Haus. Wir wollen ihm Respekt erweisen. Wenn wir ihn zeichnen, soll das nicht gedankenlos oder rezeptartig geschehen, wie das manche Anleitungen dem unbedarften Zeichner vorschlagen.

Der Maler Lovis Corinth schrieb, dass „der Stamm des Baumes mit dem Rumpf des Menschen vergleichbar" sei, „die Äste und Blätter mit den Gliedern und den Haaren". Er ergänzte: „Die Verkürzung der einzelnen Gliedmaßen [er spricht vom Aktzeichnen] lehrt uns ebenfalls entgegenstehende Äste mit ihren Blätterpartien vor- und rückwärts strebend darstellen zu können. […] Hauptsächlich aber wird man durch das Studium des menschlichen Körpers darauf gestoßen werden, dass man nicht beliebige Stämme, Wege und Gegenstände, die dort vorhanden sind, schematisch darstellt, sondern den bestimmten Baum, den bestimmten Weg usw. porträtähnlich."[24]

Der Baum ist ein äußerst raumhaltiges Gebilde. Wind durchbläst ihn, Luft dringt ungehindert bis an die Mittelachse, den Stamm. Andererseits greift er in die Umgebung aus, seine Arme (Äste) strecken sich in sein luftiges Umfeld. Der Baum tut von Natur etwas, das als scheinbar neue Erkenntnis die Architektur im 20.Jahrhundert bestimmte: Außenraum und Innenraum verzahnen sich, Gehäuse und um-

82

gebende Landschaft gehen ungehindert ineinander über. Der Baum hat jedoch noch eine andere Eigenschaft, die auch die moderne Architektur bestimmen sollte. Seine Hauptmasse, die Krone, hebt sich vom Boden ab. Das mag an Le Corbusiers „Fünf Punkte zu einer neuen Architektur" erinnern, deren einer sich mit den Stützen des Hauses befasst: "[Die Stützen] steigen unmittelbar vom Boden auf, bis zu 3, 4, 6 usw. Meter und heben das Erdgeschoss empor. Die Räume werden dadurch der Erdfeuchtigkeit entzogen; sie haben Licht und Luft; das Bauterrain bleibt beim Garten, welcher infolgedessen unter dem Haus durchgeht. [...]"[25]

Nicht nur Mensch und Haus, sondern auch Haus und Baum sind eng miteinander verwoben. Dieser Trinität gehört unsere Aufmerksamkeit beim Entwerfen. Also tut der Architekt gut daran, immer wieder skizzierend Bäume zu studieren, des Baumes plastische Qualitäten zu untersuchen, zu versuchen, dessen Spiel von Licht und Schatten (Oberfläche und Tiefe), von flirrendem Blattwerk und stabilem Geäst wiederzugeben. Er hofft, nicht nur sein Repertoire an Raumsituationen zu erweitern, sondern auch seine Fähigkeit zu sensibilisieren, eine Gestalt in eine andere zu übersetzen. Der Architekt als Metamorphotiker.[26]

Wie geht man nun beim Zeichnen von Bäumen vor?

Wie beim Menschen werden zuerst die Längsachsen des Körpers, des Stamms und seiner sich verzweigenden Hauptarme gezeichnet. Dann folgt die Kontur der Krone, leicht mit zitterndem Strich und nur andeutungsweise wiedergegeben. Anschließend versucht man, in der Blattmasse einzelne Blattwolken zu erkennen, die die Krone schuppenartig gliedern, mit vielen Zwischenräumen, in deren Dunkel Zweige und entfernter liegende Blattwolken auftauchen. Nun kann man längs der gezeichneten Achsen Stamm und Ästen die rich-

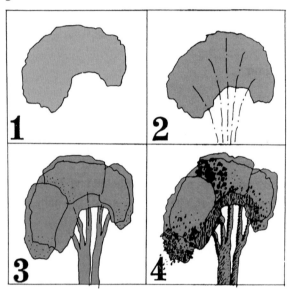

Was noch fehlt, sind Blätter und Rindenstruktur. Analog zu der Blattform des zu zeichnenden Baumes geben wir das Blattwerk als Schwarm von kleinen Kreisen oder Ellipsen oder Sternen oder Kurzschraffuren wieder. Die Blattzeichen müssen maßstabsgerecht klein sein und dürfen nicht kreuz und quer über das Papier fließen. Sie sollten wie ein Schwarm dem Einfluss eines imaginären Windstoßes folgen. Aus grafischen Gründen (die Verteilung von Hell und Dunkel auf dem Papier) ist es vernünftig, dort, wo Licht auffällt, kaum Blätter zu zeichnen, sondern nur dort, wo sie im Schatten liegen. Die Textur verdichtet sich und damit auch die

Plastizität.

Auch im Stamm, um durch allmähliche Verdich-
tung des Tonwerts Plastizität zu erreichen, wird nur
die Schattenseite strukturiert und zwar dem Säfte-
fluss im Inneren des Holzes folgend (vom Erdreich
bis in den Baumwipfel). Das gelingt am Besten mit
senkrechten Strichelschraffuren. Ist eine gewisse
Sicherheit erreicht, dann lässt sich das Verfahren
noch vereinfachen. Der Flüchtigkeit des Skizzierens
entspricht der vielfältige Wandel im Tages- oder Jah-
resverlauf. Wenn auch an den Standort gefesselt, ist
der Baum doch ein bewegtes Lebewesen.

Wie wir allerdings wissen, ist der Baum für den Ar-
chitekten nicht nur Zeichenobjekt, sondern sein Kör-
per liefert das vielleicht wichtigste Material für Haus
und Skulptur. In der Architekturausbildung sollte
die handwerkliche Auseinandersetzung mit die-
sem Werkstoff eine nicht zu unterschätzende Rolle
spielen. Da der Gestaltungsunterricht kontinuierlich
die grafischen durch dreidimensionale Übungen
ergänzt, sei hier ein Lehrbeispiel, Baum und Haus,
Skulptur und Architektur miteinander zu verbinden,
eingefügt.

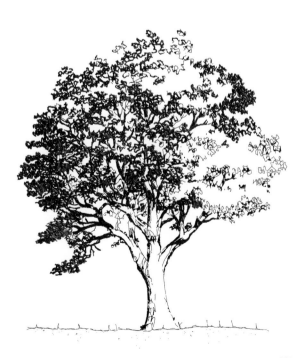

Themenübung: Skulpturenwald

Der Baum und sein Blätterdach waren vielleicht der erste Witterungsschutz für den nomadisierenden Urmenschen. Sich mit den Ursprüngen des Hauses (Baum und Höhle) auseinander zu setzen ist immer, also auch in diesem Falle eine vernünftige Vorbereitung auf den Architekturberuf. Darum folgt an dieser Stelle das Beispiel einer architektonischen Gestaltungsaufgabe zum Thema Baum: ,Ein Wald, der kein Wald ist'. Dieser Wald setzt sich aus skulpturalen Objekten zusammen, die naturgemäß von möglichst vielen Bearbeitern zu entwickeln sind.

Worum geht es? Um Einheitlichkeit in der Vielfalt zu erzeugen, erhält jeder Teilnehmer am Projekt ein Podest (90 cm hoch), das er kaum verändert als Grundlage für seine Arbeit verwenden soll. *Auf diesem Podest entwickelt er ein Gebilde, das skulpturalen und architektonischen Gesetzen folgt. Es ist zwar eine bildhauerische Arbeit, aber die Annäherung an Architektur ist durchaus erwünscht. Erwartet wird von jedem, dass er mit Phantasie und Intelligenz etwas entwickelt, das den Betrachter durchaus irritieren darf, da es weder mit Baumwuchs noch mit Hausbau sich erklären lässt, aber mit beidem zu tun hat.*

Es soll dem Bearbeiter frei gestellt sein, ob er eine geometrische oder organische Formensprache wählt. Das „Ding" soll zwar Modellcharakter haben (im Maßstab ungefähr 1:25, einschließlich Podest ca.1, 50 m hoch), aber irgendwelcher zukünftige Gebrauchswert darf ausgeschlossen werden.

Als Baumaterialien sind nicht zulässig: Papier, Styropor o. ä. und alles Pflanzliche oder schnell Verwitternde. Das hat den Grund, dass die derart verfertigte Skulptur irreparabel verletzlich und nur mit großem Aufwand zu transportieren wäre. Vor allem aber soll das Bildwerk spielerisch auf ein künftiges architektonisches Werk vorbereiten. Es braucht deswegen eine ausgeprägte Stabilität, Massivität und Materialität. Andere Werkstoffe sind erlaubt: Pappe, Holz, Kunststoff, Glas, Metall, Kabel, Draht, Schnur, allerdings Textilien und Folien nur bedingt (z.B. als Segel).

Wer Architektur studiert, sollte daran denken, dass seine Arbeit nicht nur unter gestalterischen, sondern auch unter konstruktiven Gesichtspunkten (Standfestigkeit, Haltbarkeit) beurteilt werden wird. Das heißt auch, dass eine sorgfältige, kreative Detaillierung der Fügungen, Verklammerungen, Ver-

schraubungen usw. erwünscht ist. Farben sollten sparsam verwendet werden und zwar so, dass sie einen erkennbaren Sinn ergeben. Oft sind Material-farben ausreichend.

Es ist ratsam, mit einem Konzeptmodell (deutlich kleiner, unmaßstäblich, unaufwendig) zu beginnen. Als endgültige Leistungen werden erwartet:
 – Der „Baum-der-kein-Baum-ist", fest verbun-den mit dem vorgegebenem Podest
 – Eine erläuternde Zeichnung oder Collage (ausstellungsfähig), DINA3 hoch.

Diese Aufgabenstellung ist ein Beispiel dafür, wie man mittels verblüffender Kombination von schein-bar Unvereinbarem Kreativität selbst aus vorgeblich Unkreativen hervorlocken kann. Keiner der Teilneh-menden kann sich auf Erfahrungen oder auf die vorhandene Wirklichkeit verlassen, sondern er ist gezwungen, sein Abstraktionsvermögen und seine Analysefähigkeit zur Anschauung zu bringen.

Baum, Haus und Mensch sind eine Dreiheit, gehö-ren zusammen. Deshalb ruft das Thema ‚Baum' bei den meisten, nicht nur bei Architekturstudierenden, Emotionen hervor. Ein schönes Beispiel gibt der Schriftsteller Paul Nizon: „Ich hätte die Bäume im-mer umarmen mögen, ich strich mit der Hand über die borkige Rinde, ich stellte mich ganz nah an ihre knorrige Stämmigkeit, ich wollte mir die ganze Ge-stalt mitsamt den im Boden verschwindenden Wur-zelsträngen zu eigen machen, es war mehr als An-lehnung. Und ich schaute in die Krone, das von Wind und Vögeln bewegte Blätterreich mit den hellen und dunklen Nestern und Nüstern. Während der Hund schnüffelte, staunte ich hinauf in das grüne All des Baumriesen."[27]

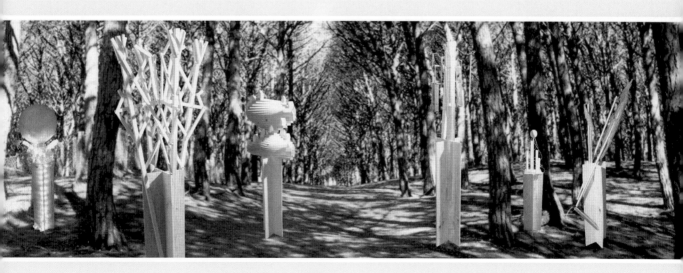

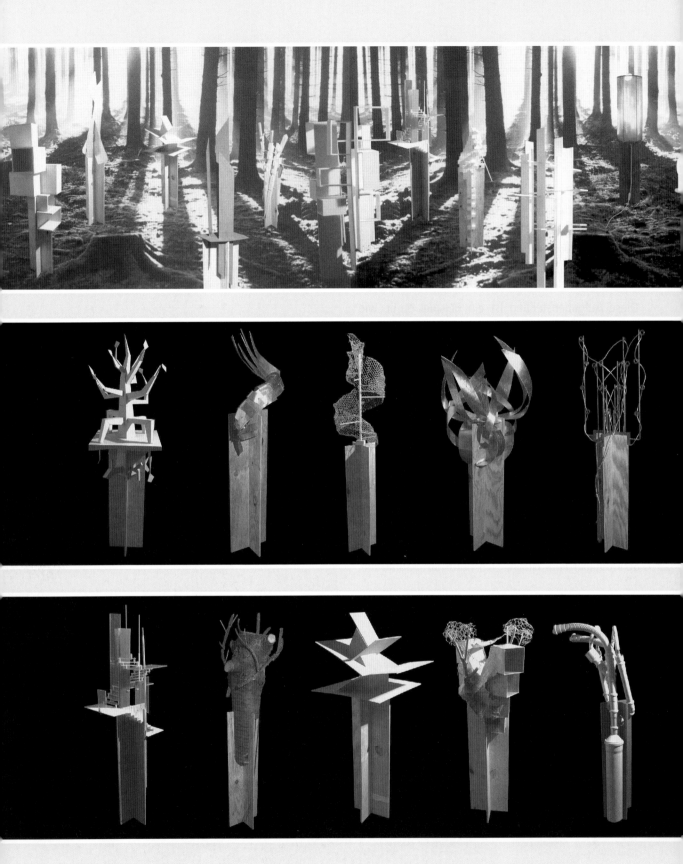

88

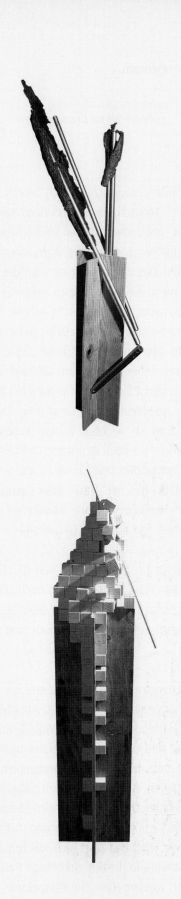
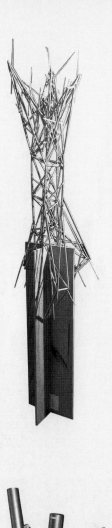

Häuser zeichnen

*Ich betrachte die Zeichnung als eine theoretische,
auf Architektur bezogene Unter suchung und
als Denkprozess.*
Alice Aycock

Einige Seiten zuvor schlich sich bereits die Vermutung ein: Mensch, Baum und Haus seien eng aneinander gebunden. Dieser Verflechtung gebührt sicher unsere eindringliche Aufmerksamkeit beim Entwerfen. Das Haus, die dritte Haut des Menschen, kündet nicht nur vom Können seiner Erbauer, sondern auch vom Geist seiner Bewohner. Den Genius Loci, also die Eigenart eines Ortes zu bestimmen, die (gebaute oder natürliche) Umgebung eines Grundstücks und seiner Atmosphäre aufzunehmen, gehört zu den ersten Pflichten des planenden Architekten. Deshalb ist Sehen lernen so wichtig. Deshalb sind Reiseskizzen so wichtig. Warum ergeben Bauten eine Einheit, die doch in unterschiedlichen Jahrhunderten entstanden sind? Liegt es am gleichen Baumaterial, an gleichen Trauf- oder Firsthöhen? Liegt es an der Homogenität ihrer Bewohner? Und warum stimmt mitunter auch das Gegenteil?

Prüfend vor Ort zu verweilen und der Sequenz der Blicke, dem Fluss der Gedanken nachzuhängen und sie in zeichenhafte Kürzel zu übersetzen, ist der Mühe wert. Stift und Skizzenbuch sind Denkapparate.

Wie aber wird ein Ortsbild skizziert? Falsch wäre es, nur orthogonale Grundrisse und Ansichten (wie es der entwerfende Architekt gewohnt ist) zu zeichnen. Das sind nur Werkstattzeichnungen, die kühl, sachlich und messbar den Handwerkern ihre Aufgaben stellen. Atmosphäre spielt dabei keine Rolle. Der Klang des Ortes, seine geheime Stimmung aber muss die Grundlage jedes neuen Architekturentwurfs sein. Und das lässt sich nur mit Bildern des Augenscheins, in die das zukünftige Haus hineingedacht ist, wiedergeben. Die Perspektive, am besten

90

die Übereckperspektive ist das rechte Mittel, um einem Bauherren und sich selbst Gestalt und Wirkung eines geplanten Projekts innerhalb seiner Umgebung vor Augen zu führen.

Darum zeichnen wir Architekten; darum führen wir ein Skizzenbuch. Wir lassen uns gerne von der Anmut eines mittelalterlichen Stadtkerns, vom Zauber eines alten Biergartens einnehmen. Hier haben wir kostenlos oder um den Preis eines Getränkes die Modellsituation, an der wir lernen, wie Anmut und Zauber auf dem Papier wiederzugeben sind. Am Computer erleben wir nur Überraschungen, wenn wir einen Fehler gemacht haben. Im Computer steckt ein Archiv trivialer Situationen. Vor Ort jedoch können wir Unbekanntes entdecken.

Ein Haus hat ein Gesicht; vor allem aber hat es einen Körper, dessen Volumen wir wiedergeben wollen. Da wir nicht das Ganze auf einen Blick übersehen können, müssen wir es von allen Seiten besichtigen und müssen uns die übersichtlichste Ansicht ausgucken. Das ist zumeist eine Übereecksituation. Wie ein Detektiv können wir von dort zwei Richtungen überwachen. *Zuerst gilt es, den Horizont deutlich von links nach rechts auf unserem Zeichenblatt zu fixieren. Zur Erinnerung: Der Horizont entspricht der Augenhöhe über dem Boden (Sitzen wir, stehen wir?). Je nachdem wandert die Horizontlinie auf und ab. Vielleicht liegt sie in Höhe einer Türklinke, vielleicht in Höhe eines Fensterriegels.*

Als Nächstes wird eine hervorspringende Übereck-Kante senkrecht dazu gespannt, auch diese am besten über das ganze Blatt. Dann werden die äußersten Kanten, also die Kontur des Hauses rechts und links, oben und unten gezeichnet. Mit dem schräg gehaltenen Stift, von sich weggestreckt, kann man eine markante horizontale Kante (die auf Grund der Perspektive steigt oder fällt) nachverfolgen und die Richtung der Linie in der Luft weiterziehen, bis sie auf den Horizont stößt. Der Kreuzpunkt ist

91

ein Fluchtpunkt (leider liegt er oft außerhalb des Blattes, aber doch beim Zeichnen annähernd erinnerbar). Senkrechten aber bleiben Senkrechten, Waagrechten hingegen verändern ihre Neigung und weisen auf die Fluchtpunkte (zur Perspektive s. a. S.72).

Sind also die Hauptkanten auf das Papier gesetzt, sind die Proportionen der eingeschlossenen Flächen (auch des Zwischenraums zur Nachbarschaft) noch einmal überprüft, kann es an die Untergliederung (Gesimse, Vorsprünge usw.) gehen. Details wie zum Beispiel Fenstersprossen folgen später, zum Schluss kommen die die Plastizität verstärkenden Schatten. Die Schattenschraffuren folgen der Richtung des Lichteinfalls, also meistens annähernd diagonal. Nicht erlauben sollte man sich das ‚Schummern', auch wenn es scheinbar schnell und mühelos eine Wirkung hervorbringt: Es erzeugt schmutzige, speckige und ungewollt verwischende Oberflächen. Nicht nur das: Dünne Linien verschwinden ungewollt unter dem Schmutz. Hilfslinien aber (Achsen und Verbindungslinien) sollten sichtbar bleiben. Sie bereichern nicht nur die Zeichnung, sondern erläutern dem Betrachter auch die gebauten Strukturen.

Warum zeichnen wir Häuser? Nicht nur aus Ehrfurcht vor bedeutenden Denkmälern der Baugeschichte, sondern auch weil wir Material für unsere eigenen Entwürfe brauchen, sozusagen ein Archiv der bemerkenswerten Eindrücke, ein Konvolut der gebauten Wunder. Das kann aber auch der Hasenstall oder die Schrebergartenhütte im Nachbargarten, das können auch Ruinen in einer Industriebrache sein. Überall sind vom Zufall herbeigeführte oder von Menschenhand versperrte Lücken und Öffnungen zu sehen, sind ungewohnte Fügungen, Oberflächen und Strukturen zu entdecken. Patiniertes Metall, zerfaserndes Holz, bröckelnder Putz, zersprungene Steine: All dies gibt Impulse für den Entwurf, Anregungen sich nicht nur mit dem naturgemäß beschränkten Angebot der Bauindustrie zufrieden zu geben.

92

Innovationen entstehen oft durch zuerst nur beiläufig, dann aber elektrisiert Wahrgenommenes. Kreative Gedankensprünge entstehen ebenso beim Zeichnen von landwirtschaftlichen Maschinen, von Elektrogeräten, von Motoren und Haushaltsgegenständen. Die frivole Metamorphose eines Gegenstandes in eine dingferne Gestalt zeichnet den phantasievollen Skizzierer aus.

Surreale Interpretation (assoziative Erweiterung)

Scheuklappen-Entfernen als Metapher für Klaren-Kopf-Behalten oder sich vom Druck-der-Konventionen-Befreien erlaubt es unter Umständen, sich in luftige Höhen des Denkens, in Spekulation und Phantastik zu erheben. Was so hoch sich aufschwingt, könnte aber auch sich verflüchtigen und bodenlos werden. Deshalb ist Zeichnen als Denkakt für den Architekten wichtig, wichtiger als das fühllose (wie mit fremder Hand) Zeichnen im Computer, denn nur so ist sein Tun mit subtilem, sensitivem Handwerk verknüpft. Anders als der freie Künstler darf der Architekt den Boden der anschaulichen Realität nicht verlassen, auch wenn er auf dem Kopf stehende Welten und fliegende Bauten abbildet. Das Unmögliche soll täuschend machbar aussehen, nur dann ist es „schön wie die unvermutete Begegnung einer Nähmaschine und eines Regenschirms auf einem Seziertisch"[28], wie der vielzitierte Satz des Poeten Lautréamont heißt.

Weder ungewohnte Materie, noch unstabile Oberflächen, noch andere als drei Dimensionen (vielleicht doch noch die Zeit als vierte Dimension) will der Architekturzeichner darstellen. Deshalb ist die Handzeichnung des Architekten unvermeidbar konservativ. Unbeeinflusst vom wechselnden Zeitgeist hat sie sich die gleichen Aufgaben und Inhalte bewahrt. Nicht die „Autonomie der Zeichnung", nicht das „Zeichnerische an sich", auch nicht die Abstraktion oder die „Zeichnung als selbstgenüg-

sames Ritual" spielen irgendeine der Rollen, die sie in der Künstlerzeichnung gewonnen haben.

Der Papierarchitekt aber, das heißt, derjenige, der wenig oder gar nicht baut, der zeichnet, um auszustellen oder zu publizieren, nähert sich dem freien Zeichner an. Er findet in der surrealen Weltsicht einen Weg: Überlagerungen unterschiedlicher Blickrichtungen, also Perspektivwechsel oder Verzerrungen in manieristische Dimensionen. Die Darstellung menschenleerer Plätze und Räume ergibt surreale Zustände, als seien die gezeichneten Ensembles nicht von dieser Welt. Ein Haus, das einem Tier gleicht, eine Skulptur, die begehbar ist, verblüfft und verunsichert den Besucher. Verunsicherung aber verändert das Bewusstsein: Wir sind nicht selbstverständlich auf der Welt.

Die Architektenperspektive versucht, räumlich und sinnlich ein Stück Welt wiederzugeben. Sie versucht, die dritte Dimension illusionistisch auf der Fläche einzufangen. Darum hat sie nur vorbereitende oder dienende Funktion: Grundriss, Schnitt und Aufriss haben Vorrang. Das heißt nicht, dass die Architekturzeichnung nicht mit künstlerischen Qualitäten aufwarten könnte. Längst ist sie zum Sammler- und Ausstellungsobjekt geworden. Der zeitgenössische Nachschub aber bleibt aus, denn die Lust am Freihandzeichnen verliert sich (und das ist äußerst bedauerlich) in Zeiten des Computerentwurfs.

Der Computer gibt uns scheinbaren Halt; er bietet eine überschaubare Übersicht über machbare Strukturen. Wie wir uns auch entscheiden: Es ist scheinbar richtig. Aber seine Zeichnung hat das Individuelle verloren. Zum Ausgleich folgt sie Designmoden und sucht das Auffällige. Sie ist wie von fremder Hand gezeichnet. Jeder Computererfahrene kann unbemerkt an ihr weiterzeichnen.

Jedoch überfällt uns nicht am Bildschirm eine falsche Selbstgewissheit? Die kreative Angst des Zeichners beim Zeichnen ist verdrängt: ‚Wo in der Leere des

94

weißen Blattes setze ich den Stift an, wohin wird er mich führen, wie holprig werden die Wege zum Ziel sein'? Wer kennt nicht das heimliche Stöhnen angesichts all der Möglichkeiten, all der zu treffenden kleinen Entscheidungen. Zeichnen ist Nerven aufreibend, von der anfänglichen Mutlosigkeit bis zum letztlichen Triumph.

Das Bedauerliche ist, dass wir am Bildschirm nicht zeichnen, sondern nur dem Computer Befehle geben: Zeichne diese Linie, zeichne diese Kurve, verschatte diese Fläche! – usw. Wir haben den Kontakt zur Bildfläche und zum realen Raum verloren. Wir müssen uns nicht quälen, wir verspüren keinen Widerstand (was oft erst zur befreienden Lösung führt); der Computer weiß schon alles und vollführt auf Tastendruck die tollsten Kapriolen.

Die Freihandzeichnung ist ein Stück tätiger Lebenszeit, die Computerzeichnung ist ein Akt fast passiven Beobachtens und Steuerns. Denn wenn die Fingerfertigkeit nicht mehr gefordert wird, wenn die immer gleichen Kombinationen auf der Tastatur ausreichen, dann versickert nicht nur das Subjektive, sondern dann verschwinden allmählich Charakter, Temperament und Emotion aus der bildlichen Darstellung, aber auch all die Nebenwege und Sackgassen, all die Radierspuren der Irrtümer, all die Zweifel, all das quälend Hilflose oder Unfertige, das unter Umständen den spezifischen Reiz einer Zeichnung ausmacht. Es ist wie im menschlichen Dasein: Runzeln und Narben kennzeichnen die Intensität und Tiefe eines unvergleichlichen Lebensweges.

Transparente Ebenen (Schichtungen)

Während wir zeichnen, vergeht Zeit. Der Ort verändert sich. Eben noch anwesende Personen verschwinden. Verkehrsmittel fahren durch das Sichtfeld. Wir müssen uns verrenken, um die wichtigen Dinge im Blick zu behalten, vielleicht müssen wir aufstehen und zu unserer Orientierung hinter eine Mauer schauen. Es überkommen uns Erinnerungen an woanders Gesehenes. Unsere Laune wandelt sich. All das können wir nebeneinander, nacheinander in verschiedenen Skizzen wiedergeben.

Wir können aber auch Bewegungen wie eine Mehrfachbelichtung, wie eine filmische Sequenz in die Szene einfügen. Wir können scheinbar Mauern niederreißen, um das Verborgene sichtbar zu machen. Wir können unterschiedliche Perspektiven zusammenschalten.

Wir können sogar verschiedenartige Positionen übereinander legen. Die eine Zeichnung scheint dann durch die andere – als seien zwei/drei Transparente übereinander gelegt. Die eine ist der Kommentar zur anderen – und umgekehrt. Sie finden zur gleichen Zeit statt. Das ist etwas anderes als ein Nacheinander. Die gezeichneten Lagen sind miteinander verklammert. Sie gehen eine untrennbare Symbiose ein und ergeben letztlich etwas Neues, Fabelhaftes. Wie mit Röntgenaugen gesehen: Was unsichtbar ist, wird sichtbar. Was es nicht gibt, in einer phantastischen Welt aber geben könnte, kommt auf diese Weise ans Tageslicht. Picabia und Polke, aber auch die Surrealisten haben dies Verfahren genutzt. Als Architekten wollen wir allerdings weniger dem Unbewussten ans Tageslicht verhelfen, als hingegen auf verborgene Qualitäten oder auch Schwachstellen eines Ambientes deuten.

Das Verfahren eignet sich für die Zeichnung. Mehrere Liniengerüste durchdringen sich und überdecken sich nur punktweise. Welche Zeichnung oben liegt,

ist nicht zu unterscheiden. Flächige Arbeiten sind eindeutig gestuft: Malerei ist dann der Untergrund für eine lineare Zeichnung, denn läge da die Zeichnung unten, wäre sie vom undurchsichtigen Gemälde bald zugedeckt.

Kunst der Reduktion (Linie und Kontur)

Die Natur verabscheut die Linie.
Zeigt mir doch etwas Gezeichnetes in der Natur.
Paul Cézanne

Das, was wir vor uns sehen, hat im Allgemeinen keine Kontur. Wir sehen Flächen oder Volumen (mehr oder weniger groß, dick, kurz oder lang), die ihre Ausmaße haben. Die Konturlinie, die eine Fläche umrandet, ist eine Abstraktion. Vier rechtwinklig aufeinander stoßende Linien auf dem Papier bleiben Linien. Es sind objektiv keine Grenzlinien des zu zeichnenden viereckigen Gegenstandes zu sehen, es sei denn, dessen Ränder waren eingeschwärzt. Jedoch bezeichnen oder umschreiben die Konturlinien die wahre Fläche (einer Wand zum Beispiel). Nur ist deren Materialität (Substanz, Struktur und Farbe) verschwunden und hat – wie einen Geisterhauch – den Abdruck von ein paar Randlinien hinterlassen.

Hören wir, was Jean Francois Lyotard, der französische Philosoph, über die Linie sagt: „[…] ich denke, dass die Linie etwas absolut Radikales und Ontologisches hat. Eine Linie ziehen auf einer Oberfläche, welcher auch immer, heißt, jenes Minimum an Sinn herstellen, von dem ich vorhin sprach. Hier haben wir es mit etwas sehr Ärmlichen […] zu tun. Ein schlichter Bleistiftstrich auf dem Papier ist eine Kunst, die karger, ärmer nicht sein kann, eine der ärmsten Formen von Kunst. Diese fast mystische Ärmlichkeit hat für mich zunächst etwas Ureigenes, Ursprüngliches."[29]

Wir zeichnen Konturen. Wir zeichnen Nähte, die nicht zu sehen sind. In Wirklichkeit hören die Dinge nur

Wie mit Röntgenaugen gesehen

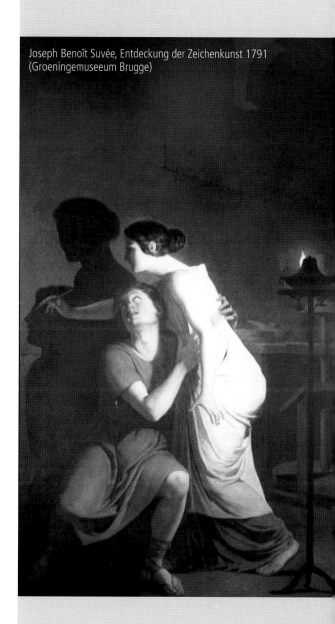

Joseph Benoît Suvée, Entdeckung der Zeichenkunst 1791 (Groeningemuseeum Brugge)

97

Die lineare Zeichnung gleicht einem transparentem Gespinst

auf und andere beginnen. Denn sie unterscheiden sich voneinander durch Form und Farbe. Sie stehen stereoskopisch vor dem verschwimmenden Hintergrund. Sie haben keine Konturen, sie sind lediglich begrenzt. Im Grunde sehen wir nur Oberflächen, die Substanz umschließen und die das Licht reflektieren. Wir sehen die Haut der Volumen, die vor oder neben einem Nachbargegenstand liegen, Volumen, die jedes eine bestimmte Färbung und bestimmte Ausmaße haben. Die Körpergrenzen aber, die wir als Konturen deuten, nehmen wir lediglich dadurch wahr, dass etwas endet (Material und Farbton) und dass etwas anderes (eine neue Fläche, eine neue Struktur) beginnt. Linien dazwischen gibt es nicht, nur Grenzen zwischen den Dingen, nur das Nebeneinander unterschiedlicher Flächen oder Körper.

Deshalb aber hat die Abbildung eines Objekts als lineare, konturierende Zeichnung etwas geisterhaft Abstraktes. Die Zeichnung ähnelt weniger der wahrgenommenen Materie als einem transparenten Gespinst. Sie ist nur Sinnbild für unsere Wahrnehmung der gegenständlichen Welt, wie die Schrift Sinnbild für die Sprache ist. Die lineare Zeichnung täuscht keine Wirklichkeit vor, sondern übersetzt sie in für jeden verständliche Zeichen. Sie dient der Kommunikation.

Es ist konventionelle Übereinkunft, dass wir das so gezeichnete Viereck innerhalb einer Architekturzeichnung nicht als dünnen Rahmen, sondern als flächige Gestalt lesen. Im Gegensatz zum Malen erfordert das Zeichnen bei dessen Produzenten wie beim Konsumenten die Fähigkeit zu abstrahieren. Die Zeichnung kann uns nicht über die Wirklichkeit täuschen: Sie ist etwas anderes. Das Gemälde kann uns wohl etwas vorspiegeln. Nicht umsonst gibt es da den Begriff des Trompe l'œil, also die abbildhafte Augentäuschung. Die lineare Zeichnung betrachten und bedenken wir distanziert, in das Gemälde versetzen wir uns hinein.

98

Das heißt aber nicht, dass wir mit der Linie nur sichtbare Enden, Ecken und Kanten wiedergeben. Sie kann unvollständig oder unterbrochen sein und im Verein mit anderen dennoch den Gegenstand vollständig darstellen, da unser Gehirn Unvollständiges korrigiert oder ergänzt. Die Wahrnehmungspsychologie hat das umfassend untersucht (Abb. rechts). Die Randlinie als Geisterhauch kann teilweise noch mehr verblassen. Auch hier gilt unter bestimmten Voraussetzungen Mies van der Rohes Wort: „Less is more."

Die Linie kann darüber hinaus präzis, zittrig, nervös geschwungen, an- und abschwellend, fett oder mager sein. Sie verrät damit des Zeichners Temperament und gibt seine augenblickliche Stimmung beim Zeichnen wieder. Sie ist ein Zeichen seiner Sensibilität und Empathie. Sie hat also mehr mit dem Zeichner als mit dem zu Zeichnenden zu tun. Unter Umständen versteht es der Zeichner kraft seiner Linienführung (Schwung oder Schwerfälligkeit), Anmutung und Atmosphäre einer Situation dem Betrachter zu vermitteln.

Die Zeichnung ist also das Ergebnis einer Analyse, eines Denkaktes, ist die Übertragung eines äußeren oder inneren Anblicks in eine Zeichensprache (gleich einem Text). Sie ist aber wie alle Kunst doppelsinnig: Sie gibt das Wesen des Zeichners und zugleich das des Gegenstandes wieder.

Kunst der räumlichen Vergewisserung (Schraffur, Lavierung)

Zeichnen ist dem Schreiben verwandt. Ich habe etwas gesehen, ich habe etwas gehört, ich habe etwas gefühlt, oder ich habe etwas gedacht, und ich will es anderen vermitteln. Insofern ist Zeichnen Information. Ich setze Zeichen, wie komplex diese auch sein mögen. Es verhält sich wie beim Schreiben. Ist der Sachverhalt notiert, so ist ihm vermeintlich Genüge getan. Aber wie die Textzeile, so ist auch

Unvollständiges wird vom Gehirn ergänzt

99

Wilhelm Busch, Klavierspieler

die Bildnotiz mitunter so flüchtig entstanden, dass nur der Verfasser und nicht der Betrachter sie lesen kann. Die Bedeutung des Hingeworfenen bleibt rätselhaft. Manchmal wünscht man sich dann die alte Tugend des ‚Schönschreibens', analog dazu die des ‚Schönzeichnens', obwohl dabei Spontanität und Temperament ins Hintertreffen geraten. Ein wenig Bedacht, ein wenig Sorgfalt, ein mittleres Maß zwischen Langsamkeit und Hast kann jedenfalls nichts schaden.

Wir sind so strukturiert, dass wir von unserer Umwelt drei Dimensionen wahrnehmen (die Zeit als vierte). Der Zeichner hat mit der zweidimensionalen Blattfläche zu tun, in die er nun mühsam auch die dritte hinein zu pressen versucht. Mit der vierten Dimension – der Darstellung von Bewegung – tut er sich noch schwerer, falls er nicht solch genialer Bilderfinder wie Wilhelm Busch ist (Abb.). An dieser Stelle wollen wir die vierte Dimension vernachlässigen. Sie kommt unter dem Stichwort Sequenz zur Sprache.

Wie ist nun aber die dritte Dimension auf die Fläche zu bannen? Die Möglichkeiten sind bekannt: Die augenfälligste Form der Wiedergabe ist die Perspektive. Dass sie jedoch nicht ohne weiteres begriffen wird, sehen wir in den (allerdings nur) scheinbar falschen Raumwiedergaben in Kinderzeichnungen, aber auch in Architekturdarstellungen des Mittelalters und noch der Frührenaissance. Es gibt eingeschliffene Konventionen der Sehweise, die unterhalb des Bewusstseins verankert sind. Der Zeichenlaie sieht, dass zwei parallele, schnurgerade Mauerkanten in der Ferne in einem Punkt zusammenlaufen, aber er zeichnet sie wahrheitsgemäß, jedoch widersinnig (weil er es scheinbar besser weiß) als Parallelen. Er sieht zwar, dass etwas in seiner Zeichnung verquer ist, aber er kann es sich nicht erklären. Er stellt dar, was er weiß und nicht, was er wahrnimmt. Wie ein Kind, das Gehen lernt, ist er unsicher im Ertasten des Raums.

100

Für den Laien einfacher zu lesen und wiederzugeben sind Darstellungen, die unmittelbar die greifbaren, sinnlichen Wahrnehmungen reflektieren (Oberflächen, Tonwerte und Materialstrukturen):

- Ein Raum beherbergt Gegenstände, die hinter einander stehen. Das angeschnittene Volumen liegt offensichtlich hinten, das anschneidende liegt vorn (Abb. 1).

- Eine Fläche ist dunkler als die andere. Die dunkle wird als im Hintergrund eines geschlossenen Raumes stehend begriffen. Eventuell ist sie von der Vorderfläche verschattet. In der Landschaftsdarstellung verschwinden dagegen die fernen Geländepartien im blassen Dunst und die dunkleren Partien liegen vorne. „Sfumato" (das Rauchige) nannten dies die italienischen Meister seit Leonardo da Vinci (Abb. 2 und 3).

- Eine Oberfläche ist deutlich strukturiert, in der anderen verlieren sich die Strukturen. Selbstverständlich wird die deutlicher strukturierte als die nähere angesehen (Abb. 4).

Diese Nah-Fern-Beziehungen in der Zeichnung wiederzugeben, erfordert ein gewisses Repertoire an Darstellungsmitteln. Die Freihandperspektive, die auf der konstruktiven Perspektive beruht, wurde hier schon behandelt (s. S. 79). Vorder-, Mittel- und Hintergrund, diese Dreiheit, mit der Zeichner und Maler seit der Renaissance Tiefenwirkung erzeugen, lässt sich mit Blässe und Verdunkelung erzeugen. Wir müssen aber deutlich unterscheiden, ob wir uns außen oder innen befinden: Die Landschaft wird in der Tiefe blasser, der umschlossene Raum meist dunkler.

Wie sind aber raumbildende Hell- und Dunkelwerte in der Zeichnung wiederzugeben, da diese doch im Gegensatz zum Gemälde als lineares Gebilde entsteht? *Ein wesentliches Darstellungsmittel ist hier die Schraffur. Sie wirkt flächig und bleibt dennoch ein Liniengespinst. Sie überlagert zwar das Detail,*

101

1

2

3

4

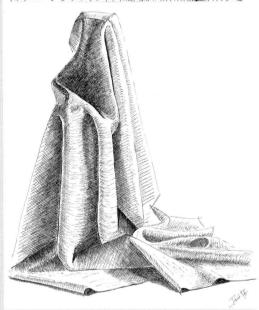

Kreative Ergänzung zweier Zeichnungsfragmente

aber verdeckt es nicht. Es sind annähernd paralle-le Striche gleicher Stärke, nicht zu eng gezeichnet, damit sie nicht miteinander verhaken (das ergibt unbeabsichtigte Knoten in der Fläche), aber auch nicht zu weit gezeichnet, damit nicht der Eindruck einer Verbretterung entsteht. Soll die Fläche dunkler werden, kreuzt man zwei Schraffurlagen. Darüber kann dann noch eine dritte, vierte, fünfte (usw.) fol-gen. Man achte aber darauf, dass mit jeder neuen Lage deutlich die Zeichenrichtung geändert wird. Andernfalls ergibt es hässliche, schleifende Über-lagerungen, die das monochrome Gleichmaß des Tonwerts stören. Soll die Schraffur einen Schatten wiedergeben, so ist sie in der Richtung des schräg einfallenden Sonnenlichts zu zeichnen.

Nachahmung bringt uns weiter. Bedeutende Zeichner und Maler haben in ihren Anfängen immer ihre Vor-gänger kopiert. Es ist äußerst hilfreich, sich Kunstbü-cher vorzunehmen und Abbildungen (meist genügen Ausschnitte, um die Verfahrensweisen der Meister zu begreifen) möglichst in der Technik des Vorbilds wiederzugeben. Eine sich als brauchbar erwiesene Übung, sowohl Professionalität als auch Kreativität zu steigern, ist, eine Abbildung am Kopiergerät zu kopieren, einen Streifen herauszuschneiden und die entstandene Lücke auf eigene Art, aber in der Technik des Vorbilds wieder zu füllen. Der gezeichnete Über-gang zwischen alt und neu darf dann möglichst we-nig bemerkbar sein. Zwei Radierungen[30] von Wendel

Dietterlin

Dietterlin (ca. 1550 – 1599) und Canaletto (eigentlich Giovanni Antonio Canal, Landschafts-, Architektur- und Vedutenmaler in Venedig, 1697 – 1768)) mögen als Beispiel dienen. Nebeneffekt einer solchen historischen Vorlage ist, dass sich vielleicht doch der eine oder andere auch mit den geschichtlichen Voraussetzungen unserer Zeit beschäftigt.

Eine weitere Möglichkeit, Dunkelwerte zu erzeugen, ist das Punktieren; es ist allerdings ein mühseliges Geschäft. Aber es kann damit gelingen, einen gleichmäßigen Verlauf vom Hellen ins Dunkle herzustellen. Auf jeden Fall sollte man als Anfänger das bereits erwähnte, so genannte ‚Schummern' (Reiben des flach gehaltenen Bleistifts über das Papier) vermeiden. Man kann es nicht oft genug wiederholen. Nichts wirkt hässlicher als die so erzeugten, teilweise speckigen Oberflächen.

Wer bereits das Aquarellieren (s. S. 128) beherrscht, hat ein einfaches und schnell zu erzeugendes Mittel, Dunkelheiten und Schattierungen einer linearen Zeichnung einzufügen: das so genannte Lavieren. *Man gibt sich blass die Konturen der einzufärbenden Flächen mit dem Bleistift vor, stellt im Wasserglas eine nicht zu geringe Menge Farbwasser her (viel Wasser, wenig Farbe, je nach Stift grau oder braun) und färbt mit nicht zu dünnem Pinsel die zu schattierenden Flächen. Mit einer zweiten Lage auf dem getrockneten Grund kann die Dunkelheit des*

Canaletto

Schattens noch verstärkt werden. Anders als das Schummern verbirgt Aquarellfarbe keine der unter ihr liegenden Linien. Trotz des eingefärbten Papiers bleibt die Zeichnung eine Zeichnung. (s. Abb. S.140 unten)

Es ist selbstverständlich: Was dem Auge nahe ist, ist deutlicher zu sehen als das ferner Liegende. Auch dies (den so genannten Texturgradienten, s. S. 35) können wir uns zur Tiefendarstellung in der Zeichnung nutzbar machen. Zum einen werden die Striche im Hintergrund dünner und blasser. Zum anderen verkleinern wir allmählich die Oberflächenstruktur, je weiter sie vom Auge entfernt ist, das heißt, die Strukturmotive und Texturen werden blasser, ungenauer, unschärfer und in Maßen und Form reduzierter.

Schraffuren allerdings sollte man nicht in der Tiefe verengen und in der Nähe weitmaschiger zeichnen. Der Abstand zwischen den einzelnen Strichen bleibt möglichst gleich. Um eine Fläche allmählich zu verdunkeln, hilft man sich, indem man neue Schraffurlagen (Kreuzschraffuren) hinzufügt.

Stillleben zeichnen

Stilllebengemälde waren immer ein Versuch, die Welt zwar umfassend, diese aber im Ausschnitt und aus der Nähe wiederzugeben. Nature morte (tote Natur), die französische Bezeichnung für das Stillleben, meint still stehende Zeit, meint getötete Natur, verweist auf den Stillstand des Lebens. Nicht grundlos ist der Totenkopf im Stillleben ein häufig auftauchendes Zeichen für das unvermeidliche Ende alles Lebendigen. Doch so ist es nicht ausschließlich: Nature Morte kann auch ‚unbewegliches Leben' bedeuten. Das sind dann Acker- und Gartenfrüchte, die sichtlich von krabbelnden Insekten angestochen und zur Fäulnis gebracht wurden. Der Künstler gibt sich auch als sorgloser Liebhaber des Stillstands, weil er nur so – ohne von der Flüchtigkeit der Zeit

abhängig zu sein – sich seiner malerischen Detailfreude hingeben kann. Das Stillleben erklärt stellvertretend das Umfassende im Ausschnitt, die weite Welt im Nahblick, den Ort und die Weise, wo und wie wir leben.

Im Stillleben werden die naturgegebenen, handgreiflich nahen Dinge präsentiert, die mitunter nur die Sinne kitzeln sollen, mitunter jedoch auch von versteckter Symbolik (Völlerei, Luxus, Vergänglichkeit) geprägt sind. Darunter fallen Jahreszeitenbilder, Mahlzeiten- und Delikatessenstillleben, aber auch gemalte Blumen- und Raucherarrangements. Im Grunde geht es um den ‚gedeckten Tisch‘ als Sinnbild für den fruchtbaren Erdboden, der uns ernährt. Immer jedoch muss dies Bildmotiv als erstarrtes Dasein gelesen werden. Die dargestellte Lebensfreude bekommt einen maroden Beigeschmack.

Die hohe Zeit dieses Bildmotivs in Europa war das 17. Jahrhundert, aber bis in unsere Tage ist es ein Genre, das nicht nur in der Malerei, sondern auch in der Bildhauerei eine Rolle spielt. Denken wir an Giorgio Morandis Flaschen- und Dosenbilder. Denken wir an Umberto Boccionis Skulptur „Entwicklung einer Flasche im Raum". Aber auch die „Fallenbilder" Daniel Spoerris oder manche andere zeitgenössische ‚Assemblage‘ lassen sich durchaus als Stillleben ansehen.

Warum aber ist es gerade für Architekturstudierende wichtig, sich mit dem Zeichnen oder Malen von Stillleben zu beschäftigen? Das Stillleben ist ein ausdrucksvolles Ensemble räumlicher Gebilde. Ging es den Malern ehemals um die möglichst naturgetreue Darstellung von Nahrungsmitteln, Geschirr, Gläsern, Blumen, Schnecken, Käfern usw., so schauen wir, wir Architekten, heute eher auf die räumliche Zuordnung oder die Geometrie der Gegenstände und ihre Oberflächenstrukturen.

Ein Stillleben kann auf uns wie die modellhafte Simulation einer dörflichen oder städtischen Umgebung

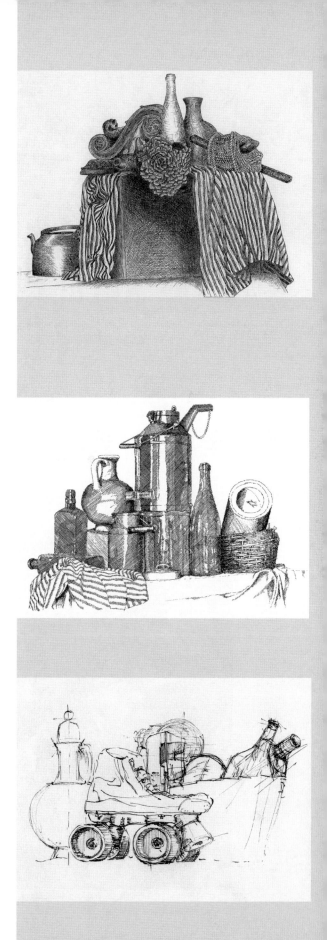

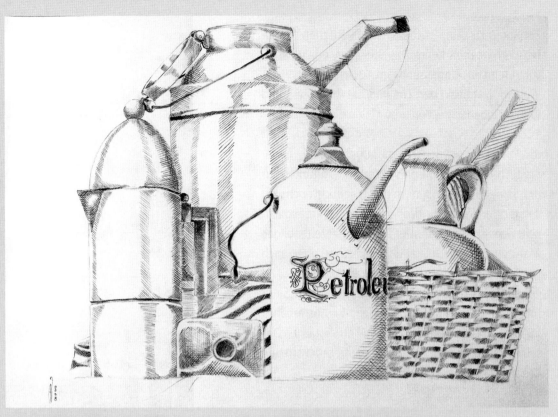

wirken. Zusammengestellt sind schlanke und üppige Volumen: Wir erfassen ihre Proportionen, ihre Ausbauchungen und Einschnürungen, ihr Nebeneinander und Voreinander, Überschneidungen und Durchdringungen. Stehen die Volumen richtig im Licht, das heißt, werden sie nur von einer Lichtquelle bestrahlt, dann werfen sie eindeutige Schatten. Schatten aber verstärken den räumlichen Effekt und klären Form und Lage der Objekte. Einiges ist transparent und lässt dahinter Stehendes durchscheinen: Glas, Netze, Flechtwerk. Einiges hat stumpfe Oberflächen, anderes hat Häute voller Glanz, voller Lichtreflexe und Spiegelungen. Oberflächen sind geknittert (Papier, Pappe), gefaltet (Textilien), geschliffen und glatt (Metall), körnig strukturiert (Stein) oder gemasert (Holz). Im Nebeneinander lassen sich so die Vielfalt und vor allem das Zusammenspiel der Oberflächenstrukturen erkunden, eine vorbereitende Übung für Studierende, um schon in der Planzeichnung die Außenhaut eines Bauwerks im Kontext der Umgebung festzulegen.

Doch nicht nur die Volumen sind wichtig, ebenso aufmerksam gilt es, die Zwischenräume zu studieren. Auch sie haben Proportionen, auch sie sind gestaltet. Es ist wie im wahren Leben. Der Architekt kümmert sich nicht nur um die Hausform, sondern auch um ihre Einbindung in die Nachbarschaft. Nicht die Einzelform (der singuläre Bau), sondern das Miteinander der Formen prägen das Stadtbild. Distanz und Verknüpfung, Enge und Weite. So sehen wir Architekten ein Stillleben als Simulation unserer Lebenswelt. Wir lesen das Stillleben als Folge von Baukörpern, als Haus, als kleine Stadt. Ebenso wie die Stadt unser ‚Zuhause' ist.

Deshalb ist es auch so wichtig, im Skizzenbuch nicht nur einzelne Gegenstände fest zu halten, sondern ihr Miteinander. Wir müssen begreifen, dass zwischen den nebeneinander gestellten Formen eine versteckte Spannung herrscht. Die Kunst des Zeichners liegt nun darin, dies „Elektrizitätsfeld" dem Betrachter zu ver-

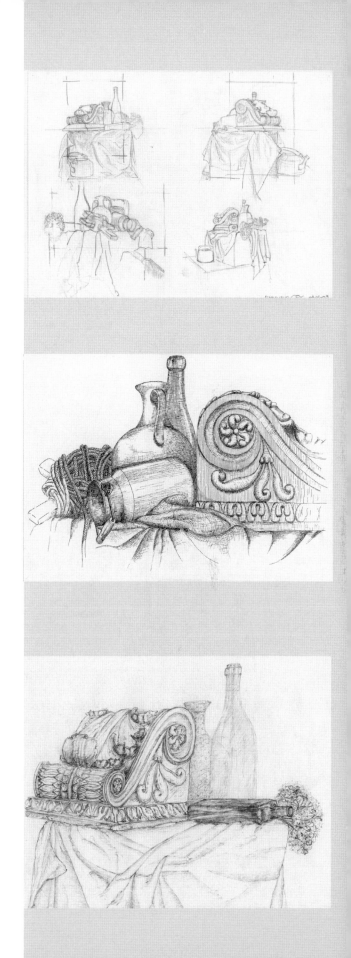

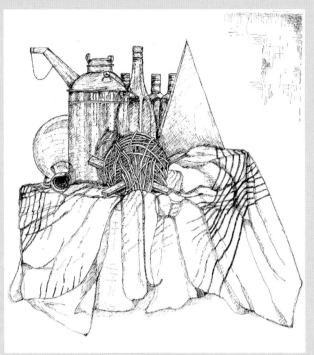

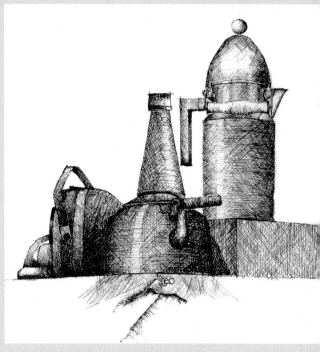

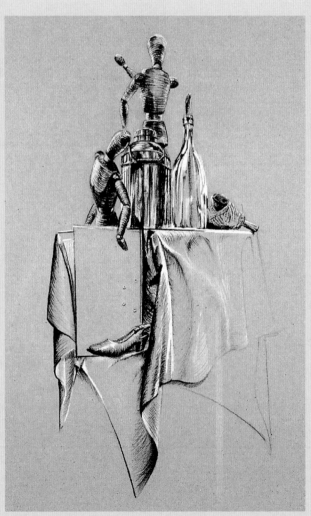

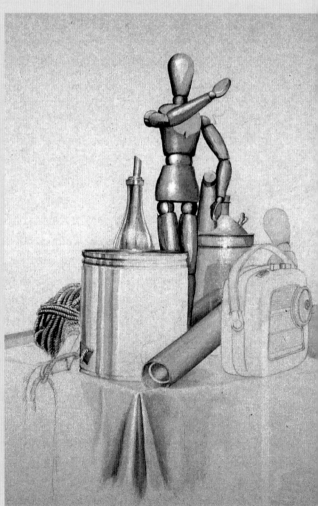

mitteln. Eine zeichnerische Übung wäre, auf die Volumen zu verzichten und nur die spannungsgeladenen Zwischenräume darzustellen. Doch wie zeichnet man Spannungen? Man zeichnet Wind und Rauch, Schattenflecken und Lichtbündel, all das vorüber Gehende und vorbei Huschende, das kaum Spuren hinterlässt, aber die Zwischenräume füllt.

Ein Stillleben ist so komplex, dass wir nur allmählich einen Überblick gewinnen. Wir umkreisen es so, wie wir auch Architektur nur im Gehen, in der Bewegung richtig erfahren können. Wir umkreisen es und halten es in vier oder fünf flüchtigen Skizzen fest. Nun haben wir einen Begriff von seinen Volumen, Leerräumen und Oberflächen. Jetzt können wir uns in das Ensemble hineindenken, uns im Geiste hineinknien und seine drei Dimensionen verständig in einer ausführlichen Zeichnung auf dem Papier festhalten.

Ausführlich zeichnen heißt aber nicht, dass wir in monotonem Fleiß jede Einzelheit stricheln. Wir beleuchten hingegen mit einem imaginären ‚Scheinwerfer‘ jene Partie, die uns fesselt, und lassen alles Weitere als ablenkendes Beiwerk im Dunst versinken. Jedoch das Beiwerk gehört zur Zeichnung, auch wenn es nur angedeutet wird. Die Kunst liegt in der Spannung zwischen Genauigkeit und beiläufigem Hinweis. Wollen wir beim Stilllebenzeichnen nicht vergessen, dass wir Architekten sind oder werden, dann suchen uns dabei allmählich Assoziationen an die Stadt heim, ihre Plätze, ihre Zwischenräume, ihre Höhen und Tiefen. Wir lernen beiläufig.

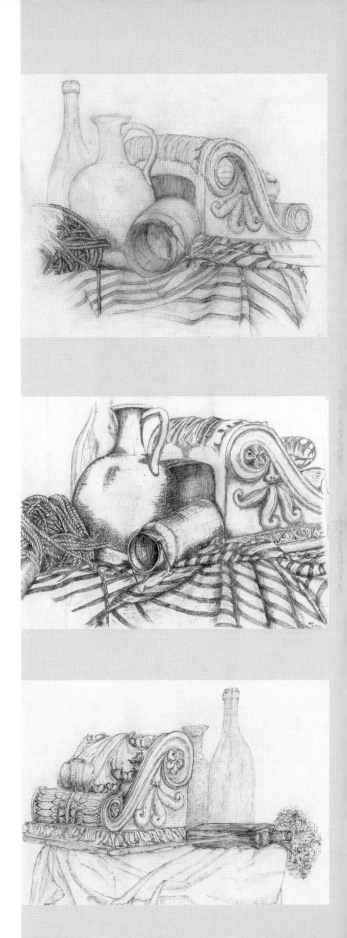

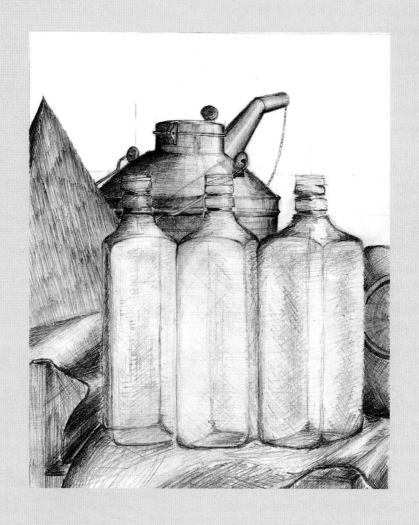

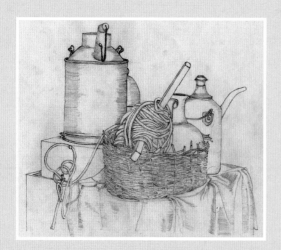

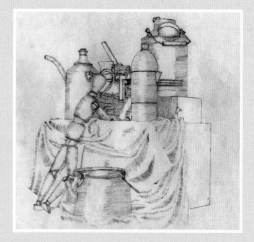

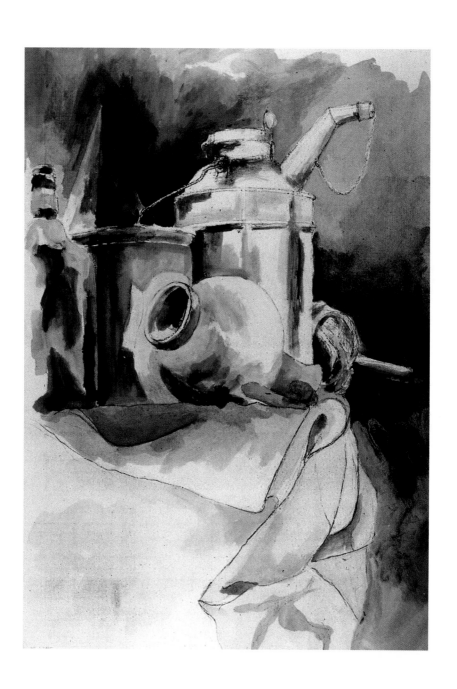

4 Malen

Avatare im Computerspiel „Second Life"

Avatar im first life

Realität und Abbild

Anders als auf die Zeichnung reagieren wir auf das Gemälde. Wir lassen uns verführen, das Bild für ein Abbild der Wirklichkeit, ja für die Wirklichkeit selbst zu halten. Aber der gemalte Hahn kräht nicht, das gemalte Lächeln bleibt starr. Nur in der Fiktion kann die Verzauberung wahr werden. Nur in Legenden erwachen Skulpturen (Pygmalion) oder aus Lehm geknetete Figuren (Golem) zum Leben. Nur in der Fiktion werden Gemälde lebendig, wie das Porträt in Oscar Wildes Erzählung „das Bildnis des Dorian Gray". Das Bild altert nach und nach zur Abbildung eines Greises, während der Portraitierte selbst für immer jung zu bleiben scheint.

Wildes Erzählung lässt sich auch als Symbolisierung der Bildersucht lesen, dem Phänomen, sich in jene Bildwelt hinein zu träumen, die realistisch genug ausgeführt ist, um einen Ausweg aus der allzu vertrauten eigenen Wirklichkeit vorzutäuschen. Wer sich vor der Bühne des Glamours sehnsüchtig niederlässt, wer sich in Computerspielen wie „Second Life" verliert, der verliert vielleicht auch die Fähigkeit, sich und seine Vergänglichkeit zu akzeptieren und damit seelisch zu reifen. In der Fachwelt hat sich für das Unvermögen, in Würde zu altern, der Begriff ‚Dorian-Gray-Syndrom' eingebürgert. Müssen wir womöglich der Neigung zur realistisch idyllischen Malerei nicht nur den Täuschungsversuch (Blick durch ein Fenster auf eine scheinbare Realität) unterstellen, sondern ihr sogar eine seelische Wachstumsstörung attestieren?

Tatsache ist jedenfalls, dass Kunst, je mehr sie sich von realistischer Wiedergabe entfernt, sich umso unzugänglicher erweist und desto mehr Einfühlung in ihre fremdartige Gedankenwelt benötigt. Der Vorgang der Betrachtung ist mühevoll. Wer ins Kunstwerk selig eintaucht und nicht die Wechselrede mit ihm sucht, der genießt zwar, wird aber letztlich, da es sich um vorgetäuschte Wirklichkeit handelt, auch

nur ein schales Gefühl des Einverständnisses emp-
finden. Ein Kunstwerk verlangt des Betrachters in-
nere Distanz, um es reflektieren zu können. Ohne
Reflex keine Wahrnehmung.

Distanz zum Gegenstand zu vermitteln ist eines der
Hauptprobleme, mit denen sich Maler bis heute he-
rumschlagen. Wie zeige ich, dass es ein Gemälde ist,
eine eigenständige Schöpfung, eine andere Wirk-
lichkeit, als die, die uns umgibt? Ein Ausweg ist, das
Material, Bildgrund und Farbmasse, mit dem ich ar-
beite, so zu zeigen, dass es nackt und ungeschminkt
dem prüfenden Auge entgegen tritt. Ein anderer
Ausweg ist, die Konstruktion meiner Schöpfung,
also Hilfslinien und Untermalungen, offen zu legen.
Ein dritter, meine mitunter mühselige Tätigkeit des
Malens, aber auch mein Temperament (also die Hef-
tigkeit des Farbauftrags und des Pinselstrichs) nicht
zu verheimlichen.

Ein Gemälde baut sich auf: Bildgrund (Papier, Pappe,
Holz, Leinwand, usw.), Grundierung (eventuell), Vor-
zeichnung (einschließlich aller Konstruktionslinien)
und eine oder mehrere Schichten der Ausführung.
All dies sind sichtbare Bestandteile des Kunstwerks,
prägen seine Eigenart und zugleich das Verständ-
nis des Betrachters. Der wissbegierig Schauende ist
neugierig, prüft und will mit Recht dahinter kom-
men, wie das Gemälde entstanden ist, warum es so
ist und nicht anders.

Er sieht, die Leinwand oder das Papier waren grob
oder fein. Er sieht, als Vorstufe wurde mit dünner
Farbe (monochrom) die Komposition angelegt: Parti-
enweise bleibt sie als Kontur sichtbar. Er sieht, zum
Teil sind die Farbschichten sorglos und heftig auf-
getragen, so dass sie wie ein zerrissenes Gewand
den Untergrund kaum verdecken. Er sieht, andere
Stellen sind mit Sorgfalt behandelt, gar mehrfach
geflickt (das heißt: übermalt), so dass ihr Schichten-
aufbau nur noch zu erahnen ist. Offenbarung und
Geheimnis ergänzen sich zu einem spannungsvollen

Ein Gemälde (hier Ausschnitt) baut sich auf:
Bildgrund, Grundierung, Vorzeichnung, mehrere
Ausführungsschichten

Der Malvorgang bleibt sichtbar (Ölbild, Ausschnitt)

Leonardo da Vinci, Die Hüllen des Gehirns, ca. 1500

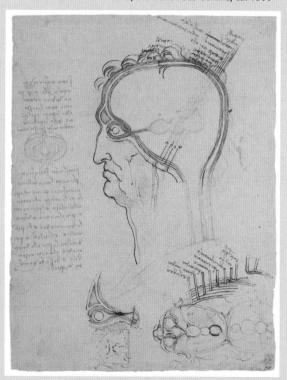

Geschehen. Die handwerkliche Substanz des Gemäldes, seine Materialität, Formgebung und Pinselführung ergeben ein jedermann zugängliches Protokoll des Malvorgangs und sind wesentliche Bestandteile des endgültig abgeschlossenen Werks. Wenn wir auf diese Dinge achten und nicht nur auf die „Erzählung" im Bilde – erst dann können wir vertraut werden mit Maler und Werk.

Skizzen und lineare Zeichnungen sind Konstruktionen; sie bringen uns den Aufbau der uns umgebenden Welt nahe. Die sinnlichen Erscheinungen innerhalb und außerhalb von uns (dieses pastose Gemenge aus Gefühlen und Wahrnehmungen unserer Sinnesorgane) reflektieren wir in Gemälden. Wie man vor sich im Raume mehr, das heißt, mehr Details sieht, sobald man sich in die Lage versetzt, ihn zeichnen oder malen zu wollen, so sieht auch der vor einem Kunstwerk Stehende mehr, wenn er sich einbildet, es kopieren zu wollen. Er vollzieht im Geiste den anstrengenden Prozess der Produktion nach. Es ist die Einfühlung, die uns die Dinge begreifen lässt.

Farbe

In unserem Sehorgan bildet sich ein optischer Eindruck, mittels dessen wir die durch Farbeindrücke repräsentierten Flächen in Licht, Halb- und Viertelton zu ordnen vermögen.
Paul Cézanne

Wir wissen mehr über uns als unsere Ahnen. Die Organe unseres Körpers sind erforscht. Wir wissen viel über die Funktion unserer Sinnesorgane. Wir können uns zum Beispiel den Vorgang des Sehens wissenschaftlich erklären. Platon genügten noch mythische Bilder, sprach noch vom inneren Feuer, das als Sehstrahl aus der Pupille unseres Auges dringt und sich mit dem Glanz des Tages, beziehungsweise mit dem von „Gegenständen ausgehenden äußeren Feuer"[31], vermischt und damit das Sehen möglich macht. Selbst im Mittelalter und noch bis in die Neuzeit hin-

ein war man wie in der Antike in Vorstellungen vom ‚strahlenden Auge' (ein Wort Goethes) befangen.

Erst im 19 Jahrhundert wurde die Natur des Lichts und die des Auges wissenschaftlich erforscht. Das Auge sendet nicht, es empfängt. Dennoch ist es notwendigerweise aktiv, denn über die Rezeptoren ‚Stäbchen und Zäpfchen' im Augeninneren schickt es Farbinformationen an das Gehirn und erzeugt dort unser Farbempfinden. Die Stäbchen reagieren auf Helligkeit und die Zäpfchen auf Farbschwingungen.

Aber unser Farbsehen wird auch subjektiv gesteuert und ist mit Emotionen verknüpft. Der Volksmund sagt es: Liebe macht nicht nur blind, sondern ist auch rot gefärbt. Gelb ist die Farbe des Neids, Grün ist die Hoffnung usw. Farben beeinflussen die Psyche. Farbintensität und Tonwerte sind abhängig von der Beleuchtung (die sich bekanntlich im Tagesverlauf immerfort ändert) und von den Farben der Umgebung. Es war vor allem der Bauhausmaler Josef Albers, der mit seinen Lehrwerk „Interaction of Color" seinen Studierenden deutlich machte, wie mangelhaft unser Sehapparat ist. Er griff auf die Experimente der Wahrnehmungspsychologie zurück und demonstrierte an Hand von Farbtäuschungen „die Relativität und Instabilität von Farbe". Grau auf gelber Fläche und das gleiche Grau auf blauer Fläche verfärben das Grau jeweils scheinbar zur komplementären Farbe (Violett und Orange) der Grundfläche hin. Albers sagt: „Die Erfahrung lehrt, dass es in der visuellen Wahrnehmung eine Diskrepanz zwischen physikalischem Faktum und psychischem Effekt gibt."[32]

Gerade wegen der Subjektivität unserer Wahrnehmungen brauchen wir Regeln. Wir halten uns deshalb an ein grundsätzliches Ordnungssystem der Farben und unterscheiden zwischen Lichtfarben und Oberflächenfarben. Lichtfarben leuchten von sich aus und Oberflächenfarben beruhen auf Reflektion. Das heißt: Oberflächenfarbe ist vom Material (Stein, Teer, Blut usw.) oder von einem Farbanstrich

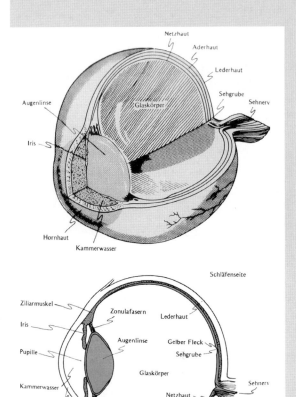

Menschlicher Augapfel

ROSE SYNOPTIQUE

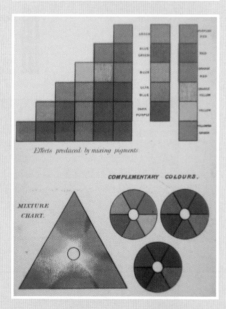

Effects produced by mixing pigments

COMPLEMENTARY COLOURS.

MIXTURE
CHART.

Farbsysteme
(von oben: Boutet 1708, Lacouture 1890, Rood 1879)

abhängig. Die Oberflächen absorbieren einen Teil des Lichtfarbenspektrums und reflektieren nur den restlichen Teil des Spektrums. Wenn alles absorbiert wird, sehen wir schwarz, wenn alles reflektiert wird, sehen wir weiß.

Beim Malen ist mehr das Wissen um die Oberflächenfarben wichtig. Hier unterscheiden wir zwischen Grundfarben (Rot, Blau, Gelb) und deren Komplementärfarben (Grün, Orange, Violett)[33]. Diese Farben, zusammen mit den Nichtfarben Schwarz und Weiß, reichen im Grunde aus, um beim Malen die gesamte Palette der Zwischentöne zu mischen. Jeder, der diese Palette nach Gefühl linear anordnet, wird feststellen, dass der Anfangsfarbton und der Endfarbton im Wert einander sich annähern. Dies war der Anlass, die Farben kreisförmig oder im Sechseck anzuordnen, was letztlich erlaubt, sich gegenüber liegende Farben als komplementäre zu erkennen.

Der Bauhauslehrer Johannes Itten verlangte von seinen Studierenden, einen zwölfteiligen Farbkreis aus gemischten Malfarben anzufertigen. So ließen sich, meinte er, die Beziehungen der Farben zueinander, ihre Nähe und Distanz, Harmonie und Kontrast, am besten ermitteln. Sein Hintergedanke war sicher auch, dass das mit den Händen Produzierte besser im Gedächtnis bleibt als nur im Kopf Ausgemaltes. Ittens Bauhauskollege Laszlo Moholy-Nagy formulierte dies so: „das erlebnis eines kunstwerks kann niemals durch schilderung zum besitz werden. Beschreibungen und analysen sind bestenfalls cerebrale wegbereiter und sie können […] mut zu dem versuch geben, es durch eigene auseinandersetzung […] zu erobern."[34]

Aus den Grundfarben entfalten sich demnach alle Zwischentöne. Nur um unserer Bequemlichkeit willen sind den Farbkästen zusätzliche Farben beigegeben. Farbkasten meint in unserem Falle Aquarellkasten und nichts anderes aus der Fülle der Malmaterialien,

118

Auf Reisen (hier: Siphnos) nicht nur flüchtig,
sondern auch mal bedächtig aquarellieren

Aquarellieren, die angemessene Malweise des Architekten

weil für uns Architekten das Aquarellieren eine leicht handhabbare (wenn auch technisch nicht zu unterschätzende) Technik ist. Wie immer gilt auch hier, man lernt viel, wenn man sich gute Vorbilder sucht. Man fühlt sich in die Arbeitsweise von geschätzten Lehrmeistern ein.

Dies war nun ein äußerst eingeschränkter Versuch, auf die Grundlagen der Farblehre zu verweisen, lediglich für den Hausgebrauch des Architekten bestimmt. Wer mehr über die Theorie der Farbe wissen will, konsultiere zum Beispiel die Bücher von Harald Küppers (s. Literaturverzeichnis).

Aquarellieren

Sich einfühlen heißt in der Kunstbetrachtung, angesichts eines Gemäldes die Augen weit zu öffnen, über das Gesehene zu sinnieren und sich den emotionalen Einflüssen nicht zu verweigern. Man identifiziert sich und nähert sich unterdessen den Geheimnissen der künstlerischen Produktion an. Bildbetrachtung ist ein Lernprozess. Jedoch gilt es auch da, Maß zu halten und das konzeptionell Brauchbare herauszufiltern. Es belastet und verwirrt, von allzu Vielem allzu viel in sich hineinzustopfen. Denn wir brauchen (als Architekten) zwar auch Anleitung, Kunstwerke zu genießen, aber vor allem die Fähigkeit, von ihnen zu profitieren – so oberflächlich das auch klingen mag.

Der künstlerisch Tätige betrachtet Kunst, um das für ihn Naheliegende zu lernen Der Architekt muss deshalb nicht alles über das Malen wissen. Malen ist für ihn zumeist eine Nebentätigkeit und gilt der Präsentation seiner Projekte oder den meditativen Ruhepausen auf Reisen. Selten wird er im Beruf die Acryl- oder Ölmalerei betreiben.

Das Aquarellieren aber scheint für ihn die angemessene Darstellungsweise für das zu sein, was er denkt oder sieht. Angemessen deshalb, weil das Arbeits-

120

material leicht und unbeschwert zu transportieren ist: ein Aquarellkasten im Postkartenformat, ein dazu gehöriger Pinsel in der Größe 10 oder mehr (auf Farbkastenlänge gekürzt), ein Aquarellblock im Maß DINA5 oder größer (mit matter Papieroberfläche, ca. 250 g/m²), ein kleines, verschließbares Wassergefäß (z. B. ein leeres Medikamentendöschen o. ä.).

Aquarellkästen haben ihren Preis. Dennoch empfiehlt es sich, sich für den heimatlichen Arbeitstisch noch einen größeren Kasten (ungefähr doppelte Länge zum vorher erwähnten) zuzulegen. Es gibt Leerkästen und Einzelfarben zu kaufen. Man braucht also nicht unbedingt die 24 Farben, wie sie in den Standardkästen angeboten werden. Die Grundfarben Rot, Blau, Gelb und Schwarz und dazu zwei/drei Brauntöne und vielleicht zwei Grüns genügen. Jeder wird im Laufe der Zeit die ihm genehme Farbzusammenstellung finden.

Bevor wir uns mit dem Malvorgang beschäftigen, sollen noch einige technische Grundfragen geklärt werden:

 – Die Blätter jeden Aquarellblocks sind rings-
 um verleimt, bis auf eine kleine, fingerbreite
 Stelle. Dort setzt man ein Messer oder einen
 Brieföffner an, um nach Fertigstellung (!) und
 Trocknung des Bildes durch vorsichtiges
 Längsziehen des Messers das Blatt zu lösen.
 Nie sollte man zuvor das zu bearbeitende
 Blatt aus dem Block entfernen: Denn wird es
 befeuchtet, so wellt es sich und kann nicht
 mehr gleichmäßig bemalt werden. Die ver-
 leimten Blockränder aber reduzieren diesen
 Wellvorgang.
 – Aquarellpinsel sind nicht billig und sollten
 deshalb sorgfältig behandelt werden. Auch
 mit dem dicksten Aquarellpinsel kann man
 haarfeine Linien ziehen, wenn dieser immer
 vorsichtig über das Blatt geführt oder ebenso
 vorsichtig in Wasser und Farbe getaucht und
 niemals (!) gestaucht wird. Haben wir nicht

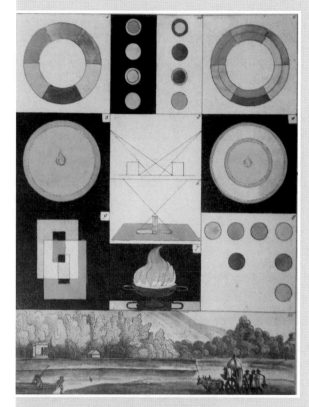

Erläuterungstafel zu Goethes Farbenlehre 1810

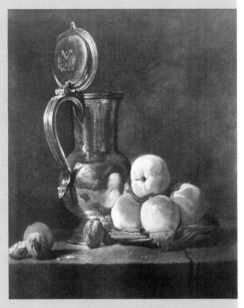

Jean B. Siméon Chardin (1699 – 1779) Stilleben mit Zinnkrug

Kompositionsanalysen

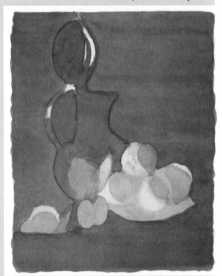

einen billigen (immer unbefriedigenden) Schulmalpinsel gekauft, sondern einen teureren, professionellen Aquarellpinsel, so kann er bei sorgsamer Behandlung Jahrzehnte seinen Dienst tun. Ist er nicht im Dienst, so werden seine Haare behutsam mit dem mitgelieferten Kunststoffröhrchen geschützt. Eine Alternative ist, die Spitze mit einem Läppchen zu umwickeln.

Gefühle und Stimmungen wiedergeben: Das ist für viele der Anlass, tief in die Farbkiste zu greifen und überschwänglich alle gesehenen Farbnuancen zu übertreiben. Deshalb ist die so genannte Nass-in-nass-Malerei so beliebt. Wie von selbst entstehen rauschhafte Übergänge vom Blau ins Gelb ins Rot. Hemmungslos schwelgt man in sentimentalen Sonnenuntergängen oder Nebellandschaften.

Der Architekt sollte das etwas gelassener und sachlicher sehen. Für ihn haben Farben weniger einen Gefühls- als Informationswert. Farben verdeutlichen den vor ihm liegenden Raum, das Relief geschichteter Oberflächen und die Dreidimensionalität von Haus und Landschaft. Ihm geht es nicht um die Vielfalt der Farbpalette oder um aparte Farbkontraste, sondern es geht ihm um Farbtönungen, um Helligkeiten und Verdunkelungen, mit denen er Licht und Schatten und die sich in mehreren Schichten aufbauenden Volumen im Raum darstellen kann. Es liegt ihm daran, die Vielfarbigkeit des Vorhandenen zu reduzieren, so dass er das ihm Wichtige wie selbstverständlich hervorheben kann.

Wie schon unter dem Stichwort Schraffur vorgeschlagen, ist es auch beim Malen hilfreich, sich in ein vorhandenes Kunstwerk und seine Komposition einzufühlen, indem man seine vordergründigen Eigenheiten skizzierend nachahmt (wie hier abgebildet ein Stillleben des 18. Jahrhunderts). Es ist ein Ölgemälde, dessen Komposition (Senkrecht- und Waagrechtachse, Diagonale, kontrastbedingtes Gleichgewicht)

sofort zu überschauen ist. Die Bildgegenstände sind auch für den Anfänger in ihrer Grundform und ihrer Zuordnung als geometrisches Formenensemble einprägsam darzustellen.

Ein Bild wie dieses kann die Einsicht in Kompositionsprobleme wecken. Aber nicht nur das: Seine melancholisch getrübte Atmosphäre ist eine hervorragende Basis für erste monochrome und mehrfarbige Versuche zur Farbgestaltung. Man hat etwas vor Augen, man analysiert in Gedanken, man reduziert Form und Farbe und fühlt sich dank des Vorläufers nicht allzu allein vor dem weißen Blatt.

Beispiel für strategisches Malen:
Die hellen Säulenquerschnitte wurden vom Beginn an ausgespart

Schichtenmalerei

Was gibt Aquarellmalerei ihr Heiteres,
Leichtes, den Tag als der weiße,
durch die übergezogenen Farben
durchscheinende Papiergrund.

Goethe, Schriften zur Kunst

Der malende Architekt befasst sich mit Architektur, vor Augen liegende oder erdachte. Er will Kanten und Bögen, Öffnungen und Mauervorsprünge wiedergeben. Seine Pinselflecken und Striche auf dem Papier sollen nicht miteinander verlaufen, sondern sollen präzis sein. Die verschwommene Nass-in-nass-Malerei ist deshalb für ihn kaum geeignet. Hingegen bevorzugt er die so genannte Schichtenmalerei.

Das bedeutet: Es werden dünne Farbschichten flächig aufgetragen, die, wenn sie dunkler oder leuchtender erscheinen sollen, teilweise mit einer zweiten (oder dritten und vierten und mehr) übermalt werden. Allmählich färbt sich das Blatt. Ein Vorhang nach dem anderen fällt und verdeckt das makellose Weiß. Farbige Flächen schichten sich nach und nach übereinander. Ein Verfahren, analog der Stereometrie der Bauten. Ein Verfahren, das zugleich die innere Ausgeglichenheit fördert, aber auch erfordert.

Das Verfahren ist Schritt für Schritt zu lernen, denn es kommt anfangs darauf an, monochrome Oberflä-

123

chen malen zu können. *Es beginnt damit, dass ein Aquarellblatt mit einer gleichmäßigen Farbschicht bedeckt wird. Dazu mischen wir uns genügend Farbwasser in der Konsistenz von kräftigem Kaffee. Man könnte tatsächlich mit Kaffee oder Tee zu malen beginnen, zumal die Farbe Braun für diese erste Übung sehr geeignet ist. Zu mittlerem Grau verdünntes Schwarz ist ebenso brauchbar. Nicht geeignet dagegen ist Gelb, weil es auf Grund seiner Helligkeit keine Fehlstellen erkennen lässt, wir also nicht feststellen können, ob wir die Technik beherrschen. Auch andere Farben, die in nachfolgenden Schichten hinzugefügt werden, werden immer (und seien es noch so geringe Mengen) in dünnem Farbwasser angemischt. Intensität der Farbe entsteht stets durch mehrmaliges Auftragen der Farbtöne.*

Um sich diese Technik anzueignen, beginnen wir nur nun mit einer monochromen Fläche. Erst wenn wir das beherrschen, können wir uns an Hand einer blassen Bleistiftvorzeichnung an kompliziertere Aufgaben wagen. Ist also das Farbwasser bereitet, das Zögern angesichts des makellos weißen Blattes überwunden, kann mit der Arbeit begonnen werden. Nun muss der Aquarellblock an einer Kante so unterstützt werden (Federmäppchen o. ä.), dass er im Winkel von ungefähr 15 Grad gegenüber der Tischfläche schräg zu liegen kommt. Der Grund ist, dass die aufgetragene Farbe allmählich von oben nach unten sickern soll. Wir malen in waagrechten Zeilen vom oberen bis zum unteren Flächenrand, fast so wie wir schreiben würden.

Der Pinsel, der keinesfalls zu dünn sein darf (mindestens Größe 10, besser größer), wird tropfnass von links nach rechts über das Papier geführt. Durch häufiges Eintauchen in das Farbwasser wird er ständig nass gehalten. Wichtig ist, dass sich am unteren Rand der Zeile eine etwas erhabene Tropfkante bildet. Ist die erste Zeile geschrieben, wird zügig die zweite in Gegenrichtung so gemalt, dass

124

sie die vorhandene Tropfkante mitnimmt, also übermalt. Das geht weiter so, Zeile für Zeile, hin und her, bis der untere Flächenrand erreicht ist. Die letzte Tropfkante wird vorsichtig mit dem nur noch feuchten Pinsel weggenommen.

Niemals darf die Farbe während des Malvorgangs antrocknen. Deshalb darf man sich durch keinen Telefonruf, keinen Ruf zum Mittagessen stören lassen. Weil durch die Schrägstellung des Blocks das Farbwasser unmerklich von oben nach unten sickert (solange die Fläche feucht ist), kann zum Schluss ein gleichförmig blassfarbener Malgrund entstehen. Fehlversuche sind anfangs nicht auszuschließen, aber letztlich muss es klappen. Damit ist eine wesentliche Grundlage der Schichtenmalerei gewonnen.

Ist diese erste Farbschicht getrocknet, kann mit der zweiten, deren Fläche etwas kleiner als die erste ist, begonnen werden. Danach mit allen anderen, jeweils etwas geringer im Umfang. Jede Lage muss getrocknet sein, bis weiter gemalt wird, es sei denn (und hier greifen wir bereits in der Erklärung vor), eine Schicht berührt nicht die zuvor gemalte und kann deshalb nicht verlaufen. Durch Flächenreduzierung entsteht zum Schluss eine stufenweise farbintensive Schichtung.

Wer die einfarbige, undifferenzierte Farbfläche beherrscht, kann sich dann dem Komplizierteren zuwenden. Je nach Bildgegenstand verkleinern sich die überlagernden Schichten. Je nach Motiv (Außenraum, Innenraum) verdunkelt sich das Aquarell zum Hintergrund hin oder im Vordergrund. Das Übereinanderlegen der Farben dient auch ihrer transluzenten Mischung. Da die Farben stark verdünnt sind, scheint die jeweils darunter liegende Farbe (auch die Bleistiftvorzeichnung) durch die obere hindurch. Es entstehen irisierende Mischungseffekte, die im Farbkasten gemischt, niemals erreicht werden könnten.

Schichtenmalerei 1

Schichtenmalerei 2

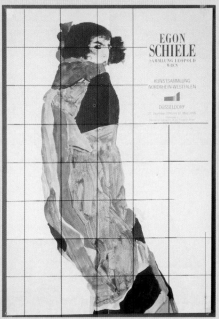

Deshalb ist eine brauchbare *Anfangsübung, sich mit dünnen Bleistiftstrichen ein Schachbrett aufzuzeichnen, die gesamte Fläche blass grau oder braun einzufärben (die so genannte Untermalung), dann nach subjektiven Gestaltungsvorlieben einzelne Quadrate mit einer zweiten Grau- oder Braunschicht zu verdunkeln und nun in einem dritten Schritt – auch wieder verdünnt – eine Komposition unterschiedlichster Farben über die einzelnen (vorher getrockneten) Quadrate zu legen.* So entsteht ein farbharmonisches Blatt, dessen scheinbar wie von selbst entstandene Qualität den Einzelnen überraschen mag. Mehr oder weniger verblüfft nimmt er wahr, dass die durchscheinende Grau- oder Braunschicht allen Farbflächen einen gleichermaßen zusammenbindenden Tonwert gibt.

Wir lernen am meisten von den Meistern, indem wir sie nicht nur kopieren, sondern einfühlsam die Machart ihrer Werke zu ergründen versuchen. Eine Konzentration erfordernde Übung ist daher, eine Gemäldereproduktion (als Beispiel abgebildet ein Frauenbildnis des 1918 im Alter von 28 Jahren verstorbenen Egon Schiele) zu rastern, das Raster auf ein Aquarellpapier zu übertragen und dann die vorherrschende Farbe jedes einzelnen Rasterquadrats der Vorlage zu bestimmen und im Aquarellraster wiederzugeben. Auch hier ist eine blasse Untermalung der Farbkomposition dienlich. Das geht nicht ohne nachzudenken: Das Muster muss komprimiert und sowohl dem Vorbild als auch unserer Stimmungslage Genüge tun. Wer sich unabhängig genug fühlt, kann dann dazu übergehen, eine Vorlage nur ansatzweise, nur in ihren Formen zu übernehmen und daraus ein eigenständiges Farbmotiv zu komponieren (noch einmal das Bildnis von Egon Schiele).

Das Verfahren der Schichtenmalerei ist ein betuliches, zahlt sich aber aus, da sich nur so präzise Kanten und eindeutig klare Flächen malen lassen. Schicht auf Schicht, nach und nach verdunkelt sich partienweise das Aquarell, wird farbiger und inten-

siver, als sei es ein Polaroidfoto, das, frisch aus der Kamera herausgepresst, seine Farbkraft nach und nach entwickelt.

Diese Technik des Aquarellierens ähnelt dem Zeichnen: Nur die Stellen, die hervorgehoben werden sollen, werden durch mehrfaches Übermalen intensiviert. Andere Teilstücke bleiben blass oder im Ungefähren. Die bleichen Stellen bilden den Hintergrund und die intensiver geschichteten Partien geraten in den Vordergrund. So interpretiert der Aquarellmaler den Raum. So entwickelt er, vom Bildgegenstand abhängig und zugleich unabhängig, eine eigenständige Komposition.

Es muss wohl nicht weiter erläutert werden, dass zum gegenständlichen Bildmotiv (besonders bei Architekturveduten) eine Bleistiftvorzeichnung gehört, die auf jeden Fall zart und keinesfalls ins Papier grabend sein sollte. Denn in Linienrillen sammelt sich unweigerlich Farbe, trocknet verdunkelnd ein und erzeugt auf diese Weise ungewollte Konturen.

Die Farbe Weiß benötigen wir nicht im Farbkasten, denn sie erhalten wir dadurch, dass wir in allen Schichten die Grundfarbe des Papiers aussparen. Das bedeutet, dass wir strategisch vorgehen müssen. Von Anfang an muss klar sein, wo es weiße, wo es blass gefärbte und wo es dunkle Flecken gibt. Der Aquarellmaler malt vom Hellen zum Dunklen, im Gegensatz zum Ölmaler, der mit den dunklen Farben beginnt und erst zum Schluss die weißen Spitzlichter setzt.

„Und im Übrigen [...] ich fange immer mit dem Himmel an", sagt Werner Tübke, der bedeutende, zeitgenössische Maler und Aquarellist im Interview. Er fährt fort: „denn hat man mit Empfindsamkeit, Fleiß und Geduld die Himmelsarbeit abgeleistet, ist das häufig schon die halbe Miete. [...] Genügend Farbe sollte übrigens immer vorgemischt sein, auch [empfiehlt] sich das Schräghalten des Aquarell-

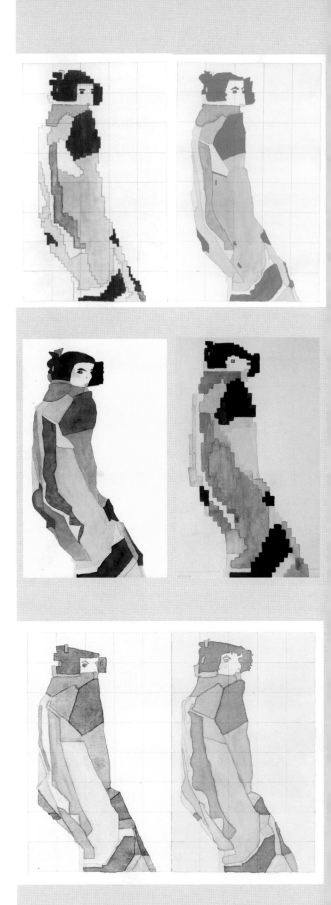

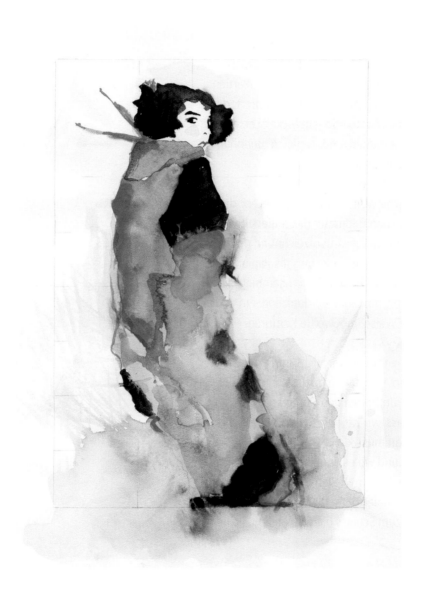

blockes; denn trotz aller Sorgfalt: je rascher die Arbeit vorankommt, desto besser. Am Rationellsten ist es, die ganze Angelegenheit in zwei bis drei Schichten übereinander zu erledigen."[35]

Es ist unmöglich, die Farben der Dinge (die so genannten Lokalfarben), die uns umgeben, wiederzugeben. Die Farbwirkung ist abhängig von der Tageszeit, das heißt, von der Sonneneinstrahlung – im Abendlicht eher warm, zur Mittagszeit hart usw. Wolken ziehen und bedecken die Sonne, die dann im Tagesverlauf zeitweise hinter Bäumen oder Hauswänden verschwindet. Der Reflex eines roten Tischtuchs verändert unmerklich die dahinter liegende Wandfarbe. Natürlich beeinflusst auch die Jahreszeit unsere Wahrnehmung. Unser Farbempfinden erfordert Entscheidungen zur Farbgebung, die mit unserer Aufnahmefähigkeit und unserer Emotionalität zu tun haben und nicht mit einer Wirklichkeit, die letztlich nicht vor Ort, sondern in unserem Gehirn entsteht.

Goethe bemerkte dazu in einem Gespräch über die Landschaftsbilder Claude Lorrains: „[Seine] Bilder haben die höchste Wahrheit, aber keine Spur von Wirklichkeit. Claude Lorrain kannte die reale Welt bis ins kleinste Detail auswendig, und er gebrauchte sie als Mittel, um die Welt seiner schönen Seele auszudrücken."[36]

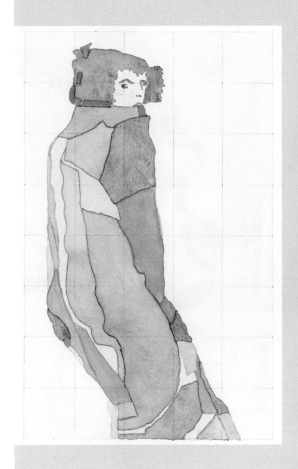

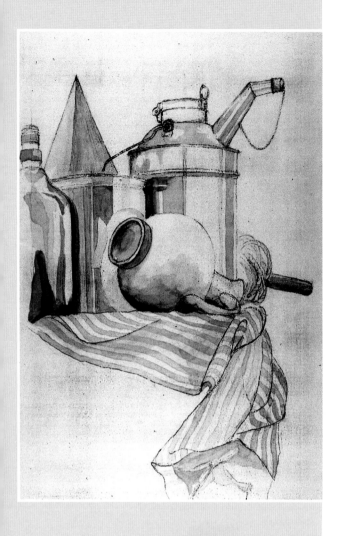

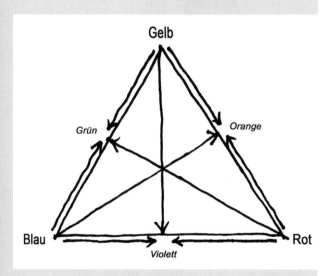

Farbkomposition

Zeichnend wie malend beschränken wir uns auf eine Auswahl des Sichtbaren und bereichern sie zugleich mit unserer Sichtweise. Das trifft auch auf die Farben zu: Wir sind überfordert von der Fülle der Schattierungen und Reflexe und nehmen nur jene Valeurs wahr, die ins Bild passen. Um die Dreidimensionalität des Raumes zu verdeutlichen, verstärken wir die Klarheit der Dinge im Vordergrund und tauchen jene im Hintergrund in eine milchig getrübte Blässe. Wir warten auf den ‚richtigen' Sonnenstand, wir suchen den besten Standort. All das sind Manipulationen, um unsere Aussage zu bekräftigen.

Zeichnen und Malen ist, wie die gesamte Wahrnehmung unserer Welt, Interpretation und damit subjektiv. Diese Erkenntnis zwingt uns, die Dinge bzw. ihre Wiedergabe, mit unserer augenblicklichen Gemütslage einzufärben und mit Überschwang oder Distanz, mit Kälte oder Wärme, Frost und Feuer, die Welt in unserer eigenen Sichtweise kunstvoll zu reflektieren. Zu bedenken ist jedoch, dass unsere ‚Sichtweise' nicht beständig ist, dass sie in einer Minute umschlagen kann. Unsere Psyche ist stets mit im Spiel. Heute finden wir unser Werk womöglich schäbig, das wir gestern noch mit Stolz betrachteten.

Das mag mit dem Vorgang des Lernens zusammenhängen. Wenn alles gut geht, wird man von Mal zu Mal besser, womöglich aber auch routinierter. Und manchmal bewirkt Routine, dass man Stimmungen nicht fühlt, sondern vortäuscht, dass das eine das andere durchlöchert. Es lohnt sich, früher gezeichnete oder gemalte Bilder hervorzuholen. Mitunter wirkt deren scheinbare Unvollkommenheit, aus der zeitlichen Distanz betrachtet, plötzlich frischer und wahrhaftiger, auch unbekümmerter als die angebliche Perfektion des neueren Werks. Warum sonst bekam die Kinderzeichnung einen so hohen Stellenwert bei vielen Künstlern des 20. Jahrhunderts (Klee, Miró, Dubuffet, usw.)?

130

Die Schichtenmalerei hat den Vorteil, dass mit ihr fast unbeabsichtigt Farbharmonie entstehen kann. Denn ist mit der ersten Schicht das Papier überzogen und sind nur die später weiß erscheinenden Flächen ausgespart, so ist ein Untergrund erzeugt, der durch alle folgenden Schichten hindurch schimmert. Hat man zum Beispiel ein blasses Braun gewählt (auch für den Himmel), so werden darüber gelegte kalte (blaue) Farbschichten alle zu einem warmen Ton hin verändert. Die braune Untermalung verringert die Buntheit und gleicht selbst Kontrastfarben einander an. Die hemmenden Zweifel, ob denn die Farben zueinander passen, werden derart gelindert. Ton-in-Ton-Kompositionen oder Farbkontraste oder gedämpfte Farbnuancen: Das sind die heiklen Fragen, die jeder Modebewusste von der morgendlichen Kleidungswahl kennt.

Das heißt aber nicht, dass der Architekt nicht wenigstens die Grundlagen der Farbtheorie kennen sollte. In den zwanziger Jahren des vorigen Jahrhunderts kam er zumeist mit den drei Primärfarben aus. Die holländische Bewegung „De Stijl" machte es zu ihrem Credo, außer den drei Nicht-Farben Weiß, Grau und Schwarz nur Blau, Rot und Gelb (unvermischt!) zuzulassen.

Das hat sich zuletzt in der Folge der Pop-Art deutlich geändert. Bonbonfarben und getrübte Töne gehören wieder zum Repertoire eines sich zeitgemäß fühlenden Architekten. Wer Mischfarben verwendet, muss sich allerdings mit dem Prinzip ‚Primär- und Komplementärfarben' vertraut gemacht haben. Das ist nicht sonderlich schwierig. Jede Primärfarbe (Rot, Gelb, Blau) hat als Komplementärfarbe die Mischfarbe aus den beiden anderen Primärfarben (siehe nebenstehendes Farbdreieck).

Ein für Architekten brauchbarer Sonderfall des Aquarells ist die Lavierung (auch Lavur genannt). Hier reicht zur Not ein brauner oder schwarzer Farbnapf aus, obwohl Farbmischungen immer zu empfehlen

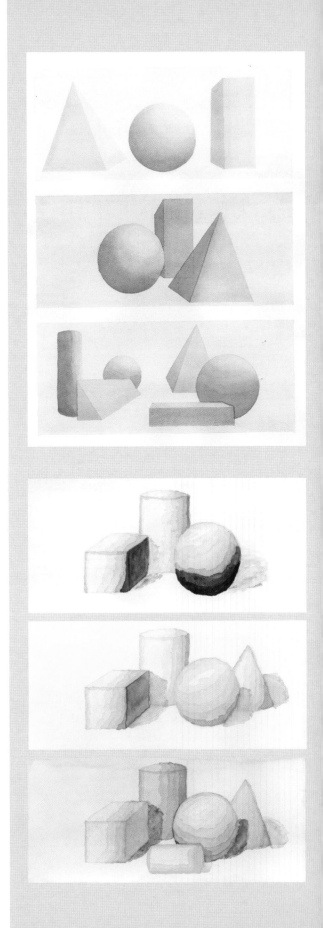

Panorama von Istanbul, lavierte Beistiftskizze

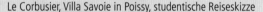

Le Corbusier, Villa Savoie in Poissy, studentische Reiseskizze

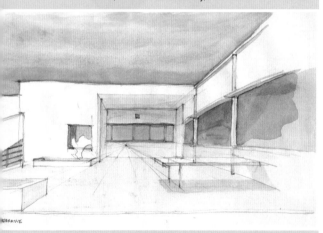

sind. Man rührt sich nur eine für das Vorhaben ausreichende Menge Farbwasser an und keine weitere. Damit wird Schicht für Schicht, wie schon beschrieben, allerdings nur monochrom gemalt. Man hat bereits eine Bleistiftskizze verfertigt. Nun aber sollen Vorder-, Mittel- und Hintergrund deutlicher voneinander geschieden werden. Vor allem aber sollen Dunkelheiten und Schatten hinzugefügt werden. Das könnte man sicher auch mit Schraffuren erreichen.

Effektvoller und müheloser gelangt man aquarellierend zu einem anschaulichen Ergebnis durch monochromes Anlegen der Teilflächen: eine erste Schicht für großflächige Partien und darüber gelegte Schichten für kleinere, in verschattete Tiefen reichende Teile. Es ist ratsam, nicht nur Baukörper- oder Landschaftskonturen, sondern auch Schattengrenzen zuvor mit dünnen Bleistiftstrichen einzutragen.

Architekten zeichnen Pläne, erläutern diese mit Skizzen oder ausgefeilten Perspektivzeichnungen. Die Weiterbearbeitung mit Aquarellfarben hat den Vorteil, dass sie dank deren Transparenz die Zeichnung nicht zudeckt, sondern präzis durchscheinen lässt und dennoch dem eher abstrakten Strichwerk den Anschein von Realität und Plastizität hinzufügt. Farbige Lagepläne und Grundrisse sind anschaulicher als nur gezeichnete und können dem laienhaften Betrachter die Besonderheit bestimmter Räume und die darin entstehenden Atmosphären vor Augen führen. Sie erleichtern dem Planer und seinem Kunden die Einfühlung in die hintergründigen Qualitäten eines vordergründigen Entwurfs.

Einen praktischen Nebeneffekt hat die Schichtenmalerei: Der in den Farben enthaltene Leim firnisst die Bleistiftvorzeichnung. Nichts kann nun mehr verwischen, allerdings kann auch kaum mehr radiert werden. Manche lavierte Zeichnung ist durch zu heftiges Radieren unheilbar beschädigt worden, weil die Vorzeichnung längst von Aquarellfarben fixiert war.

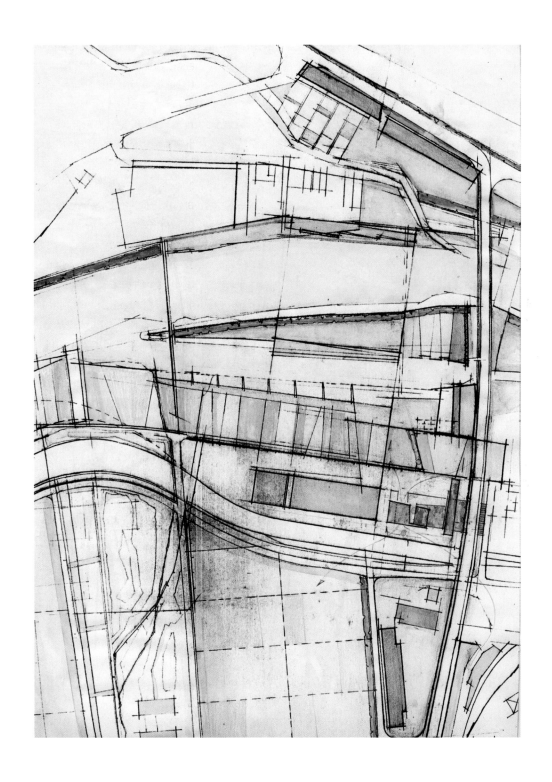

5 Grafisches Gestalten

Plan und Darstellung

Schrift strukturiert unsere Wahrnehmung. Schrift ordnet das Gewimmel um uns herum und in unserer Gedankenwelt zu Nachrichten, die auch unseren Mitmenschen verständlich sind. Schrift ergänzt Sprache, kann sie sogar ersetzen. Ein Stummer, der schreiben kann, kommt zurecht. Schwierig wird es, wenn er weder zu sprechen noch zu schreiben vermag. Kommunikation wird dann auf einfache Gebärden reduziert. Schrift ist die Vorbedingung für dauerhafte und komplexe Verständigung. Schrift bestimmt unsere Wegfindung, befriedigt unsere Neugier, erklärt unsere Handlungen, übermittelt anderen unsere Erfahrungen und unser Wissen.

Aber der Plan ist das entscheidende Kommunikationsmittel mit Entwurfslehrern, Bauherren oder Behörden. Es beginnt schon mit der ersten Überlegungsskizze, wenn sie Besprechungsgrundlage werden soll. Sie wird nicht einfach von der Skizzenrolle, sondern längs der Kante eines auf das Blatt gelegten Lineals abgerissen. So erhält man einen geradlinigen Abrissrand, der eine gewisse Sorgfalt suggeriert. Die Skizze kann unausgegoren und hastig skizziert sein, aber ihre Beschriftung sollte ordentlich mit handschriftlichen, geometrischen Großbuchstaben geschehen. Wie man das macht, wird weiter unten im Unterkapitel „Handschriften" erläutert.

Abgesehen von den vielen im Papierkorb landenden Vorskizzen, die keine anderen Augen als die eigenen zu sehen bekommen, sollte jede Zeichnung diskussionswürdig, das heißt, lukullisch aufbereitet sein. Nicht nur die Form von Plan und Schrift, ihre Platzierung spielt eine ebenso gestalterische Rolle. Auch ein Skizzenblatt (noch so flüchtig entstanden) ist ein nach den Kompositionsregeln entstandenes und beurteiltes (!) Produkt.

Wir unterscheiden (neben Skizzenblättern) Vorentwurfs-, Wettbewerbs-, Ausführungs- und Werkpläne.

136

All diese Pläne müssen unter Umständen Kommissionen präsentiert werden, das heißt, sie werden an Pinnwänden aufgespießt. Deshalb sollten sie ein handhabbares Breitenmaß (DINA2 – DINA0-Format) nicht überschreiten. Oft sind mehrere Grundrisse, vielleicht auch noch Schnitte und Grundrisse auf einem Blatt vereint. Selbstverständlich sollte sein, dass alle im gleichen Maßstab gezeichnet sind. *Grundrisse (Erdgeschoss und Obergeschosse) müssen so übereinander oder nebeneinander angeordnet sein, dass mit fiktiven Horizontalen und Vertikalen übereinander liegende Wände und Stützen in den verschiedenen Stockwerken identifiziert werden können. Das trifft auch auf die Platzierung von Schnitt und Ansicht zu. Eine im Schnitt gezeichnete Stütze liegt senkrecht über der im darunter liegenden Grundriss dargestellten.*

Zweifellos sind Architekturpläne auch grafische Kompositionen. Nicht nur im Entwurf, auch in der Darstellung zeigt sich der Meister. Deshalb verdient auch die Beschriftung unser Augenmerk. Betrachten wir Schrift wie Möblierung als grafisches Zusatzelement. Im Wettbewerbsplan sind wir relativ unabhängig. Vielleicht halten wir den oberen oder unteren Blattrand frei für Überschrift, Kennziffer oder Motto und Ähnliches. Einzelzeichnungen auf dem Blatt werden immer an gleicher Stelle betitelt, am besten unterhalb und links bündig mit der äußeren Senkrechten von Grundriss, Schnitt und Ansicht. Schrift innerhalb der einzelnen Pläne sollte wie Möblierung behandelt werden. Eine Raumbezeichnung im Grundriss behandeln wir so, als sei sie eine Bank. Eine Bank jedenfalls setzen wir ja auch nicht in die Mitte eines Zimmers, sondern schieben sie gegen eine Wand.

Mit drei Schriftgrößen müssen wir auskommen: die kleinste für die Raumbezeichnungen, die mittlere für die Zeichnungstitel und die größte für die Blattüberschrift, analog einer Schlagzeile. Alle Schriftzüge sind einheitlich vom gleichen Schrifttyp abgeleitet. Für

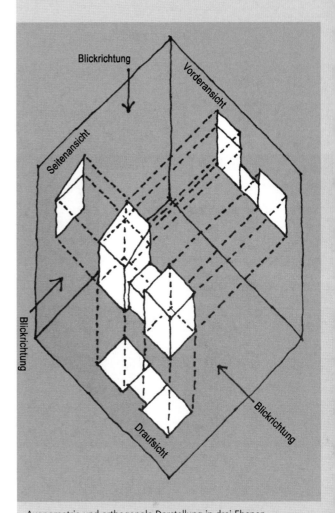

Axonometrie und orthogonale Darstellung in drei Ebenen

137

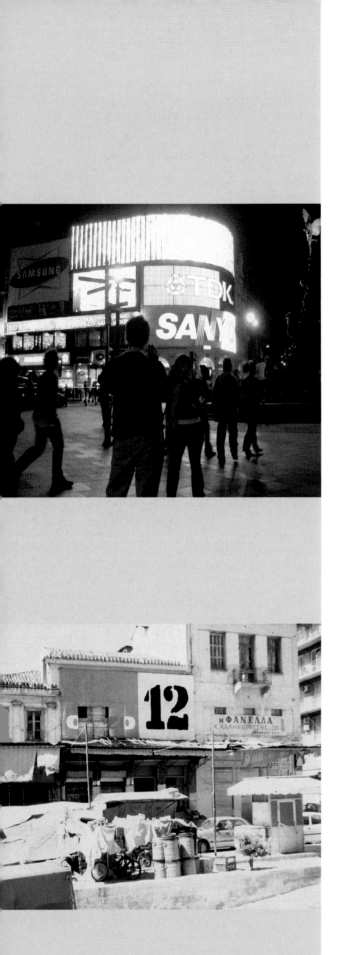

Ausführungs- und Werkpläne empfiehlt es sich, in die rechte untere Ecke einen Schriftblock zu setzen, der Angaben zu Projekt, Ort, Bauherrn, Maßstab, Datum und Architekt enthält. Wenn Kopien der Pläne auf DINA4-Format gefaltet werden, dann kommt so der Schriftblock immer obenauf zu liegen.

Es macht sich bezahlt, grafische Gestaltung schon im Vorfeld, während der Planung, nicht zu vernachlässigen. Doch auch reale Hausfassaden sind wie Zeichnungen zu lesen. Sie lassen sich zwar eher mit Reliefs vergleichen, stellen für den Entwerfer aber zugleich flächige Probleme dar. Spannungen der Einzelelemente untereinander, ihre Gewichtungen zueinander und ihre Proportionen verlangen kreative Anspannung. Hinzu kommen Reklamewünsche des Bauherrn, also Schrift am Bau, die der Architekt in seinen Entwurf einbauen muss.

Schrift am Bau

Typografie auf Architektur soll werbend Inhalt und Zweck eines Baus verdeutlichen. Es handelt sich dann meist um Reklame oder um die Anzeige einer innewohnenden Institution. Typografie dient vorrangig der Nachrichtenübermittlung. Aber Schrift am Bau muss auch zu dessen Anmutung beitragen. Sie muss ein Beitrag zur gestalterischen Lösung eines Architekturentwurfs sein. Dessen visuelle Gestalt wird von Schrift beeinflusst.

Schrift durchdringt alle Bereiche unserer Zivilisation, auch die Architektur. Die Wände nächtlicher Innenstadtstraßen sind überschwemmt von einer Unzahl unterschiedlichster Leuchtschriften. Gebäude werden dann zum Hintergrund und verschwinden scheinbar im Dunklen. Vorgelagerte Schriftzüge verdrängen sie. Am Tage aber kann Schrift am Bau störend sein und der Formgebung des Baus ungewollt widersprechen. Deshalb dürfen Architekten sich Schriftgestaltung – von wem auch immer – nicht aus der Hand nehmen lassen.

138

Wie erscheint Schrift auf Fassaden? Buchstaben als Körper, als Relief, als Linienzug, als Fläche: Die Möglichkeiten haben jeweils ihren Sinn. Sollen Nachrichten übermittelt werden? Soll Werbung überzeugen? Reicht ein Substantiv, um im Leser eine Fülle von Assoziationen zu wecken? Wird ein originelles Zeichen als Firmenlogo erkannt? Schrift im Straßenraum kann schlichte Information geben (Straßenschilder, Verkehrshinweise), dient jedoch in den meisten Fällen der Werbung. Hier beginnt die Schwierigkeit für den Architekten. Er muss bereits gestaltete, vorgegebene Werbeträger und Zeichen in seinen Entwurf integrieren. Denn Konzerne sind selten geneigt, ihr Zeichen unter den Scheffel zu stellen, das heißt, kompromisslos beharren sie auf ihrer Darstellung, auf Art und Ort der Präsentation von Schriftzug und Logo. Das Ärgernis der missglückten Kombination von Schrift und Gebäude verstört nicht nur den Architekten. Dass auch der Passant sich gequält fühlen könnte, das müsste auch jeden vernünftigen Auftraggeber von einer besseren Lösung überzeugen.

Neonröhren, zu Schriftbändern gebogen, legen ähnlich wie Balkongeländer, unabhängig von ihrer Leuchtkraft, eine transparente Schicht vor die Fassade (was leider etwas aus der Mode gekommen ist). In die Betonwand eingelassene Buchstaben, eventuell mit dem Scharriereisen behandelt, bringen nicht nur die Massivität der Wand zur Geltung, sondern verstärken auch das Licht- und Schattenspiel auf der Oberfläche. Zu kubischen Lichtkästen geformte Zeichen ersetzen die notwendige Beleuchtung. Flache, dauerhafte Transparente oder Lichtwände, aus Schriftzügen und werbenden Bildern komponiert, verändern die Straße zur scheinbar musealen Galerie.

Mit diesen und anderen Mitteln haben Architekten die Chance, ein offenbar nicht zu vermeidendes Übel zu einer sowohl ästhetischen als auch funktionalen Notwendigkeit umzupolen. Wandernde Schatten, Bildergalerie und Feuerwerk: Piccadilly Circus in

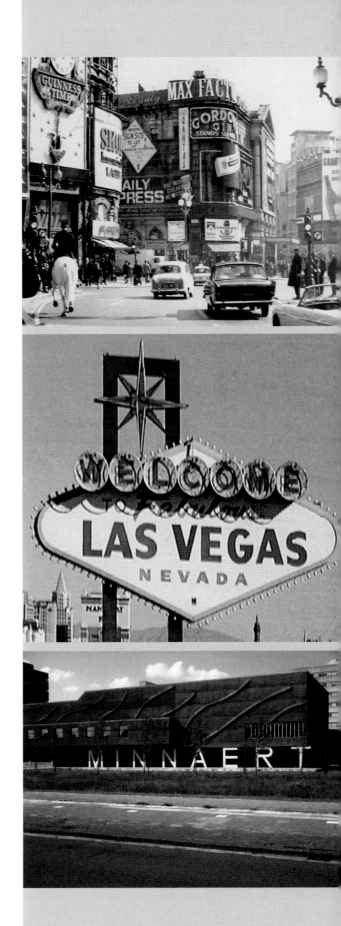

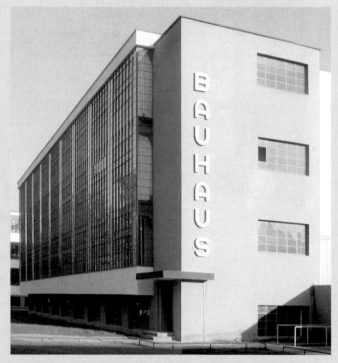

Walter Gropius, Bauhaus in Dessau

Schaufensterwerbung

Peter Behrens, Turbinenfabrik in Berlin

Musicalwerbung in Köln

London, der Broadway in New York oder die Ginza in Tokio sind auf diese Weise zu urbanen Anziehungspunkten, ja, zu Sehnsuchtsorten geworden – Zonen des Spektakels, die auch unabhängig vom Konsumrausch funktionieren.

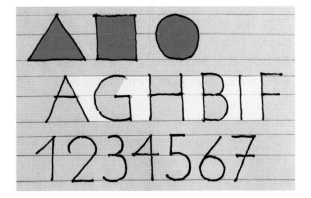

Handschriften

Wir wissen bereits: Schrift hat für den Architekten noch eine andere handwerkliche Bedeutung. Trotz Computerarbeit mit der Fülle unterschiedlichster vorprogrammierter Schriftarten muss er locker und ansehnlich seine mit der Hand gezeichneten Vorskizzen beschriften können. Wie notwendig Skizzen als ein erläuterndes Hilfsmittel während des Entwurfsstadiums sind, wurde bereits festgestellt. Eine unbeholfene Schrift kann jedoch jede noch so anschaulich gezeichnete Skizze ruinieren.

Schrift und Zeichnung sind eine Einheit, aus dem gleichen Verständnis heraus entwickelt. Sie ergänzen sich und sie informieren. Es muss uns klar sein, dass jede Skizze samt Beschriftung, wenn sie denn für das Auge eines fremden Betrachters gedacht ist, innerhalb eines Rahmens – der Blattgrenzen – wie selbstverständlich erscheinen muss. Das Verhältnis von Skizze und Leerfläche zueinander, die Platzierung der Schrift: All das sollte bedacht werden, denn der skizzierte Entwurf muss den Auftraggeber von Anfang an überzeugen.

Die Schrift muss deutlich, aber unauffällig sein. Das geschieht am besten, wenn sie sich der Architektursprache anpasst. In den überwiegenden Fällen wird ein Entwurf sich den Gesetzen der Geometrie beugen. Schon um der Bautechnik willen wird der rechte Winkel dabei eine große Rolle spielen. Daraus folgt, dass auch die Beschriftung der Zeichnungen diesem Prinzip gehorchen sollte. Also stehen die Buchstaben aufrecht und sind keineswegs geneigt wie Schriftzüge im handgeschriebenen Brief.

Da die Planzeichnung nur kurze Stichworte enthält – Plankennzeichnungen, Raumangaben usw. – werden nur Großbuchstaben verwendet: *Die Buchstaben orientieren sich an den geometrischen Grundformen: Kreis, Rechteck und Dreieck. Alle Buchstaben sollten serifenlos sein (Serife = Füßchen, auch Schraffe genannt), sollten also keine Häkchen oder Ähnliches quer zur Grundrichtung eines Buchstabenstrichs aufweisen. Damit die Buchstaben nun nicht wie betrunken über das Blatt torkeln, sind stützende Hilfslinien notwendig. Die Zeichen werden in ein Linienkorsett eingebunden. Dies Gerüst besteht aus einer horizontalen Grundlinie, einer Mittel- und einer Oberlinie. Der Abstand zwischen den Linien der Zeilen ist immer gleich, es sei denn, wir machen einen Unterschied zwischen Überschriften und untergeordneten Bezeichnungen.*

Die Mittellinie sollte leicht nach oben versetzt werden. Der Grund ist folgender: Jeder Buchstabe steht auf der Grundlinie und stößt an die Oberlinie. Die eine ist der Boden, die andere ist die Decke. Die Buchstaben stehen breitbeinig auf dem Grund. Das ist beim „A" einleuchtend. Da aber die meisten Buchstaben vertikal geteilt sind, könnte es geschehen, wenn die Mittellinie genau mittig säße, dass die obere Hälfte des Zeichens bei zügiger Beschriftung unversehens ein Übergewicht bekommen könnte. Das „B" ist so ein Kandidat. Um den ‚Unterleib' wie beim Stehaufmännchen zu vergrößern

142

und standfest zu verankern, wird die Mittellinie (das gilt dann für das gesamte Alphabet, ebenso für Zahlen) leicht nach oben versetzt.

Offenbar zwingen uns auch beim Schreiben archaische Verhaltensrudimente dazu – Ordnungssucht zum einen und der Hang zur Bodenständigkeit zum anderen – die Dinge in Reih und Glied zu stellen und ihnen ein festes Fundament zu geben. Selbstverständlich gibt und gab es immer Ausbruchsversuche, Versuche, einen leichtsinnigen und luftigen Tanz der Zeichen zu inszenieren. Aber das ist ein anderes Thema: sich nicht geradlinig und charaktervoll, sondern geheimnisvoll und fern aller bürgerlichen Ordnung darzustellen.

In der römischen Antike wurde besondere Sorgfalt auf eine ausgewogene Schrift verwendet, was sich heute noch in einigen Schriftnamen niederschlägt (Times Roman und Antiqua zum Beispiel). Nicht nur die Buchstaben wurden gewissenhaft in Form und Gestalt aufeinander bezogen, sondern ebenso ihre Zwischenräume. Das heißt, jede Leerfläche erhielt ungefähr den gleichen Flächeninhalt. Da Buchstaben nun aber unterschiedliche Formen und Breiten haben, korpulent oder mager sind (siehe M oder I), musste der Abstand zwischen dem letzten Buchstabenstrich des breiten M und dem dünnen I-Strich zum Beispiel größer sein als der zwischen F und I, denn anders als beim M greift die Leerfläche zwischen F und I in das offene F hinein. Ist der Buchstabe rechts offen oder gebogen, dann ist der Abstand zum folgenden senkrechten Strich näher. Endet der Buchstabe mit einer Senkrechten, dann muss der Abstand größer werden. Diese Gestaltungsprinzipien gelten selbstverständlich auch heute noch.

ABCDEF
GHIJKL
MNOPQR
STUVWX
YZØ123
456789

Am Schriftbeispiel in der nebenstehenden Spalte sieht man deutlich, dass der Verfasser die ehrwürdigen Regeln nicht beachtete: Der Abstand zwischen G und H ist zu eng, zwischen I und J ist er viel zu weit.

Aber hat man erst einmal probeweise ein paar Seiten nach diesen Grundsätzen geschrieben (Zahlen folgen den gleichen Regeln), dann wird man kaum noch über Ordnung und Gleichmaß der Bezeichnungen nachdenken müssen und die Schrift läuft zügig und am rechten Ort über das Papier.

Helga Schneider, Studienblatt

144

6 Bildnerisches Gestalten

Skulptur und Architektur

Wir wollen uns kaum des Körperschutzes entledigen: Mit Kleidung als zweiter Haut, dem Haus als dritter Haut, dem Mikrokosmos, in dem wir leben (unsere nähere Umgebung), als vierter Haut schützen wir uns, aber offenbaren auch unsere verletzliche Person. Die bequeme, faltenreiche Kleidung, das geräumige Haus, die Distanz zu den Dingen, jeder Griff, jeder Schritt nehmen ein Stück weit Raum in Besitz. Nicht nur das. Der uns nahe, uns umgebende Raum wird zeitweise von uns geprägt, gehört dann zur Person. Wir sagen etwas über uns, mit Blässe oder Bräunung, Creme und Tattoo (der ersten Haut), mit Mütze, Mantel und T-Shirt (der zweiten Haut), mit Wohnung und Hausfassade (der dritten Haut) und mit Gärten und Terrassen, mit Blumenrabatten und Zaun (der vierten Haut). Wir können aber kaum verhindern, dass zumindest zwischen uns und dritte oder vierte Haut auch Unbefugte eindringen. Gestaltung heißt hier denn auch, Raum greifende Distanz und deutliche Schwellen schaffen.

Wir können das Handwerk sowohl der Baukunst als auch der Bildhauerkunst auf ganz einfache Prinzipien reduzieren. Es gilt Volumen zu schaffen und Raum zu bilden. Die Begriffsgrenzen zwischen Bauwerk und Plastik sind fließend. Es gibt etwas, das Platz verdrängt, vielleicht durchlöchert und ausgehöhlt ist und zugleich in den umgebenden Luftraum seine Tentakeln ausstreckt. Volumen und Umraum, Innen und Außen verzahnen sich. Es ist deshalb folgerichtig, wenn Architekten sich von Skulpturen und zeitgenössische Bildhauer sich häufig von Architektur inspirieren lassen. Mensch und Hülle sind seit der Antike das Hauptmotiv der Skulptur. Als im 20. Jahrhundert sich der Kunstbegriff erweiterte, wurde selbst das Haus (die dritte Haut!) als Abbild seiner Bewohner zum bildnerischen Gegenstand.

Seit der Antike wurden in die Architektur schon immer die anderen Künste einbezogen: als Mosaiken,

148

Deckengemälde, Karyatiden oder Orgelprospekte. Der Architekt fühlte sich als Schöpfer eines Gesamtkunstwerks. Berühmt ist der Anfang des Gründungsmanifests des Bauhauses (Walter Gropius, 1919): „Das Endziel aller bildnerischen Tätigkeit ist der Bau! Ihn zu schmücken, war einst die vornehmste Aufgabe der bildenden Künste, sie waren unablösliche Bestandteile der großen Baukunst."[37] Wenn auch in geringerem Maße, gilt das auch heute. Joseph Beuys sprach vom „erweiterten Kunstbegriff".

Das bedeutet für uns Architekten, dass wir unser gestalterisches Repertoire aus dem benachbarten Themenpark der bildenden Künstler ergänzen können. Deshalb ist bildnerisches Gestalten ein so wichtiges Grundlagenfach für Architekturstudierende. Einige Beispiele dafür wurden bereits ergänzend zu den Kapiteln ‚Bäume und Menschen Zeichnen' gezeigt (‚Ein Baum, der kein Baum ist' und ‚Lebende Skulpturen').

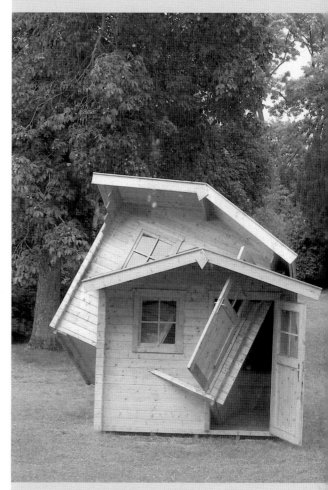

Via Lewandowski, architektonische Skulptur

Flüchtige Volumen wie ein Hauch

149

Exkurs Modellbau

Wir klären und erklären uns ein architektonisches
oder bildnerisches Vorhaben mit Hife von Skizzen.
Mehr als den Bildhauer aber verleitet das flächige
Skizzieren den Architekten, das jenseits der Abbil-
dung (vor oder hinter, unter oder über der Form)
Liegende zu übersehen – weil er in papierdünnen
Schnitten oder Ansichten zu denken gewohnt ist.
Anschaulich wird manches erst, wenn es handgreif-
lich, also dreidimensional, vor den Augen liegt. Wie
dem Kind in seiner Spielzeugeisenbahn gelingt es
dann dem Entwerfer sich so klein zu denken, dass er
scheinbar im Modell eines Projekts spazieren gehen
kann. Komplizierte Volumen oder Details, die sich
nicht an die rechtwinklige Geometrie halten, sind
anders oft garnicht zu verstehen. Die plausibelsten
und kreativsten Entwurfsgedanken entstehen meist
beim Bauen eines Modells.

Es kann dem Anfänger nicht oft genug vor Augen
geführt werden, dass Entwerfen nicht mit dem Fine-
liner sondern mit Messer, Spachtel, Ton, Pappe oder
Holz beginnt. Ein Anfängerfehler ist, dass das Ar-
beitsmodell mit dem Ausführungsmodell verwech-
selt wird. Ein Arbeitsmodell muss schnell hergestellt
werden können und muss schnell veränderbar sein.
Es darf, ja es muss provisorisch aussehen analog zu
einer ersten Skizze. Meist entsteht eine Fülle von
skizzenhaften Modellen zu einem einzigen Projekt.

Wie geht das? Da man keinesfalls sparsam, son-
dern verschwenderisch mit dem Material umgehen
sollte, braucht man preiswerten, am besten kosten-
losen Werkstoff. Am Eingang von Supermärkten
findet man immer Kartons aus Wellpappe zum Mit-
nehmen. Das Material ist dick genug, um Wandstär-
ken zu simulieren, lässt sich leicht mit dem Skalpell
schneiden und ebenso leicht mit Stecknadeln zu-
sammenstecken. Beschriftungen und Verfärbungen
des Kartons stören überhaupt nicht, denn es geht
nur um die Form und um räumliche Zusammen-

O.M.A., Studienmodelle, Ausstellung im NAI Rotterdam

150

hänge. Es ist erstaunlich, wieviel man aus einem schludrig gebauten Modell herauslesen kann und wie anregend es für die fernere Arbeit sein kann.

Nachlässig gebaut muss das Skizzenmodell sein, weil es ein Testmodell ist, an dem ständig neue Gedanken umgesetzt und ausprobiert werden müssen. Zu früh erzeugte Perfektion macht einen endgültigen Eindruck, lässt sowohl Entwerfer wie Berater zögern, zerstörerisch und wieder aufbauend am Modell zu arbeiten. Geschliffenheit erzeugt den Anschein von Unveränderbarkeit, obwohl noch so viel, vielleicht sogar Grundsätzliches zu korrigieren wäre.

Ein flüchtig gebautes Skizzenmodell muss dennoch nicht schlampig sein, denn man möchte natürlich seinen Chef oder Bauherren oder Professor auch im frühen Entwurfsstadium bereits von seiner Idee überzeugen. Zum Beispiel ist ein mit dem Skalpell (oder Mehrzweckmesser) am Lineal gezogener Schnitt nicht nur akkurater, sondern genauso schnell zu erzeugen wie ein unakkurat mit der Schere geschnittener.

Steht der Entwurf zur Benotung an oder sind eine Jury und Geldgeber zu überzeugen, dann erst ist es Zeit, an ein endgültiges Modell zu gehen. Aber auch da ist eher Understatement angesagt: Nichts ist peinlicher als ein mittelmäßiger Entwurf, dargestellt in Formen aus bronzierten Blechen, aufgehübscht durch Modellbauautos, Plexiglashauben, aufwändigen Sockeln und Ähnlichem. Für skulpturale Entwürfe wird man Gips, Ton oder Plastilin und die dazu gehörigen Werkzeuge verwenden. Für architektonische Projekte (die uns hier stärker interessieren) ist anzuraten, keine Materialschlacht zu veranstalten: entweder Holz (Balsaholz, Spanplatten, Sperrholzplatten) oder Pappe (Buchbinderpappe, Finnpappe, auch die bereits erwähnte Wellpappe, jeweils zwei bis drei Millimeter stark) oder Kunststoffe (Acrylglas, Leichtstoffplatten). Papier aber ist

UNStudio, Möbius-Haus, Arbeitsmodell

Claus Bury, Studienmodelle, Ausstellung im DAM Frankfurt

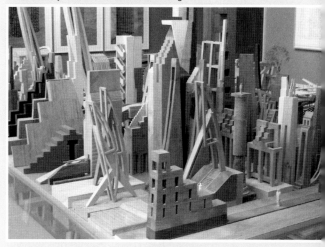

Yona Friedman, Stadtutopie, Modell aus Verpackungsmaterial

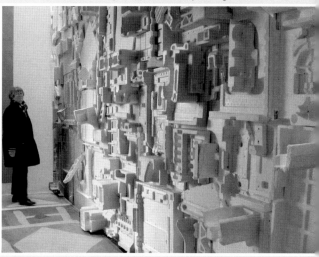

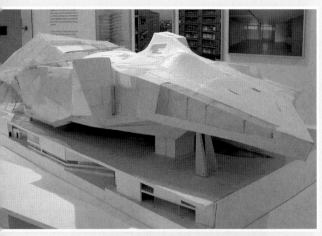

Coop Himmelb(l)au, Musée des Confluences, Arbeitsmodell

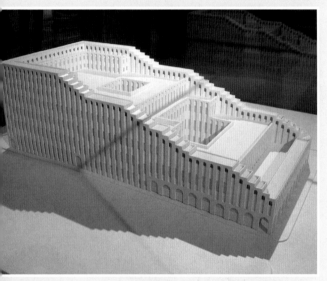

Hans Poelzig, Haus der Freundschaft
(Projekt für Istanbul, 1916), Ausstellungsmodell

kein Modellbaumaterial, weil es sich ungewollt ver-
biegt, weil es ‚fleischlos‘ ist und folglich damit keine
Wandstärken darzustellen sind.

Modelle sind dünnwandig, nur ihre Bodenplatten
sind um der Stabilität willen ungefähr zwei Zenti-
meter stark. Es ist empfehlenswert, am Arbeitsplatz
eine Kiste mit Modellbaumaterial zu deponieren.
Darin wird alles gesammelt, was irgendwann ir-
gendwie mal Verwendung im Modellbau finden
könnte: Holz- und Pappreste, Dosen- und Tubende-
ckel, Acrylglasstücke, Drähte und Schnüre, Nägel und
Nadeln, Zahnstocher, Eingeweide von ausgedienten
Elektrogeräten, Kleinmaterial aus dem Elektro- oder
Sanitärladen usw. Werkzeug ist allerdings besser in
einem eigenen Behältnis zu bewahren.

Farben sind zu reduzieren. Oft reichen Materialfar-
ben aus. Werden jedoch zusätzliche Farben einge-
setzt, so verdeutlichen sie Vor- und Rücksprünge,
dienen der Licht- und Schattenwirkung und unter-
stützen folglich das Relief eines Volumens. Keines-
falls aber darf Farbe eingesetzt werden, um Fenster,
Türen, Gesimse und Ähnliches auf eine Fläche zu
malen. Fenster und Türen sind wie in Wirklichkeit
Einschnitte ins Innere des Gebäudes, ins Innere des
Modells.

Körperskulpturen

Der menschliche Leib ist die maßgebende Größe in der Architektur. Auf ihn bezieht sich alles, im Großen wie im Kleinen. Selbstverständlich ist es daher, wenn auch in der bildnerischen Lehre der Menschenkörper grundlegend ist. Und das nicht nur im übertragenen Sinne, sondern wörtlich. Der Körper kann zum Fundament oder zum Sockel für bildhauerische Erfindungen werden. Skulpturen sind im allgemeinen immobil, was ihren Schöpfern Sicherheit und Erleichterung verschafft. Wenn sie nun aber mit einem lebendigen und beweglichen Körper verbunden sind, kommen bewusstseinsschärfende Irritationen und ungewohnte Anforderungen hinzu. Präsenz und hohe Aufmerksamkeit sind gefordert: Mobilität, Stabilität, Statik, sich stetig verformender Untergrund (Muskeln usw.) und sich immerfort verändernde Umgebung verschärfen den Anspruch, schärfen aber auch Wachheit, Selbstkritik und Erfindungsgeist des Bearbeiters.

Erinnert sei, dass Architektur sich in den letzten Jahrzehnten immer häufiger vom festen Boden löste (praktisch und theoretisch). Schon Le Corbusier stellte in den zwanziger Jahren seine Villa Savoye auf Pilotis (Stützen), um den umgebenden Rasen unter dem Haus hindurchfließen lassen zu können. Der Holländer Herman Hertzberger lässt Wohnhäuser auf Grachten schwimmen. Einst sagte Zaha Hadid, dass Architektur fliegen müsse und die Architektengruppe Coop Himmelb(l)au behauptete: „Architektur muss brennen", Architektur müsse sich himmelwärts in Rauch und Asche auflösen. Lebbeus Woods zeichnete unterirdische, aber auch fliegende Häuser. Schiff, Auto und Flugzeug haben ebenso das Architekturverständnis im 20. Jahrhundert stark verändert. Der Mensch wurde mobiler denn je. Man könnte auch sagen: Er wurde haltloser.

„Lebende Skulpturen" (s. S. 86) ist eine auf solchen Gedanken beruhende, die eingeschliffenen Sichtwei-

Foto: Andreas Groll 1857

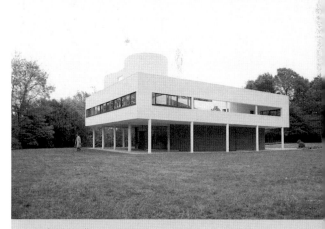

Le Corbusier, Villa Savoye 1929-31
Foto: Florian Afflerbach

sen verwirrende Aufgabenstellung für Architektur-
studierende. ‚Sich vom Boden lösen' ist dabei eines
der gestalterischen Ziele. Jedoch auch skulpturale
Ergänzungen von Schulter, Brust und Kopf erfordern
ein Gespür für Balance, verstärken das Gefühl für
Statik und Gleichgewicht und befreien zugleich den
von Scheuklappen behinderten Blick. So sollen im
Folgenden drei Möglichkeiten für künstliche/kunst-
volle Körperergänzungen dargestellt werden.

Lebbeus Woods, Free Zone Zagreb

Themenübung: Kopfbauten

Am 23.Januar 1931 findet im Hotel Astor in New York ein Beaux-Arts-Kostüm-ball statt: „Fete Moderne. Eine Phantasie in Feuer und Silber". Eingeladen sind Künstler und Architekten, sich an einer kollektiven Suche nach dem „Geist der Epoche" zu beteiligen. „Die Fête Moderne soll modernistisch, futuristisch, kubistisch, altruistisch, mystisch, architistisch und feministisch [...] sein. Phantasie ist Trumpf, Originalität wird prämiert." Die Architekten der Skyline New Yorks verwandeln sich in ihre eigenen Wolkenkratzer. „Wie ihre Türme sind die Männer in Kostüme gekleidet, deren wesentliche Merkmale mehr oder weniger gleich sind [...]. Unterschiede treten nur an der Spitze der Gebäude zutage."
(zit. n. Rem Koolhaas, Delirious New York, S. 126ff)

Der eigene Kopf soll Basis für ein artifizielles Objekt werden. Wie in allen gestalterischen Aufgaben soll die Wahrnehmung sensibilisiert werden, allerdings über das Visuelle hinaus. Es ist erwünscht, wenn der Körpersinn (unser sechster Sinn), wenn Tastsinn und Hörsinn, eventuell auch Geruchs- und Geschmacks-sinn zusätzlich aktiviert werden. Der Körpersinn in-formiert uns – fast unbemerkt – über Gleichgewicht und Masseverteilung mit Hilfe von sogenannten Tiefensensoren in Muskeln, Sehnen und Gelenken. Ansonsten könnten wir kaum Gehen, Radfahren oder Balancieren. Wir könnten vor allem diese Ge-staltungsaufgabe nicht lösen, da sie fordert, nicht nur den Körperumfang zu vergrößern, sondern auch dessen Gewichtung zu verändern. Eine Schwer-punktverlagerung wird unumgänglich, was aber dank des Körpersinns kaum jemanden Probleme be-reiten wird. Das erinnert uns wiederum an das „kon-trastbedingte Gleichgewicht", ein Prinzip, das uns unbewusst fast jede Schieflage ausgleichen lässt.

Die Aufgabe soll nun näher erläutert werden: Der Leib wird zum Sockel und der Kopfbau (und damit der Student selbst) zum Ausstellungsstück. Das Ex-ponat sollte entweder auf den Schultern ruhen oder – etwas höher und labiler – auf Hals und Schädel. Zu überlegen wäre auch, ob das ‚Kunststück' sich dem Körper anschmiegt oder ob es eine gewisse Distanz bewahrt (zum Atmen, zum Sehen usw.), ob es den Kopf ganz oder nur teilweise verbirgt, ob es die vorhandenen organischen Rundungen aufgreift oder im Gegenteil mit geometrischen und tech-nischen Elementen spielt. Der Bearbeiter muss sich überlegen, ob sein Werk eine Metamorphose „vom Kopf zur Architektur" sein wird, oder ob es sich um den architektonischen Schutz eines verletzlichen Körperteils handelt. Ist es eine Prothese oder eine Mutation?

Bei derartigen Aufgabenstellungen neigen die Be-arbeiter zu symbolischen Überfrachtungen. Es ist Aufgabe des Betreuers, die Studierenden auf den „Boden der Tatsachen" zurückzubringen. Der Ver-zicht auf Bedeutungsschwere, hingegen sachliche Zurückhaltung erzeugt Mehrdeutigkeit und wird damit zum Gewinn. Viel ist erreicht, wenn die Er-kenntnis unter den Lernenden wächst, dass Gestal-tung (vor allem Architekturgestaltung) mehr ist als nur die Produktion einer Sequenz von Bildern.

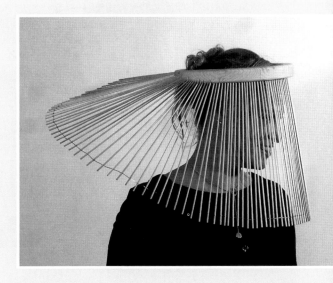

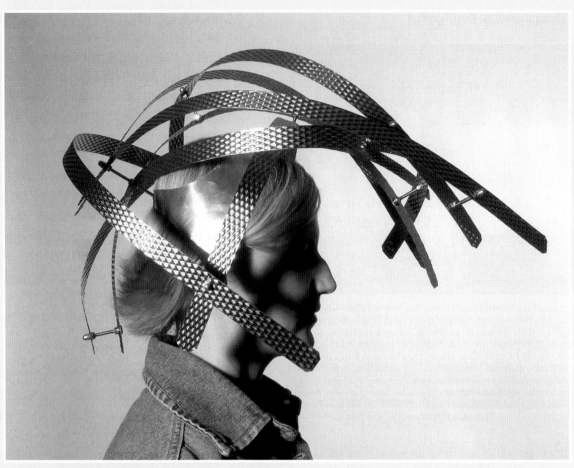

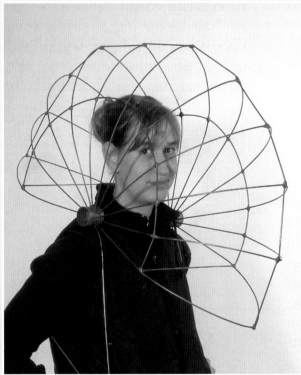

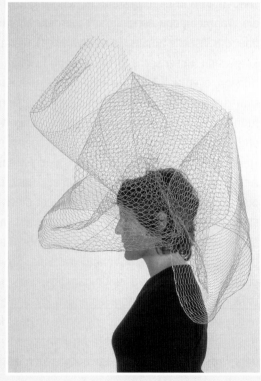

Themenübung: Brustkorb

Mehrdeutigkeit ist schon in der Aufgabenstellung Brustkorb angedeutet. Zum einen könnte das Wort auf den Oberkörper Bezug nehmen, das heißt, zur Veränderung, Verbiegung, Ausdehnung, Ergänzung oder imaginären Öffnung des eigenen Leibs (Skelett, Muskeln, Organe, Nerven) auffordern. Zum anderen könnte die Rede von einem auf der vorderen Körperfront zu tragenden Behälter sein. Die Frage stellt sich also, ob es sich um eine Körperteilerweiterung oder um einen aufgesetzten Fremdkörper handelt. Wie zumeist sollte man die Deutungen nicht vermischen. Eine Entscheidung ist notwendig.

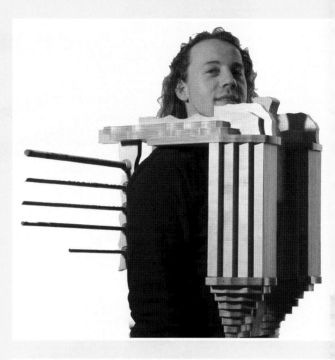

Auch diese Aufgabe muss näher erläutert werden: Ein zusätzlicher Körperteil, auf den eigenen Leib zugeschnitten, ist zu entwickeln. Abzuwägen ist, welche Materialien verwendet werden („Less is more" – oft, aber nicht immer), welche Verknüpfungen gewählt werden, wie Verschnürungen oder andere Befestigungen am Körper zu sein haben und vor allem, welchen kompositorischen Ideen zu folgen ist.

Da es sich bei den Bearbeitern nicht um Bildhauer, sondern um angehende Architekten handelt, muss auch der architektonische Aspekt berücksichtigt werden. Das gestalterische und das konstruktive Detail spielen dabei eine nicht zu vernachlässigende Rolle. Wenn etwas zu schrauben ist, dann ist Schraubkopf, Unterlegscheibe und Mutter sorgfältig zu wählen, unter Umständen zu verstärken oder gar zu übertreiben. Wenn etwas zu kleben ist, dann soll dies nahtlos, präzise und fleckenlos geschehen. Wenn etwas zu färben ist, dann ist zu entscheiden, ob die Farbe informativ oder kompositorisch, ob sie den Zweck oder die Form stützend einzusetzen ist. Entweder sind Signalfarben die richtige Wahl, oder die Plastizität des Objekts wird durch farbliche Verdunkelung der Schatten gesteigert. Auch Knoten, Schlaufen oder ähnliche Verknüpfungen dienen nicht allein der Haltbarkeit, sondern sollen zur Gestaltwirkung beitragen.

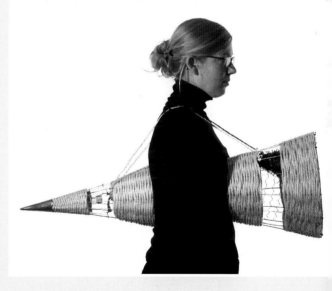

157

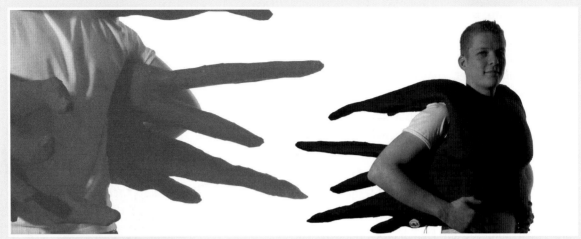

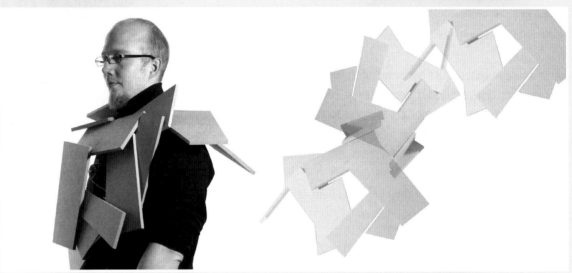

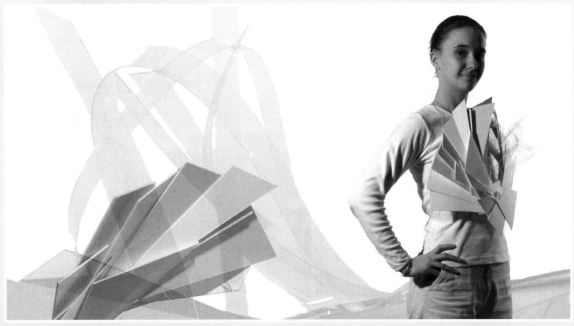

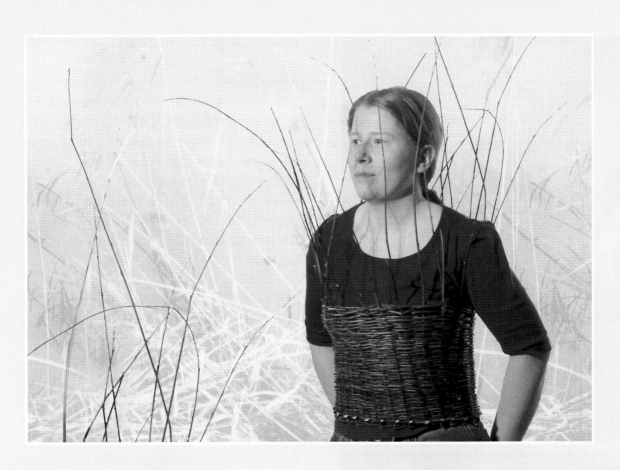

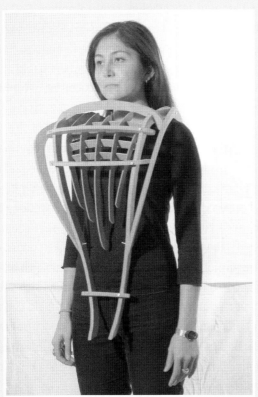

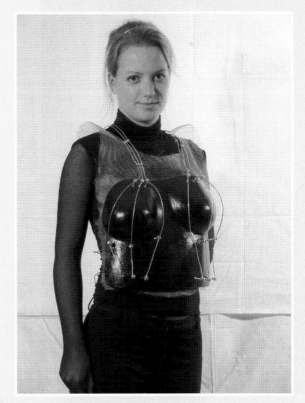

Themenübung: Schulterschluss

Haben die Aufgabenstellungen Kopfbauten und Brustkorb das scheinbare Ziel, in den menschlichen Körper einzugreifen, ihn zum Bearbeitungsmaterial zu erklären, so nimmt die Aufgabe Schulterschluss den Körper nur zum Sockel. Die Skulptur verändert weniger die Person, sondern geht eher eine Symbiose mit ihr ein. Trotzdem heißt das jedoch, dass die eigene Leiblichkeit behutsam erkundet und für ein Zusammenspiel von Körper und Last bereitet werden muss.

Dies vor Augen ist anfangs das gerade noch erträgliche Gewicht des „Schulteraffen" zu ergründen, ein Konzept zu formen, schließlich den Kampf mit dem Material (Klebrigkeit, Bröckeligkeit, Scharfkantigkeit) zu bestehen. Zugleich ist die Statik und Verletzbarkeit des eigenen Körpers (Muskeln, Knochen, Gelenk) zu berücksichtigen, ist die Horizontale der Schulter und der rechte Winkel zwischen ihr und Hals zu entdecken und ist die heikle Labilität von toter Last und lebendigem, schwankendem Sockel zu bewältigen. Das Ergebnis wird ein Parasit sein, ein „Ding", das sehr viel mit Körpererfahrung zu tun hat, gleichzeitig aber dem entgegen arbeiten und als Femdkörper ‚eindrücklich', gar rücksichtslos geformt werden kann.

Die Aufgabe könnte so formuliert werden: Formen Sie eine Skulptur, die Sie freihändig und bequem auf einer Schulter (ob rechts oder links) herumtragen können. Daraus folgt, dass die Figur weder zu groß, noch zu schwer und nicht sperrig sein sollte. Sie sollte aber eine gewisse Eigenständigkeit gegenüber dem Körper haben. Sie sollte sich zugleich anschmiegen und abheben. Die Skulptur muss sich sowohl der Schulter anpassen (Befestigung), als auch dem seitlichen Kopfprofil antworten. Dennoch sollte die Figur sich mehr oder weniger deutlich in Farbe, Material, Bauweise und Gestalt vom eigenen Körper unterscheiden.

160

Zur Bewältigung der Anforderungen lassen Sie sich vorrangig auf skulpturale Qualitäten ein, das heißt, auf Kriterien wie offen – geschlossen, vorne – hinten – seitlich, transparent – verhüllt, ausgreifend – einschließend, konvex – konkav, beleuchtet – verschattet, glatt – rau, organisch – geometrisch. Lassen Sie sich weniger auf bildhafte Assoziationen ein, also nicht oder kaum erinnernd an Katze, Papagei, Rucksack. Was Sie auf der Schulter tragen, sollte etwas so noch nicht Gesehenes sein. Die primäre Anforderung an das Werk ist Qualität und Schlüssigkeit, die sekundäre ist Tragbarkeit und Absturzsicherung. Vergessen Sie die Lasten, die bereits auf Ihren zarten Schultern ruhen und geben Sie sich lieber mit Inbrunst und Lust der Formung dieser nutzlosen, aber nicht zwecklosen Last hin.

Vom Sinn befremdlicher Aufgaben

Diese drei beschriebenen Körperskulpturen sind nur drei erprobte Beispiele aus einem weiten Feld von Möglichkeiten. Rücken, Arm und Bein, Knie und Ellenbogen, Gesicht und innere Organe, Auge, Ohr und Mund lassen sich ebenso phantasievoll erweitern. Auf jeden Fall sind all dies Gelegenheiten, sich mit grundsätzlichen Fragen, die Architekturstudierende kennen sollten, auseinander zu setzen. Das sind Tragfähigkeit, Konstruktion, Volumen und Oberfläche, Verbindungen und Materialgefüge, Durchdringung von Innen und Außen, Farbe, Licht und Schatten. Die Beziehung zwischen menschlichem Körper, Bauwerk und Skulptur, alle einzeln und zusammen Gestaltung fordernd, auch wenn diese mitunter nur hinein interpretiert wird, zu erkennen und zu bearbeiten, muss der pädagogische Hintergedanke einer anfangs befremdlichen Aufgabe sein. Sie ist durch Routine und Handwerk allein nicht zu bewerkstelligen und ohne Einfühlung nicht zu lösen.

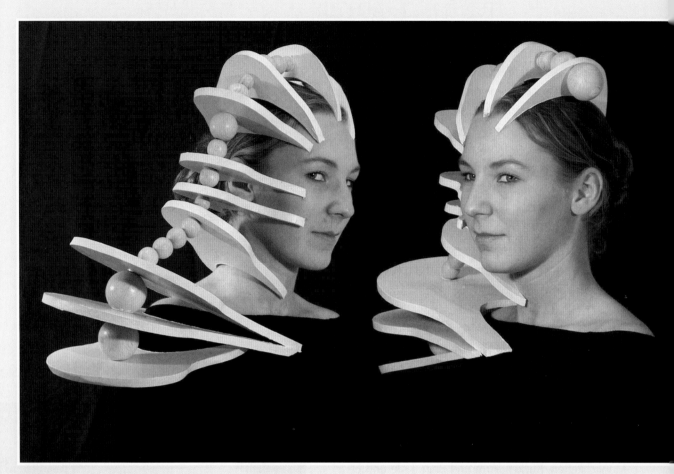

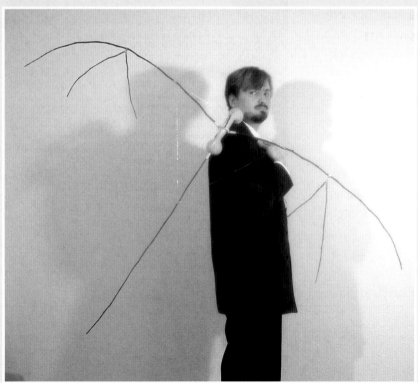

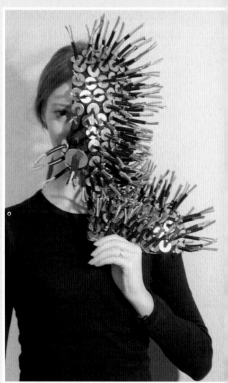

Apparative Skulpturen

Oft sind es Konfrontationen, harte thematische Gegensätze, deren Überwindung den Ehrgeiz wecken und die zum künstlerischen Tun anregen. Mitunter sind es Alltagsbeobachtungen, manches Mal handwerkliche Hindernisse, deren erfolgreiche Bewältigung fesseln und Aha-Erlebnisse hervorrufen. Oft sind es unerwartete Klippen, die die Leistungsfähigkeit steigern.

Wer Architektur studieren will, wer wissbegierig in fremdes Gelände eindringt, erhofft zunächst einen bequemen Weg zum Ziel. Er erwartet präzise Anleitungen zum Häuserbauen. Sich mit grenzüberschreitenden „Nutzlosigkeiten" zu befassen, ist dann befremdlich genug. So erzeugen auch konventionellere Aufgabenstellungen wie Stuhlobjekt oder Klangskulptur genügend schöpferische Ratlosigkeit. Die Gehirnkammern, vollgestopft mit Richtlinien und verstaubten Rezepten, müssen leer geräumt und gesäubert werden, um Frischluft und neue Ware einzulassen. Wer scheinbar Unbekanntes, Flaschenpost und Sperrgut in seinem Denkapparat einlagert und unkonventionell verarbeitet, wächst über sich selbst hinaus.

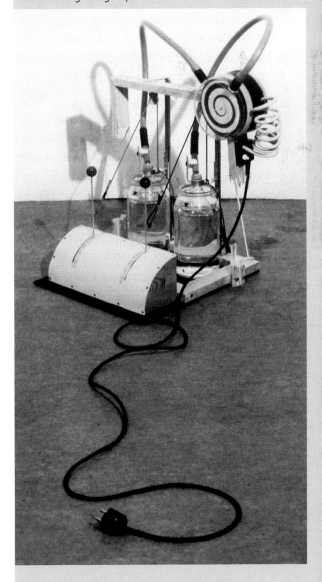

Themenübung: Klangskulptur

Themenübung: Klangskulptur

Die Aufgabe, eine Klangskulptur zu entwerfen, führt noch am ehesten zum Verständnis bei unerfahrenen Studenten. In Abwandlung einer Binsenweisheit sei behauptet: Das Auge hört mit. Das will sagen, dass der gesamte Sinnenapparat teilnimmt, wenn ein Sinnesorgan gefordert ist. In seltenen Fällen wird dies bewusst wahrgenommen (ich sehe eine Zitrone und der Speichelfluss wird aktiviert), im Allgemeinen aber fehlt es an der Bewusstwerdung. Wir aber wollen unsere Sensibilität und damit unsere Kreativität stärken. Bei dieser Übungsaufgabe interessiert uns nun die Doppelung der Reize. Denn nur wenn uns Doppelwertigkeit irritiert, entsteht mehr als akute Bedürfnisbefriedigung. Ästhetische Reize entwickeln sich aus der Vielfalt und Ambivalenz der Stimulationen. Sehsinn und Hörsinn werden gleichzeitig beansprucht.

Ein Klangobjekt ist vorrangig kein Musikinstrument. Es klingt, es dröhnt, es klappert, es piept, es kräht, es klirrt, es rasselt, es knallt, hat also zweifellos mit der Erzeugung von Tönen zu tun, ist aber als ästhetisches Gerät zugleich eine Demonstration in den Bereichen von Mechanik, Kunsthandwerk, Skulptur und Architektur. Welcher Architekt hat nicht schon fasziniert in die Eingeweide eines Klaviers oder in den Mechanismus einer Orgel geschaut und dabei hoffentlich assoziativ sein eigenes Entwurfsdenken überprüft.

Spannend sind die Schritte der Klangerzeugung, spannender noch sind die Wegstrecken oder Umwege: von der Taste zur Saite, vom Rad zum Hämmerchen, von der rollenden Kugel zum dröhnenden Blech. Das Ergebnis selbst unterschiedlichster Lösungen der Aufgabe wird die Erfahrung sein, dass sich Bewegungsvorgänge vorhersehbar und immer wieder identisch gestalten lassen. Die Qualität der Detailgestaltung und die Verdeutlichung der Schritte vom ersten Antippen zum endlich erzeugten Ton ma-

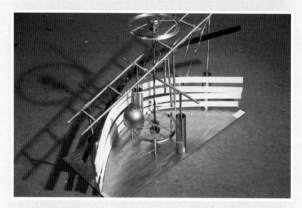

chen den Reiz und das Lehrhafte dieses Projekts aus. Dabei ebenso erhellend ist die Erkenntnis, dass Begriffe wie Tonalität, Dissonanz oder Rhythmus von einer Kunst in die andere übertragbar sind und dass es gestalterische Regeln gibt, die die verwandschaftlichen Beziehungen unter den Künsten offenbaren.

Die Gestaltungsaufgabe selbst, wie sie in Siegen gestellt wurde, lautete folgendermaßen:
Es soll ein dreidimensionales Gebilde entwickelt werden, das skulptural/kleinarchitektonische Qualitäten aufweist und zugleich musikalisch verwendbar ist, das heißt, mit dem Objekt (nennen wir es Skulptur oder Apparatur) sollen Klänge erzeugt werden können.

Wichtige Vorgabe ist: Ein für alle entstehenden Arbeiten vergleichbares Grundgerüst soll aus einer Dachlatte von 2,80 Meter Länge entwickelt werden. Wie diese Latte behandelt wird, bleibt jedem überlassen. Sie kann geschnitzt, geschliffen, poliert, ge-

färbt oder in beliebig viele Stücke zersägt werden, aber sie soll in ihrer ganzen Länge am Objekt nachweisbar bleiben (abgesehen von Abfallschnitzen, Sägemehl oder Ähnlichem).

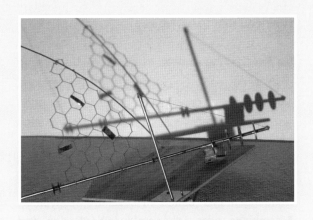

Eine zweite Vorgabe: Es dürfen und sollen weitere Materialien und Fundstücke hinzugefügt werden, welche aber die aus der Dachlatte gefundene Kubatur nicht wesentlich vergrößern sollten. Ob das Objekt mit Saiten bespannt, mit Blasröhren bestückt, mit Trommelhäuten versehen oder mittels eines sinnreichen Zupf- oder Hammerwerks in Aktion gesetzt wird, bleibt jedem selbst anheimgegeben.

Und noch eine dritte Vorgabe: Es sollen mindestens drei Klänge (Töne) erzeugt werden können. Nicht erlaubt ist jeglicher Lärm (Geratter, Gerassel usw.). Es ist zu überlegen, wie Töne und deren Lautstärke moduliert werden können. Aus all dem Gesagten geht hervor, dass Konserventöne wie Kassettenrekorder, Radioapparate, MP3-Player usw., aber auch vorgefundene Musikinstrumente nicht gut geheißen werden.

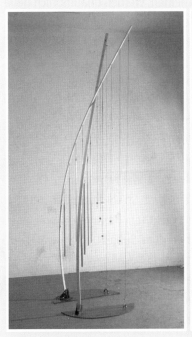

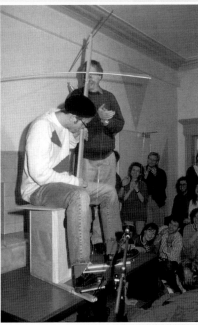

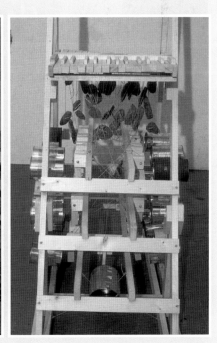

Themenübung: Stuhlobjekt

Die Zweckentfremdung, zum Beispiel die Umnutzung eines verlassenen Gebäudes, die Neubestimmung eines überflüssig gewordenen Geräts oder der überraschende Gebrauch eines zu anderer Verwendung vorgesehenen Objekts, haben Design und Architektur im 20. Jahrhundert stark bestimmt. Stichworte aus der Vielfalt der bewusst missbräuchlichen Verwendungen sind ‚Bauen im Bestand', Readymade, Assemblage oder ‚Adhocism' (wie der Design- und Architekturtheoretiker Charles Jencks die Tendenz zur ‚kreativen Neudefinition' eines Alltagsobjekts benannte).

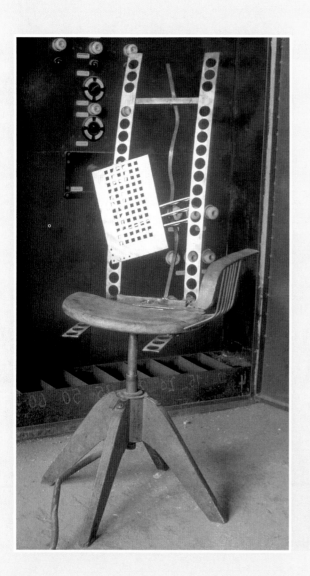

Es gibt heutzutage kaum eine Stadt, in der nicht eine leer geräumte Fabrik in ein Kulturzentrum verwandelt wurde. Im Zusammenhang dieses Kapitels interessiert aber mehr die künstlerische Neudefinition und provokative Zweckentfremdung von Alltagsobjekten. Das heruntergekommene Gerät wird zur Grundlage für skulpturale Gestaltungsübungen: Im Sperrmüll gefundene Gegenstände, Stuhl, Telefonapparat, Fahrradschlauch oder ähnliches, werden dekonstruiert, neu zusammengefügt, bearbeitet, mit ungehörigen Fundstücken ergänzt und damit zur Skulptur erhoben. Das achtlos beiseite Geworfene wird zum beachtlichen Ausstellungsstück und wird, aufs Neue betrachtet, aufs Neue gefügt, zum Wertstück.

Die Gestaltungsaufgabe „Stuhlobjekt" soll hier beispielhaft erläutert werden. Der Stuhl steht uns buchstäblich nahe. Wie der Mensch hat der Stuhl Füße, Beine, Sitzfläche und Rücken. Er ist gemütlich, weich, bescheiden – oder das Gegenteil. Er setzt sich in Positur. Unter Umständen nimmt er die Stelle des Abwesenden ein. Er wird zum Thron. Der versuchten Demütigung Wilhelm Tells hätte auch Geßlers Sitz statt seines Huts dienen können. Weil Stühle so wesenhaft zu sein scheinen, werden unaufhörlich neue erfunden; als gelte es, nicht Gebrauchsgegenstände, sondern Individuen zu gebären.

„Wer die Sessel begreifen kann, die aus Zeiten herrühren, in denen man noch verstand, beim Speisetisch zu sitzen, wird die Sessel, die Sesselgespenster von heute zurückweisen", schrieb Adolf Loos (1929) und gab damit auch seine Einschätzung vom magischen, „geistvollen" Möbel zu erkennen. Die Vorstellung ist weit verbreitet. So sollte es denn möglich sein, das stumme Objekt (ein heruntergekommenes Fundstück) zum beredten Subjekt zu verwandeln? Liebevoll hergerichtet, liebevoll poliert, gibt es die Liebe zurück. Indem wir die Gestalt proportionieren, das Fleisch (Material) kneten, die Oberflächen glätten, entsteht allmählich aus einem groben Klotz ein

166

anmutiges Geschöpf. „Die Jahresringe mussten sich genau der geschweiften Form [des Sessels] anpassen", berichtet Loos von einem Werk des Tischlers Veillich (gedanklich etwas ungenau, denn: Wer passt sich da wem an?).

Aufgabe ist also, Stuhlleichen aus dem Sperrmüll zu retten und ins Leben zurückzuholen. Reizvoll wird es sein anzusehen, wie der Fund sich nach der „Decke", das heißt, nach seinem Retter streckt. Charaktere erwachen. Analogien zu gesellschaftlichen Rollen offenbaren sich: Bravheit oder Übermut, der Zwang zur Maske, zur Perfektion, zur Albernheit. Die ureigene Aufgabe der Bildhauerei, sich mit dem menschlichen Körper auseinanderzusetzen, soll hier auf dem Umweg des Negativabdrucks der menschlichen Rückseite gelöst werden.

Konkret: Man verschaffe sich einen alten ausrangierten Stuhl und (erster Schritt:) nehme ihn auseinander, füge ihn aber neuartig wieder zusammen. Das Ziel ist, er muss ‚besitzbar' bleiben. Man entferne Teile (zweiter Schritt:) und passe andere an deren Stelle ein: Es muss nicht Holz sein, auch andere, auch vorgeformte Materialien dürfen verwendet werden. Es entsteht ein stuhlähnliches Gebilde, ein Zwitter aus Möbel und Skulptur. Man beachte jedoch, dass es dem späteren Gebrauch in der Wohnung standhalten sollte.

Die Arbeit beginnt mit dem Abschälen der Häute (Abbeizen, Schleifen, Hobeln), setzt sich mit dem Herauspräparieren der Knochen fort (Entfernen von Polstern, von manchen Holzteilen, dem Einfügen von Prothesen, Metalladern oder Scharnieren) und geht weiter mit dem Hinzufügen von Reizstoffen und Verblüffungshilfen (der Transplantation von scheinbar unvereinbaren Fundstücken). Der Vorgang ließe sich als Not- oder Schönheitsoperation beschreiben. Zum Wiederbeleben gehört ebenso das wieder Ansehnlichmachen. Das reparierte, ergänzte und umgeformte Gebilde wird beigebogen, gekittet, ausstaf-

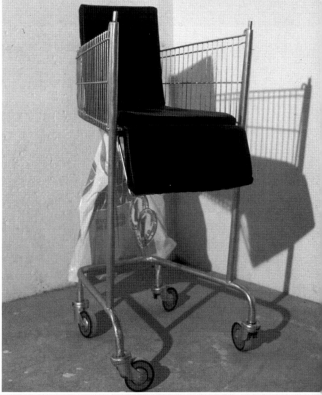

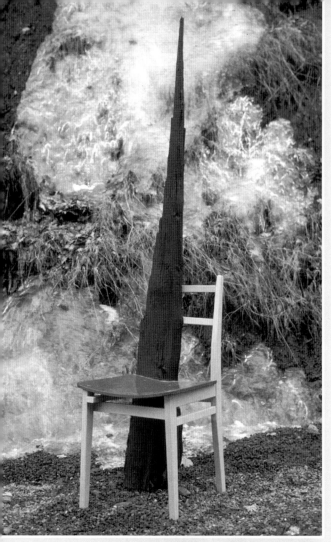

fiert, umhüllt, gerundet, präzisiert und gefärbt, bis es sich glänzend oder samtig, sanft oder aggressiv, prahlend oder bescheiden darbietet.

Warum werden hier Aufgaben und ihre Lösungen derart ausführlich erläutert? Es sollen beispielhafte Vorschläge sein, wie der eigenen Kreativität Flügel zu verleihen sei. Wir sind träge, wir sind Gewohnheitstiere. Wir neigen dazu, befremdliche, ungewohnte Aufgaben oder solche, für die es keine erprobte Lösung zu geben scheint, beiseite zu schieben. Sie verwirren zunächst. Doch ist dies eine Verwirrung, die lockert und befreit, denn um sie zu überwinden, muss der Erfindungsmotor in Gang gesetzt werden: eine Kreativitätsmaschine, von der manche nicht wissen, dass sie sie beherbergen.

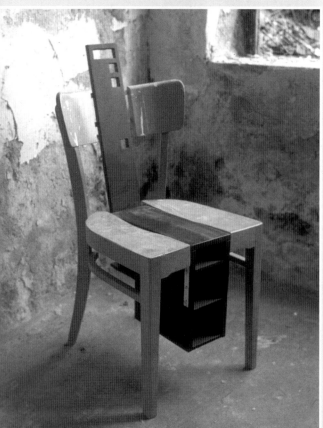

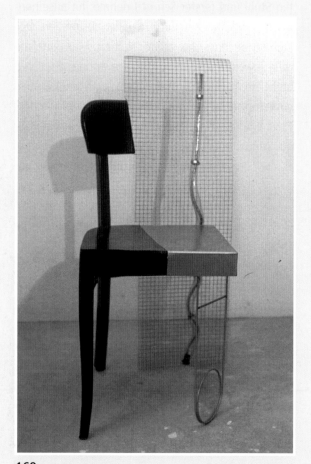

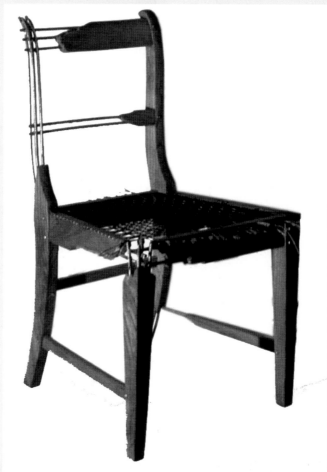

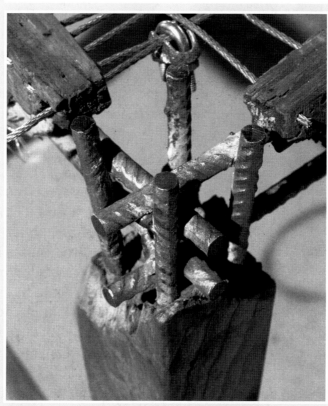

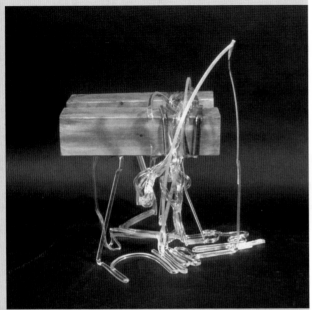

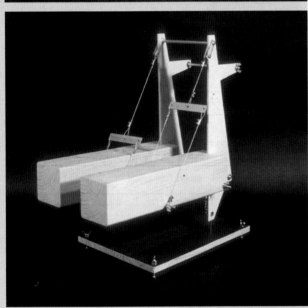

Brückenkopf

Konzeptuelle Skulpturen

Wir polarisieren gerne: Himmel und Erde, Feuer und Wasser, arm und reich. Alle Zwischenschritte sind bereits mitgedacht und warten nur darauf, bewusst zu werden. Wir denken zwei Endpunkte und meinen eine ganze Welt zu umspannen. Aber auch die scheinbar unsinnige Anregung, einander Fremdes, Gegensätze und Widersprüche, zu vereinen, ist der Versuch, eine neue, noch nicht dagewesene Welt zu erschaffen. Sie bringt das Hirn und damit die Phantasie zum Rotieren. Die Surrealisten haben sich solch wunderlicher Konfrontationen bedient (Salvador Dalis Schubladenfrauen, brennende Giraffen oder tropfende Taschenuhren).

Die Begriffe können gar nicht weit genug auseinander liegen: Flasche und Schädel, Brücke und Kopf, Fels und Raster (diese Worte als Übungsbeispiele dafür, dass entfernt Liegendes verknüpft zu ungewöhnlichen Kreationen führen kann). Bequemes, in eingefahrenen Spuren Denken wird so unmöglich. Wer sich aber auf das Experiment, Unvereinbares zu vereinigen, einlässt und es auch zu Ende bringt, wird womöglich zur eigenen Verblüffung das Erlebnis fast rauschhafter Kreativität auskosten können. Und nicht nur das: Wie im Traum entstehen scheinbar schlüssige Verknüpfungen, die in gar nicht seltenen Fällen zu brauchbaren Erfindungen heranreifen.

Organische Körperformen (Schädel, Schulter, Brust), kristalline Naturformen oder Industrieprodukte (Felsbrocken, Brücke oder Flasche) und rationale Strukturen (Raster, geometrische Grundformen) werden miteinander vermengt und ihre Karambolagen untersucht. Gibt es Durchdringungen oder Verschmelzungen? Sind Fugen oder Verbindungsstücke nötig? Müssen die Berührungspunkte stilisiert, übertrieben oder zurückhaltend behandelt werden?

Letztlich stellt sich die Frage, wie beeinflusst die eine thematische Vorgabe (Fels, Flasche) die andere (Ra-

ster, Schädel), wie gleichen sie sich an, wie verändern sie sich gegenseitig. In der bestandserhaltenden Architektur ergeben sich solche Konfrontationen immer häufiger: Die Atmosphäre der alten Fabrikhalle oder Scheune soll bewahrt bleiben und dennoch eine neuzeitliche Nutzung (Bibliothek, Konzertsaal) inkorporiert werden. So wird in kleinen Lehrübungen das Bewusstsein für spätere Großaufgaben geschaffen. Denn Problembewusstsein, die Lust an der Problemlösung und zugleich die Lust an der Erkundung seiner eigenen Schaffensgrenzen entstehen nicht von alleine, sondern müssen erst geweckt werden. Das ist Vorgabe und Sinn jeglichen Lernens.

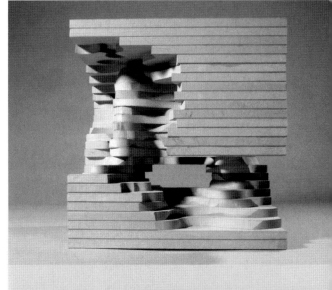

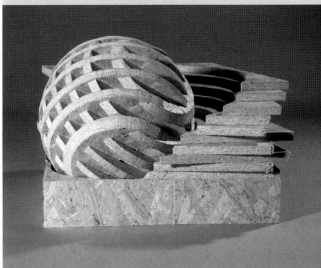

Flasche und Schädel

Fels und Raster

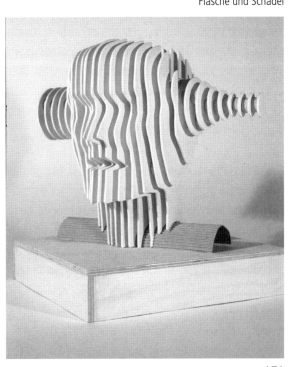

Themenübung: Dreidimensionale Sequenz

Nicht weniger bedeutsam ist die Erkenntnis (die dem Anfänger erst vermittelt werden muss), dass Architektur nicht beständig ist, sondern sich verändert. Sie verändert sich im Laufe der Zeit: Sie wird umgebaut, erweitert, anders genutzt, sie bröckelt, wird instabil, setzt Patina an und wird restauriert. Wie weit das schon in der Planung berücksichtigt werden muss, ist eine Frage der Bauaufgabe, aber auch der Einstellung von Planer und Bauherren.

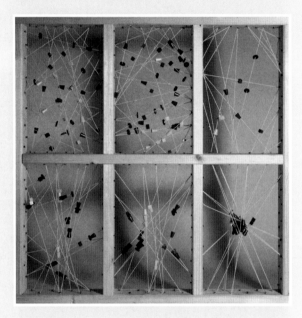

Gebäude und Benutzer sind einander verbunden. Benutzer wechseln nach geraumer Zeit, ebenso ändern sich ihre Empfindungen angesichts des Baus. Der Bau wird nach und nach mit anderen Augen gesehen, seine Anmutung wechselt. Der Benutzer umrundet das Haus, inspiziert das Innere, spaziert von Raum zu Raum. Tief in Gedanken verdächtigt er sein Haus, dass es Gestalt, Farbe und Ausdruck von Schritt zu Schritt verändere. Jeder Bau ist offenbar eine verdichtete Sequenz von imaginären Baugestalten. Das bedeutet letztlich, dass schon der Planer in Gedanken kontrollierend durch sein fiktives Projekt wandern muss, um möglichst keine Ecke, keinen Fleck ungeprüft zu lassen.

Wie aber verändert die Psyche des Hausbewohners die Hausgestalt, wie die Mobilität des Benutzers die Immobilität des steinernen, stählernen Volumens? Ein Bauwerk macht von Tag zu Tag neue Metamorphosen durch, wenn diese auch nur in der Wahrnehmung des Betrachters stattfinden. Die Sensibilität für derart schillernde Raumsichten zu wecken, ist Aufgabe des Gestaltungslehrers. Zeichnerische Versuche sind bereits im Kapitel ‚Freies Zeichnen‘ (s. S. 61) abgebildet und behandelt. Ein Vorschlag für eine skulpturale Übung sei im Folgenden dargestellt.

Eine Sequenz soll entwickelt werden, die den Anschein einer ‚gefrorenen‘ Bewegung vermittelt. Dies lässt sich als metamorphotische Reihung wiedergeben. Ein Ereignis, eine dreidimensionale Collage, ein Nebeneinander von Objekten oder ein einzelnes Objekt wird stufenweise in seinen Veränderungen während einer zu bestimmenden Zeitspanne dargestellt. Als sei ein Film angehalten und dadurch würden die Einzelbilder, die zusammen Bewegung vortäuschen, sichtbar.

Konkret heißt das: Innerhalb eines Holzrahmens mit dem Außenmaß 50 x 50 Zentimeter (Profil der Rahmenleiste ca 5,0 x 1,5 Zentimeter) soll in mindestens sechs Schritten die Verwandlung eines Ereignisses oder Objekts veranschaulicht werden. Wert wird dabei auf Folgerichtigkeit und nachvollziehbare Distanzen (räumlich wie zeitlich) zwischen den einzelnen Gestaltzuständen gelegt.

Wir leben in einer Zivilisation, die sich kontinuierlich verändert, auch wenn wir dies aus Trägheit oft nicht wahrnehmen wollen. Dass das Denken über Architektur, ja dass die Architektur selbst ständig im Wandel begriffen ist, diese kreative Ungewissheit zu vermitteln, gehört zur Aufgabe der Gestaltungslehre.

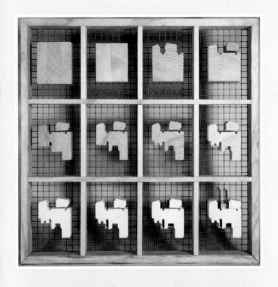

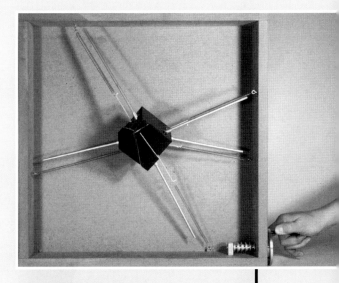

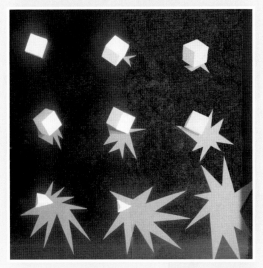

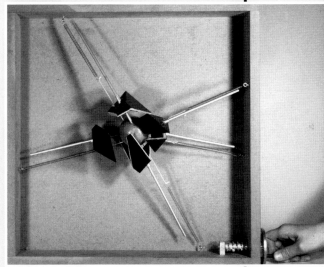

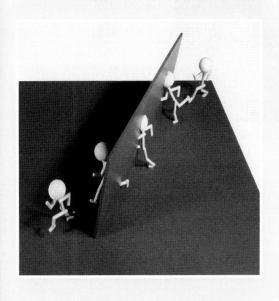

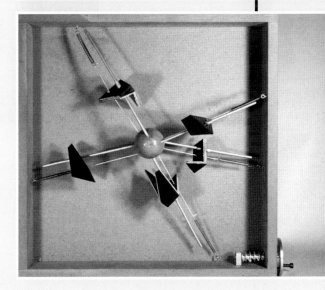

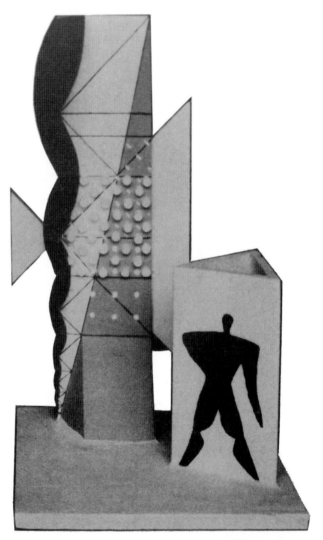

Ein Denkmal für Le Corbusier

7 Gestaltbezogene Architekturtheorie

Praktische Architekturkritik

*Architektur schrieb die Geschichte der Epochen
und gab ihnen ihre Namen.*
Mies van der Rohe

Der römische Tempel ist nicht ohne den griechischen, die romanische Basilika nicht ohne die römische Markthalle, die palladianische Villa nicht ohne Andrea Palladio und dessen antike Vorbilder denkbar. Architektur bezieht sich auf Architektur, Architekten lernen von Architekten. Walter Gropius hat angeblich, als er seine Lehre an der Harvard University begann, den baugeschichtlichen Apparat der Fachbibliothek verschließen lassen. Seine Studenten sollten „modern" entwerfen und sich nicht von historischen Vorbildern beeinflussen lassen. Das konnte nicht funktionieren, schon deshalb nicht, weil Architekturgeschichte und Theorie nicht in der fernen Vergangenheit enden, sondern immer auch dem Pfeil in Richtung Zukunft folgen.

Gestern Beendetes ist unabwendbar bereits heute Geschichte. Zeitgenossenschaft bedeutet, dass viele fast gleichzeitig Ähnliches denken und tun, dass viele sich gegenseitig beeinflussen. Der eine lässt etwas nur ein wenig früher entstehen als der andere, der es wie elektrisiert aufnimmt und es weiter entwickelt. Wechselseitig wird der eine des anderen Epigone. Hin und her werden sie einander zur Historie.

Es ist für Architekturstudierende unabdingbar, sich mit Geschichte und Theorie der Baukunst zu beschäftigen. Sie müssen fähig werden, gotische Details (nur ein Beispiel) zu beurteilen und unter Umständen auch zu kritisieren. Es geht nicht darum, Details zu kopieren, sondern es geht um kompositionelle oder konstruktive Ungereimtheiten. Sie sollen Disproportionen, missglückte Anschlüsse, fehlende Übergänge zwischen Bauteilen und gestörte Reihungen erkennen lernen. So werden sie auf Selbstkritik an eigenen Projekten vorbereitet. Sie lernen hoffentlich auch, dass Architekturtheorie nicht allein

176

die Beschäftigung mit geschriebenen Quellen sein kann, sondern dass Zeichnungen, Filme, Modelle ebenso zu Bestandteilen einer umfassenden Architekturtheorie werden können.

Das Fach Gestaltung kann zur Projekt-Reflexion beitragen, indem es fachübergreifende Themen bearbeitet. Die bereits vorher vorgestellten bildnerischen Übungen sind nicht ohne konstruktive Überlegungen zum erfolgreichen Ende zu bringen. Wie aber sind Geschichte und Theorie in die Praxis zu übersetzen?

Dass über das, was uns umhüllt (Kleidung, Gebäude), analytisch nachzudenken ist, ist beileibe nicht selbstverständlich. Nachdenken ist Arbeit – und um diese zu vermeiden, verwechseln Architekten gerne Architekturtheorie mit Baugeschichte. Bauwerke Epochen zuordnen, Motivreihen über Zeiten und Orte hinweg verfolgen: Ordnung schaffen und Systematisieren bewirken da den beglückenden, aber ungerechtfertigten Schauer gefestigter Erkenntnis.

Solche Erkenntnis aber ist abstrakt, ist meist eine vorläufige und zu leicht verdient. Denn der Schatz auswendig gelernten Wissens wird im täglichen Planungsgeschäft eher als Ballast empfunden. Wird diese Wissensbürde angewendet, beendet es den kreativen Zustand geistiger Beunruhigung mitunter zu früh. Man muss nicht alle Bezüge zur Baugeschichte kennen und kann dennoch sinnvoll über historische Architektur sprechen und nachdenken – auf Grund der Konstanz menschlicher Wahrnehmung.

Das Alltagsleben und seine Verrichtungen wandeln sich kaum im Laufe der Menschheitsgeschichte, das heißt, sie tun dies nicht parallel zum Fortschreiten von Zivilisation und Technik. Mit sturer Beharrlichkeit wird die individuelle Aneignung des Lebensraums über weite Zeiträume hinweg mit identischen, mittlerweile selbstverständlichen Verhaltensweisen betrieben. Fernseher und Kühlschrank sind nichts

Rigorose Architekturkritik: Berlin, Palast der Republik, Abriss 2006–2008 aus politischen Gründen

Architekturvisionen sind als Kritik am Bestand zu verstehen:
„Updating Germany. Projekte für eine bessere Zukunft"
Ausstellung im Deutschen Architekturmuseum, Frankfurt 2008

anderes als die zeitgenössischen Entsprechungen für die archaische Feuerstelle, dem Ort des behaglichen Miteinanders, und des Brunnens, der Quelle des lebenspendenden Wassers.[38]

Das heiß aber auch: Der allgemeine Konsens über Räume und Wege, über Weite und Nähe, über kontemplative und kommunikative Orte, über sich Einkapseln und sich Öffnen, (auch wie Konstruktion sich ausdrückt als Schichten, Fügen, Lagern oder wie Statik sich äußert als Stabilität, Labilität, Leichtigkeit und Schwere) bleibt über die Zeiten hinweg fast gleich. Wer sich als Entwerfer mit Baugeschichte befasst, beschäftigt sich nicht mit chronologisch geordneten Stilelementen, sondern mit den zeitlosen Strukturen der Baukunst und ihrer Monumente – und derer Details.

Dass Theorie auch praktisches Handeln (vergleichen, messen, skizzieren, modellieren) bedeutet (Handarbeit in untrennbarer Symbiose mit Kopfarbeit), muss Studierenden immer wieder vor Augen geführt werden. Deswegen sollen hier zwei mögliche bildnerische Übungen vorgestellt werden, die unvoreingenommen und auf der Grundlage äußerst geringen Basiswissens historische Vorlagen zur Bearbeitung vorschlagen.

178

Themenübung: Vorbild und Sinnbild

Das Ergebnis der Übungsaufgabe (Vorbild und Sinnbild. Modell-Piktogramme prominenter Bauten) wurde 1986 im Deutschen Architekturmuseum in Frankfurt am Main als kleine Ausstellung präsentiert. Aufgabe war, sich mit einem prominenten Bauwerk – vornehmlich der Moderne – analytisch in einem räumlichen Modell auseinander zu setzen. Allerdings würde das maßstabsgerechte Modell allzu leicht dazu führen, sich auf handwerkliche Akrobatenkunststückchen, auf den Effekt der märklinhaften Miniaturisierung zu verlassen. Auf die Art gerät man lediglich in eine Bestandsaufnahme, nicht in ein Gespräch über Architektur, erst recht nicht in ein fiktives mit den großen Kollegen. Deshalb gab es die zusätzliche Vorschrift, den Bau innerhalb eines vorgegebenen Rahmens im Relief darzustellen.

Es galt also, hervorragende Ansichten, Übereckperspektiven oder Details herauszufinden, die das Bauwerk prägnant repräsentieren. Durch die geringe Tiefe des Reliefs bedingt, musste mit Ausschnitten, Scheinperspektiven und extremen Verkürzungen gearbeitet werden, was zur Reduktion auf das charakteristische Merkmal und mitunter zur karikaturhaften Übertreibung stimulierte, aber damit zugleich versteckte Entwurfsgedanken verdeutlichte.

So ist ein ‚Gespräch' eröffnet und die selbständige Interpretation – bis hin zur Collage aus herausgebrochenen Architekturelementen – ermöglicht. Der ungenierte Umgang mit den „heiligen Kühen der Moderne" war beabsichtigt, in der Ausführung oft verblüffend und meist wohltuend.

Die beispielhaften Abbildungen zeigen:
1. Willem M. Dudoks Nähe zur Künstlergruppe ‚De Stijl' werden durch kaum merkliche Verzerrungen der Fassade seines Rathauses in Hilversum (1928-30) und die Einfügung in eine Mondrian'sche Komposition verdeutlicht.

2. Mies van der Rohes Idealentwurf einer Backsteinvilla (1923), der prägnant darstellt, wie Landschaft und Haus nahtlos ineinander fließen könnten, wird im Grundriss als rahmensprengende Verzahnung von Innen und Außen dargestellt.
3. Dass das Pariser Centre Pompidou (1971–77) die Innenwelt (Konstruktionselemente, technische Installationen, Rolltreppen usw.) nach außen stülpt, ist nur im Ausschnitt aus seinem Skelett wiedergegeben. Dennoch scheint alles Wesentliche gezeigt zu sein.
4. Richard Meiers Entwurfsgedanke für das Museum für angewandte Kunst (1982–84) in Frankfurt – nämlich der Bezug auf die vorhandene klassizistische Villa – wird durch einen Spiegeltrick überraschend einfach demonstriert.

Die scheinbar rücksichtslose Annäherung an Inkunabeln der Baukunst – mehr spielerisch als wissensbelastet – stellt längst verkrustete Meinungen des Architekturjournalismus in Frage, deckt unvermutete Analogien auf und führt mit leichter Hand vor, wie Architekten denken.

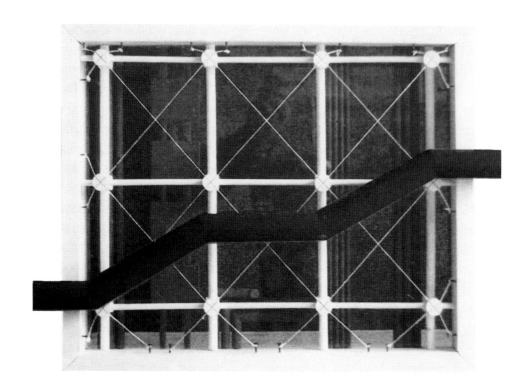

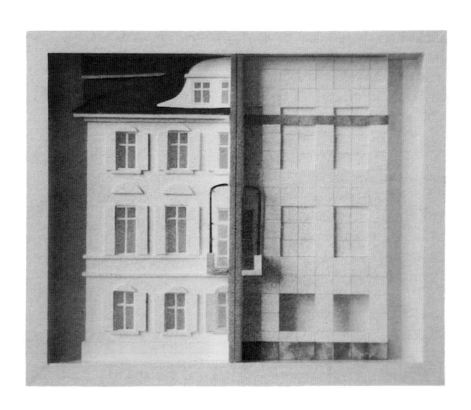

Themenübung: Carceri

Es gibt sicher zahllose Möglichkeiten, Baugeschichte in Gestaltungsaufgaben einzubinden. Hüten wir uns allerdings davor, der Realität zu nahe kommende Abbildungen zu produzieren. Immer muss es um Transformationen in eine andere Sprache gehen. Ein Vorschlag für die kreative Übersetzung einer flächigen Vorlage (Zeichnung, Grafik, Gemälde, Foto) in eine dreidimensionale Skulptur sei folgender:

Eine Radierung Giovanni Battista Piranesis (1720–1778) aus seinem Mappenwerk „Carceri" soll als Vorlage für ein skulpturales Modell genommen werden. Piranesi war fasziniert von der römischen Antike und erfand eines Tages wie im Fieberwahn eine Folge von Gefängnis-Darstellungen, die völlig surreal die Welt als unendlichen, steinernen Kerker wiedergeben.

Für unsere Skulptur-Aufgabe ist Tafel XIV (siehe Abb.) besonders anregend, weil sie scheinbar eine ‚Kippfigur' (wie Wahrnehmungspsychologen es nennen) enthält: Ein Arkadenpfeiler scheint sowohl einer Vordergrundebene wie auch einer Ebene im Hintergrund zuzugehören. Der Pfeiler ‚springt' von einer Ebene zur anderen, je nachdem auf welche Schicht man seine Augen fixiert. Scheinbar irreal, scheinbar im Modell unbaubar. Dass diese Kippfigur aber kein Perspektivfehler ist, sondern nur von einer raffinierten Standpunktsuche Piranesis herrührt, hat erstaunlicherweise Alex Görg im Modell nachgewiesen und damit gewisse Spekulationen mancher Theoretiker widerlegt.

Tafel XIV in eine Skulptur umzusetzen und neu zu interpretieren, war eine Übung im Siegener Fachbereich, die Ende eines zweiten Semesters ausgegeben wurde und im letzten Drittel des dritten Semesters beendet sein musste. Anschließend in einer unterhaltsamen und lange währenden Sitzung wurden die Ergebnisse präsentiert und besprochen. Hier folgt ein

Auszug aus dem Aufgabenblatt:
Vorgegeben ist eine Grundfläche: 45/45 cm, ca ein bis zwei Zentimeter stark (z. B. Sperrholz). Die Höhe steht in Ihrem Belieben, sollte aber das doppelte Maß, also 90 cm, nicht überschreiten. Verwenden Sie als Material: Holz, Kunststoff, Metall, Glas und/ oder Pappe u. ä. (Materialstärke mindestens zwei Millimeter, ausgenommen Draht und Schnüre). Nicht zugelassen sind: Papier, Styropor und verderbliche Substanzen. Farben sind zugelassen, sollten aber nur zur Unterstützung des Dreidimensionalen verwendet werden. Bedenken Sie, dass Materialfarben oft völlig ausreichend sind.

Es handelt sich um eine Architekturskulptur mit Modellcharakter. Sie können demnach das, was Sie bereits im Entwerfen, im Modellbau und in der Gestaltungstheorie gelernt haben, hier einsetzen. Denken Sie an Ihren künftigen Beruf, das heißt, dass Sie Wert legen sollten:
- auf detaillierte Fügung der Materialien,
- auf präzise Verknüpfungen oder Knoten,
- auf Licht und Schatten,
- auf ausgewogene Gewichtung der Volumen und Zwischenräume.
Es ist empfehlenswert, von einem zentralen Punkt oder Knoten oder Achse (die nicht mittig liegen müssen) auszugehen und von dort Ihr Werk sich entfalten zu lassen. Vergessen Sie dabei nicht die Prinzipien ‚Unendlichkeit' und zugleich ‚Verkerkerung'.

Beginnen Sie mit einem kleinen, ganz flüchtigen Überlegungsmodell (Handgröße), mit dem Sie zur Besprechung bei mir erscheinen sollten. An endgültigen Leistungen werden von Ihnen erwartet:
- eine Skulptur wie beschrieben (stabil, also auch transportfähig)
- eine ausstellungsfähige Zeichnung oder Gemälde oder Collage zur Erläuterung des Konzepts (keine erläuternde Schrift).

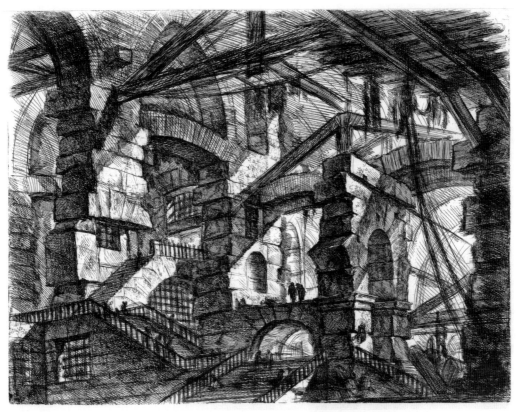

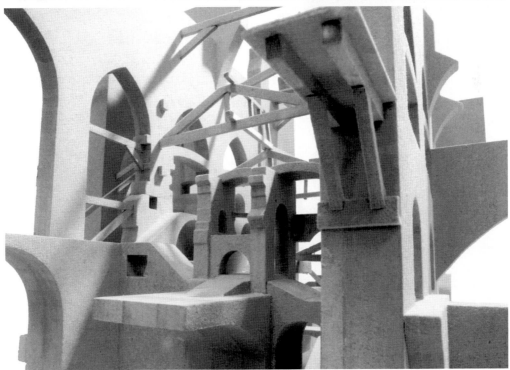

Alex Görg, Carceri, Tafel XIV als Modell

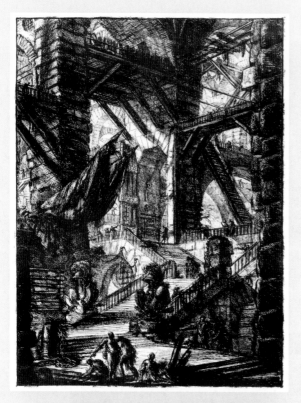

Wie bei den Übungen „Flasche und Schädel" oder „Fels und Raster" geraten auch hier die Bearbeiter in die verwirrende Bedrängnis, Ungewohntes leisten, Unvereinbares miteinander vereinen zu müssen. Kerker sind darstellbar, aber Unendlichkeit? Die Studierenden werden darauf gestoßen, dass intellektuelle Zwangslagen zu kreativen Leistungssteigerungen führen können. Pädagogisches Ziel ist, herauszufinden, dass es keine Sackgassen im kreativen Handeln gibt, schlimmstenfalls Verzögerungen.

Wenn Studierende sich gestaltend in vergangene Epochen hineinfühlen, dann geraten sie unweigerlich in Konflikt mit dem Geist ihrer eigenen Zeit. Diese Konfrontation als Chance zu begreifen, etwas Eigenständiges zu produzieren, muss auch eines der Lehrziele im Fach Grundlagen der Gestaltung sein.

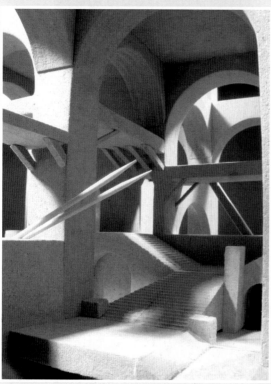

Ea Dietrich, Carceri, Tafel VIII als Modell

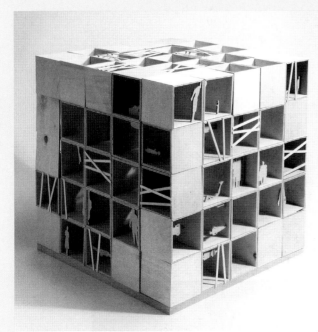
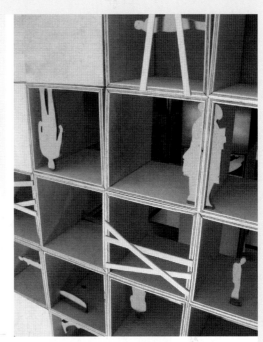
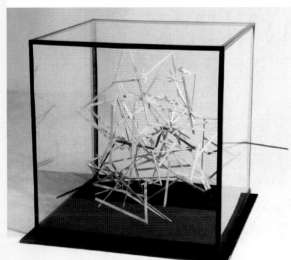
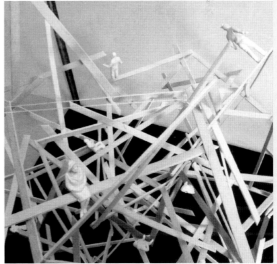
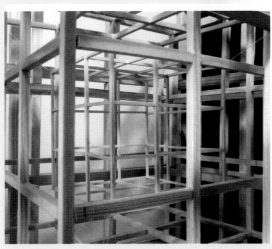

Themenübung: Carceri

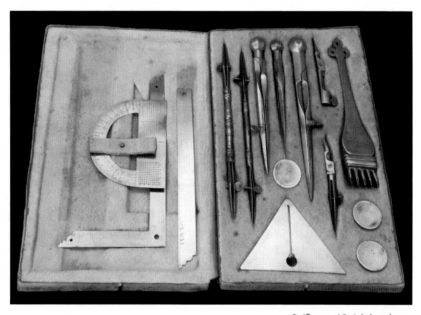

Reißzeug, 18. Jahrhundert

8 Zeichenmittel

Mit großen Brocken zeichnen

Scharrzeichnung in der Nazca-Ebene (Peru),
„Kolibri", ca. 90 Meter lang

Mitunter sitzen wir ratlos und wie gelähmt vor dem leeren Bogen Papier. Dann hilft, sich zu entfesseln, kindliche Unbekümmertheit zurückzurufen, über den eigenen Schatten zu springen und vielleicht in Gesellschaft mit anderen, vergleichbar dem ‚Brainstorming', Undenkbares zu denken, vor allem aber es einander zu vermitteln, das heißt, es zu skizzieren. Man glaubt zu wissen, wie und womit man zeichnet und malt. Aber der Möglichkeiten sind weniger Grenzen gesetzt, als man denkt. Fast mit allem, jedem und überall lässt sich skizzieren und pinseln: mit Ast und Streichholz, mit Besen und Nadel, mit Steinen und Grassamen, Mit Finger und Ellenbogen, mit Lappen und Schwamm, mit Traktor und Rasenmäher; mit Rotwein und Kaffee, mit Schokolade und Öl, mit Ruß und Blut, auf Verpackungskarton und Tapetenresten, im Sand und auf Brachland oder mit dem Strahl der Taschenlampe in der Nacht.

Wenn der Architekt jedoch für sich projektbezogen nachdenkt, nicht am Computer entwirft, wenn er noch in der Anfangsphase seines Projekts seine Ideen skizziert – oder aber wenn am Ende die Präsentation ansteht und er endlich seiner Lust frönen und den Bauherren demonstrieren kann, dass er nicht nur ingeniös, sondern phantasievoll, kreativ und in den Künsten zu Hause ist, dann bleibt er dennoch – im Gegensatz zum freien Künstler – handwerklichen Einschränkungen unterworfen. Sein auf dem Zeichentisch liegendes Arbeitsmaterial und der notwendige Zwang, sich allgemein verständlich auszudrücken, setzen ihm Grenzen. Noch der avantgardistischste Entwurf ist in seiner Darstellungsweise konservativ, das heißt, gegenständlich. Des Architekten Werkzeuge sind gebräuchlich, klein und handlich und im großen Ganzen seit Jahrhunderten erprobt:

Bleistift, Buntstift, Stahlfeder mit Halter, Rohrfeder, Tinten- und Tuschefüller, Marker, Kugelschreiber, Aquarellkasten und Farben, Aquarellpinsel, Ra-

188

*diergummi, Schere, Maßstab, Lineal, Zirkel, Drei-
eckswinkel, Messer (Skalpell), Kreisschablone,
Radierschablone, Skizzenbuch, Skizzenrolle, un-
terschiedliche Papiere und Zeichenblöcke, Zeichen-
lampe.*

*Die Zeichenmittel sollen nun im Einzelnen be-
schrieben werden. Die meisten wird man kaufen
(nach und nach) oder sich schenken lassen müssen.
Falsche Sparsamkeit aber kann nur schaden. Von
Anfang an sollte man sich darüber klar sein, dass
man womöglich in kürzester Zeit (noch während
des Studiums) ‚Profi' sein wird und dazu gehört
nun mal professionelles Werkzeug. Mindere Quali-
tät ist ein ständiger Anlass zum Ärger, eine Quelle
der Unlust, eine Bremse der Gestaltungskraft.*

Bleistift

Der Bleistift ist zweifellos das wichtigste Skizzier-
und Ausführungswerkzeug. Auf den meisten Unter-
gründen zu verwenden, nur nicht auf glänzenden
und fettigen Oberflächen. Er trägt seinen Namen
mittlerweile zu Unrecht. Blei ist in seiner Mine schon
lange nicht mehr enthalten. Graphit und Ton werden
vermengt und dann gebrannt. Umso mehr Ton in der
Mischung enthalten ist, desto härter ist die Mine.
Weiche Bleistifte tragen die Bezeichnung B (= Black,
6B ist am weichsten, auch am schwärzesten), harte
Stifte die Bezeichnung H (= Hard, 6H ist am här-
testen, aber auch am blassesten). Dazwischen lie-
gen HB- oder F (=Firm)-Minen, die dem Skizzierer
nachdrücklich zu empfehlen sind. Weder verschmiert
mit dem HB-Stift die Zeichnung so leicht wie mit B-
Minen, noch wird sie so blass wie mit H-Minen (6H-
Minen werden für präzise technische Zeichnungen
gebraucht). Stifte in Holzfassung sind am gebräuch-
lichsten, denn mit ihnen lässt sich leicht die Strich-
stärke variieren. Durchgesetzt für die flüchtige Skiz-
ze haben sich aber auch Feinminenstifte, die es in
unterschiedlichen Strichstärken gibt. Ihr Vorteil: Der
Strich ist gleichmäßig, es ist kein Nachspitzen der

Holzbleistifte und Minenhalter

189

Minen nötig, ihr Nachteil: Es ist kaum ein An- und Abschwellen des Strichs möglich. Alle dickeren Minenhalter (z. B. für Kohle oder Rötel) sind im Allgemeinen für die Architekturskizze zu vernachlässigen, wenn sie auch manchem Zeichner aus individuellen Gründen notwendig erscheinen mögen.

Buntstift

Es gilt ungefähr das für den Bleistift Gesagte. Hinzu kommt die Auswahl der Farben. Man kann sich einen Farbkasten kaufen, der umso größer und inhaltsreicher ist, desto konsumfreudiger man ist. Aber mit der Zeit wird man feststellen, dass manche Stifte schnell kürzer werden, manche unverändert bleiben. Warum also nicht sparen und Stifte einzeln kaufen. Eine vernünftig reduzierte Auswahl hat den Vorteil, dass man nicht verführt wird, Buntheit zu erzeugen. Deshalb besorgt man sich nur ein paar Farben: vielleicht Kadmiumgelb, Scharlachrot, Violett, Ultramarin, Phthaloblau (mittel), Olivgün, Ocker gebrannt, Umbra Natur. Da man die Farben schraffierend übereinander legen kann, sind viele Zwischentöne möglich. Noch ein Hinweis: Farbharmonie erzeugt man am einfachsten, indem man eine gleiche Grundfarbe unter alle anderen Farben legt.

Buntstifte

Spitzer

Bleistiftminen nutzen sich beim Zeichnen spatelförmig ab. Dem kann man eine Zeit lang abhelfen, indem man den Stift währen des Zeichnens zwischen Daumen, Zeige- und Mittelfinger ab und zu dreht. Das währt eine Weile, aber dann kann man nicht umhin, die Spitze wieder nach zu schärfen. Man kann Bleistifte in Holzfassung mit dem Taschenmesser anspitzen, aber gleichmäßiger wird das Ergebnis mit Metallspitzern (in der einfachsten Fassung sehr preiswert und klein), mit Dosenspitzern (enthält einen praktischen Spänebehälter) oder mit Bleistiftspitzmaschinen (sehr komfortabel, aber für unterwegs zu groß).

Spitzer (Varianten)

Radiergummi

Manche Zeichenlehrer verbieten ihren Schülern das Radieren. Sie verlangen, dass auch zufälliges Gekrakel dokumentiert wird. Denn es kann Spontanität ausdrücken, es korrespondiert mit den ach so menschlichen Schwächen: Man stolpert, man eckt an, man verläuft sich und entdeckt dabei Unerwartetes. Jedoch manchmal ist der Strich allzu unzulänglich. Dann wird das rigide Verbot dieser Kollegen fragwürdig, denn nun muss radiert werden. Zudem kann der Radiergummi zum unentbehrlichen Zeichenmittel werden, wenn die Zeichnung bewusst sehr dicht geworden ist (mittels Schraffuren). Mit dem Radiergummi lassen sich dann weiße Spitzlichter, Lichtkanten oder Sonnenstrahlen in die Graphitfläche radieren. Einst radierte man mit Brotkrumen, dann mit speziellem Knetgummi (auch heute noch für 6B-Bleistiftminen oder Kohle zu empfehlen). Der klassische Radiergummi aber besteht aus Naturkautschuk und hat zwei unterschiedliche Seiten, eine Seite (rot) für Blei- und Farbstifte, eine Seite (blau) für Tusche und Tinte. Sein Nachteil ist, dass er altert und dann die Zeichnung verschmiert. Am Brauchbarsten sind milchfarbene Kunststoffradierer (es gibt sie ebenfalls mit blauer Hälfte). Sie altern nicht und sie schmieren nicht.

Radiergummis

Radierschablone

Wer exaktere Kanten, Kurven, Kreise radieren will, benötigt eine Radierschablone. Sie besteht aus rostfreiem Federstahl, ist knapp handgroß, ist von verschieden geformten Ausschnitten durchlöchert und ist unentbehrlich, wenn man weiße Linien, Rechtecke oder kreisrunde Punkte in eine vorhandene Bleistiftzeichnung einarbeiten will.

Radierschablone

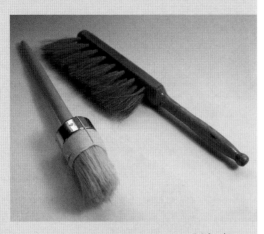

Zeichenbesen

Zeichenbesen

Radiergummis erzeugen Radierkrümel. Wer versucht, sie mit der Hand wegzuwischen, verschmiert die Zeichnung. Um das zu verhindern, braucht man einen Zeichenbesen. Ein breiter Borstenpinsel aber tut es auch.

Füllfederhalter und andere

Einen Füllfederhalter haben die meisten noch aus ihrer Schulzeit. Wenn man keine Design-Ansprüche hat, reicht er zum Skizzieren völlig aus. Schwarze Tinte aus dem Glas oder als Patrone wirkt zeichnungsgerechter und neutraler als blaue Tinte und ist daher zu empfehlen. Auf keinen Fall darf Zeichentusche eingefüllt werden. Wer es gerne etwas blasser hat, gibt eine Spur Leitungswasser in die Tinte. Vielfältiger lässt sich mit Holzfederhalter und Zeichenfeder arbeiten, auch weil man mit stärkerem oder schwächerem Druck Linien an- und abschwellen lassen kann. Zeichenfedern sollte man nach persönlicher Neigung auswählen: breit, mittel und/oder dünn. Ihr Vorteil ist, dass alle möglichen farbigen Tinkturen verwendet werden können: Tuschen, Tinten, Aquarellfarben, flüssig gemachte Acrylfarbe, Tee usw. Einen Stofflappen zum Reinigen der Federn (vor dem Eintrocknen) muss auf jeden Fall bereit gehalten werden. Erwähnt werden muss noch der Kugelschreiber mit schwarzer Mine, der ein preiswertes, durchaus brauchbares Zeichengerät ist – mit (je nach Druck der Hand) kräftigem oder zartem Zeichenergebnis.

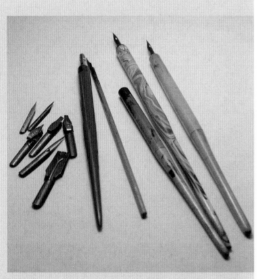

Zeichenfedern und Federhalter

Aquarellkasten, -Farben und -Pinsel

Aquarellfarben sind eine Bereicherung für Reiseskizzen, sowohl im Aquarellblock als auch im Skizzenbuch (siehe unten). Auch hier ist Sparsamkeit fehl am Platze. Lieber spart man an der Anzahl der Farbnäpfchen, die einzeln zu kaufen sind. Ein Farbnäpfchen der zu empfehlenden Firmen Schmincke, Horadam, Lukas, Winsor & Newton kostet ungefähr

drei Euro oder (je nach Farbe) noch etwas mehr. Es gibt verschiedene Kastenformate. Für Reisen ist aus Platzgründen das halbe (oder noch kleinere) Format zu empfehlen. Am besten kauft man die Kästen leer und füllt sie mit einer eigenen Farbauswahl. Als Architekt bevorzugt man vielleicht erdige, in der Natur vorkommende Farben, ähnlich der Buntstiftauswahl: Kadmiumgelb, Scharlachrot, Violett, Ultramarin, Phthaloblau (mittel), Olivgün, Ocker gebrannt, Umbra Natur. Mehr braucht man für den Anfang nicht. Der Kasten hat dann noch Platz für Ergänzungen.

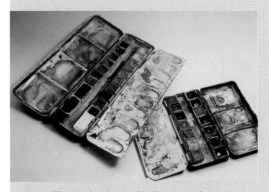

Aquarellkästen (ganzes und halbes Format)

Aquarellpinsel gibt es in verschiedenen Ausführungen. Die besten, aber auch teuersten sind Kolinsky-Rotmarderhaarpinsel, preiswerter und dennoch gut sind Fehhaarpinsel. Seit einiger Zeit haben sich preiswerte Synthetikfaserpinsel durchgesetzt, von denen es in Zeichenbedarfsläden zumeist eine breite Auswahl gibt. Für alle Pinsel sind die Größe 10 oder höher zu empfehlen, für Feinarbeiten die Größe 4. Für kleine Aquarellkästen muss man den Pinselstiel leider kürzen. Ein Stofflappen oder Papiertaschentuch zum Tupfen oder Entfernen überschüssiger Farbe muss bereit gehalten werden.

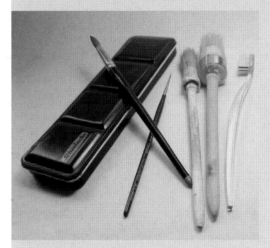

Aquarellkasten (geschlossen),
Aquarellpinsel und Borstenpinsel

Messer (Skalpell)

Skalpelle gibt es in verschiedensten Ausführungen. Man benötigt sie vor allem für den Modellbau, aber auch zum Herstellen von besonderen Zeichenschablonen, zum Beispiel aus Zeichenkarton. Nützlich sind sie auch (alternativ zum Taschenmesser) zum Lösen einzelner verleimter Blätter des Aquarellblocks.

Lineal und Dreieckswinkel

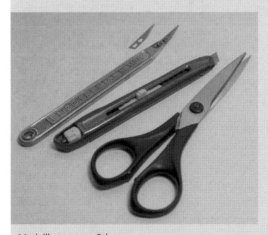

Modellbaumesser, Schere

Die gespreizte Hand, auf dem Tisch aufliegend, misst zwischen Daumen und kleinem Finger ungefähr zwanzig Zentimeter. Das zu wissen, hilft einem unterwegs, wissensgierig ein Detail skizzierend, durch-

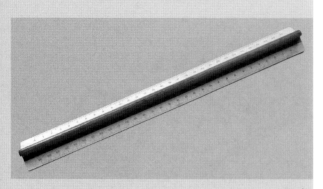

Lineal

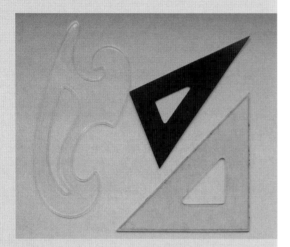

Dreieckswinkel und Kurvenlineal

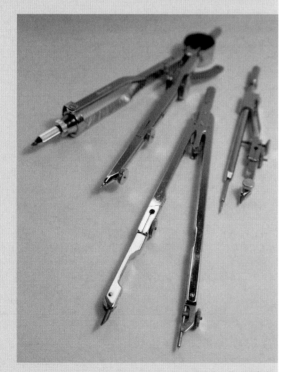

Zirkel

aus weiter. Beim präzisen Zeichnen zuhause sollte man dann einen Maßstab zu Hilfe nehmen. Ratsam ist es, sich dabei <u>nicht</u> auf den sogenannten Dreikant mit den Maßstäben 1:20. 1:25, 1:50, 1:75, 1:100, 1:125 zu verlassen. Die unterschiedlichen Anlegekanten verwirren nur und verführen zu Maßfehlern. Es lohnt sich, die nötigen Verkleinerungsmaßstäbe im Kopf zu berechnen. Die Routine hat man schnell erreicht. Wichtig ist vor allem, dass man so das Gefühl für den Zentimeter, ja letztlich für den Meter, gewinnt, bzw. nicht verliert. Dies Vermögen, Maße abzuschätzen ist auf Grundstücken, Baustellen oder in historischen Gebäuden und Ensembles außerordentlich nützlich. Wer auf den Dreikant nicht verzichten will, sollte wenigstens nicht ahnungslos zum Ingenieur-, sondern zum Architektendreikant greifen. Besser ist, sich ein Lineal mit einfacher Zentimetereinteilung (aus transparentem Kunststoff) zuzulegen. Aus transparentem Kunststoff sind auch Dreieckswinkel. Man benötigt sogenannte 45°-Winkel (mit den Ecken zweimal 45° und einmal 90°) und einen 60°-Winkel (mit den Ecken 30°, 60° und 90°).

Zirkel

Der Zirkel ist seit der Antike für Architekten, Ingenieure und Bauleute ein unentbehrliches Hilfsmittel. Er dient nicht nur zum Kreise Zeichnen, sondern auch zum Maße Abgreifen und sie zu übertragen. Auch für geometrische Lösungen ist er unabdingbar, zum Beispiel um den goldenen Schnitt zu konstruieren (siehe S. 43). Auch hier sollte man nicht sparen. Ein Zirkel ist ein Präzisionsinstrument. Ein schlichter Schulzirkel leiert leider zu schnell aus. Ein Ratschlag: Auf Flohmärkten finden sich oft sehr preiswert ursprünglich teure Zirkelkästen.

Papier, Skizzenrolle, Skizzenbuch

Skizzieren lässt sich auf jedem Papier, auch auf Servietten, Kopierpapier oder Bierdeckeln, aber für relevante Skizzen sind schon bessere Qualitäten (z. B.

194

in losen Bögen oder im Zeichenblock, 90 g/m² und mehr) erforderlich. Ist der Architekt allerdings am Projektieren und versucht, die sich überstürzenden Ideen in den Griff zu bekommen, dann verbraucht er unweigerlich viel Papier, von dem das meiste im Papierkorb landet. Dafür ist die Skizzenrolle ausreichend: dünnes, transparentes Papier, aufgerollt in ungefähr 30 cm Breite. Skizzenbücher gibt es in vielen Formaten und vielen Qualitäten (siehe S. 52 ff.). Jeder muss das für ihn Passende herausfinden, ob für die Jackentasche oder für den Rucksack.

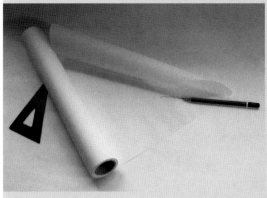

Skizzierrolle

Zeichenlampe

Bewährt haben sich Klemmlampen, die es in verschiedenen Modellen gibt. Wichtig ist der schwenkbare, zu neigende und zu drehende Arm. Preiswerte Lampen der Art findet man in Kaufhäusern. Zeichenlampen sind auf jeden Fall links vom Zeichner an den Zeichentisch zu klemmen, damit die rechte Zeichenhand nicht die Zeichnung verschattet.

Sicher ist die Aufzählung der benötigten Werkzeuge unvollständig, aber Schere, Klebstoffe, Filzschreiber usw. brauchen keine Erläuterung. Jedoch die hier aufgelisteten und erörterten Zeichenmittel sind (anders als im vorigen Jahrhundert, wo sie zum unbedingten Standardwerkzeug des Architekten gehörten) auch heute noch unentbehrlich für die kreative Anfangsphase des Entwurfs. Werk- und Präsentationszeichnungen dagegen werden im Computer entwickelt, obwohl es durchaus gewitzt und klug sein mag, in Architekturwettbewerben mit Handzeichnungen zu prunken und damit seine kreative Lässigkeit unter Beweis zu stellen. Gerade das sichtbar Spontane, flüchtig Gezeichnete, das scheinbar Unfertige erweckt den Eindruck: Da steckt offenbar noch mehr dahinter.

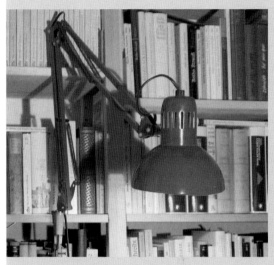

Zeichenlampe

Nicht jeder Zeichner fängt klein an, skizziert im Postkartenformat. Manch einer schätzt die große Geste oder hofft, die gesamte Umwelt gestalten

195

zu können. „Van Stoel tot Stad", vom Stuhl zur Stadt heißt ein entsprechendes Buch des Architekten Jacob Bakema. Le Corbusier plante in den zwanziger Jahren unaufgefordert ein neues Paris („Plan Voisin").' Weltenbaumeister' zu sein, füllt träumerisch die Köpfe von vielen und wenn es nur der Wunsch ist, seinen Plan sichtbar für alle (Werkzeug Flugzeug) als Graffito in den blauen Himmel zu zeichnen, „in feurigen Lettern an den leeren Himmel [zu] schreiben" (Joseph Conrad, Mit den Augen des Westens). Wolkenkuckucksheim nannte Aristophanes die im Himmel schwebende Stadt in seiner Komödie „Die Vögel".

Am Himmel zeichnen

Statt eines Nachworts

Über den Zufall

Wir Architekten neigen dazu, mit unserem Gestaltungswillen unsere Mitmenschen zu indoktrinieren (ihr Umfeld vom Stuhl bis zur Stadt zu bestimmen). Selten wird uns bewusst, dass wir so zum Handlanger eines jedermann kontrollierenden Systems werden. Die Qualität einer Planung liegt auch darin, Freiheiten zu verschaffen, Spielräume zu lassen, Engstellen und kaum nutzbare Brachen zu verteidigen, die von Minderheiten, Jugendlichen und Kindern besetzt und nach ihrem Gutdünken benutzt werden können. Ein wenig Planlosigkeit gehört zur Attraktivität eines Stadtraums, ja sogar einer Wohnung. Hüten wir uns also vor allzu rigoroser Gestaltung, preisen wir den Zufall.

Zufälle korrigieren unsere Entscheidungen. Skizzierend sitzen wir über einem bereits ausgeplotteten Grundriss. Das Projekt scheint zwar beendet, stellt uns aber womöglich nicht in allem zufrieden. Unerwartet dann ein kleiner Schock: ein Fleck. Inmitten des Blattes zeichnet sich eine dunkle Kurve ab. Wie stört uns, wie irritiert uns, wie kränkt uns die unappentitliche, ausgefranste Spur – im Grundriss drei/vier Räume verletzend, Schwellen vorschlagend, wo keine sein sollen. Und dennoch evoziert diese lästige, kreisrunde Verschmutzung eine Idee – dank einer achtlos abgestellten Tasse. Ein Schacht, ein Brunnen, ein Turm, eine Rotunde, eine Kuppel, eine Arena: Die Bilder jagen sich. Die Hand wird behend und die Stimmung amüsiert. Wir haben es nicht gewollt, aber nun mutmaßen wir in den Entwurf das hinein, was ihm fehlte. Er wird sperrig, provokant, unangepasst und, wie wir meinen, charaktervoll. Jetzt beginnt die Arbeit aufs Neue, der Implantation muss ein Sinn gegeben werden.

Jeder Handlungsstrang (das Zeichnen des Grundrisses, das Abstellen der Tasse) hat für sich betrachtet

Zufällige Kleckse können stimulieren und die ,Angst vor dem leeren Blatt' nehmen

Zufall bestimmt Form:
Es beginnt mit Klecksen und Farbspritzern. Daraus
entwickelt sich die endgültige Kompostition.

eine folgerichtige Entwicklung genommen. Selbst ihr Zusammentreffen hat seine Konsequenz. Dennoch überrascht uns das in sich schlüssige Ereignis. Wir haben die beiden Parallelhandlungen in ihren parallelen Abläufen nicht unter Kontrolle. Das Ergebnis des nicht gleichzeitigen Beherrschens mehrerer Tätigkeiten müssen wir Zufall nennen.

Das verblüffende Zusammentreffen zweier Ereignisse, wie Lautréamont es als „unerwartete Begegnung einer Nähmaschine und eines Regenschirms auf einem Seziertisch" beschrieb, stimuliert uns. Wir werden hellwach und zugleich hellträumend. Ein Beispiel aus dem vorigen Jahrhundert: Auch Daniel Spoerris ‚Fallenbilder' (um 1960) experimentieren mit der „Topographie des Zufalls", zumindest scheinen sie zufällig entstanden zu sein. Ein nicht abgeräumtes Frühstück wird auf der Tischplatte fixiert und als Komposition an die Wand gehängt. Angesichts der ungewohnten Position des Arrangements geraten wir ins Sinnieren und erkennen, trotz des Wirrwarrs hat jede Einzelheit (selbst das Ensemble der Kippen im Aschenbecher) eine nachvollziehbare Geschichte.

Was uns irritiert, ist eher die Kakophonie der Geschichten und der abrupte Abbruch des während des Frühstückens ständig weitertreibenden Zeitflusses. Durch den Stillstand wird die Zukunft ungreifbar, es gibt keine Anzeichen, wie sie sich entwickeln könnte. Verschwunden ist das Durcheinander unkoordinierter Bewegungen und damit jeder prognostische Verdacht. Der verbogene und abgerissene Handlungsstrang, der keine deutbare Richtung mehr hat, erscheint uns zufällig.

Die Frage nach der Identität von Zufälligkeit und Planlosigkeit beschäftigt den Architekten. Schließlich ist das Wort Planlosigkeit der Oberbegriff für eine Folge oder ein Nebenbei durchaus überlegter Handlungen. Nur deren Vielzahl und ihr Nicht-miteinander-Verknüpftsein, lässt den Eindruck von Zufall entstehen.

Aus verschiedenen Richtungen und verschiedenen Zeiten fahren die Raumpläne aufeinander zu, beenden ihre Fahrt vorzeitig, schießen über ihr Ziel hinaus, durchdringen einander, verklammern sich, verletzen oder verbiegen sich gegenseitig. Vergnügt genießen wir dieses Prinzip in den Altstädten, denn wenn nichts wie am Schnürchen läuft, kämpfen wir ums Durchkommen, zwingen uns zum Widerstand, stoßen uns notfalls, laufen jedoch nicht (wie woanders) mechanisch im vorgegebenen Raster, sondern fühlen uns gefordert und beteiligt, spüren jedenfalls unser Lebendigsein.

Die Zufälle des Daseins, die Undurchschaubarkeit unserer Umgebung verführen uns zu Eskapaden, gaukeln uns zumindest ein Gefühl von Abenteuer vor. Die Details eines Stadtteils, dessen Wildwuchs noch nicht einem alles regulierenden Konzept unterworfen wurde, wecken Assoziationen zuhauf, Erinnerungen die Fülle und eröffnen jede Menge Ausblicke ins geheimnisvolle Abseits.

So ist es begreiflich, dass manche Architekten in ihren Plänen gerne ein wenig Planlosigkeit bewahren, melancholische Reminiszenzen an ein scheinbar verlorenes Paradies. Es ist, als wollten sie damit ein Stück bunte Kindheit mit ihren Geheimnissen und pittoresken Geisterhausphantasien retten. Ihr Glaube an die Kraft der Provokation wird zur Stimulanz im Entwurf. Die Brüskierung hat geradezu psychoanalytische Funktion. Sie öffnet Oberflächen und zeigt auf Verborgenes. Wie der Psychoanalytiker den Traum, so benötigt der Planer den Zufall. Das äußert sich dann in den Projekten derart, als verharre ein konstruktives Geschehen auf dem Balancepunkt zwischen Unordnung und Ordnung. Den schönen Schein des Rätsels, was denn geschehen wäre, wenn der Stillstand nicht eingetreten wäre, wollen wir Zufall nennen.

Das Vorhaben dieses Buches war zu sensibilisieren, nicht Rezepten oder Moden nachzufolgen, sondern

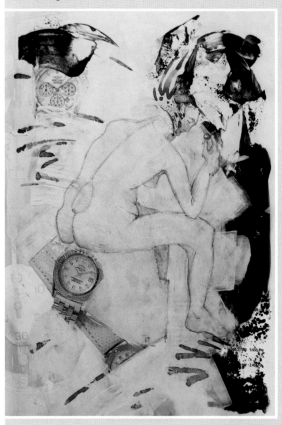

Zufall bestimmt Form und Inhalt:
Uhrenwerbung, teilweise grundiert und nach der Anweisung Leonardos (s. S. 47) weiter bearbeitet

eine eigenständige Sicht auf die Umwelt zu gewinnen, auch wenn diese unbewährt, unsicher und fehlerbehaftet erscheinen mag. Deshalb endet das Buch mit einem Plädoyer für den Nutzen des Zufalls, für das Ungestaltete im Gestalteten.

Zufallsskulptur:
textiler Frostschutz für einen Rosenstock,
digital bearbeitet

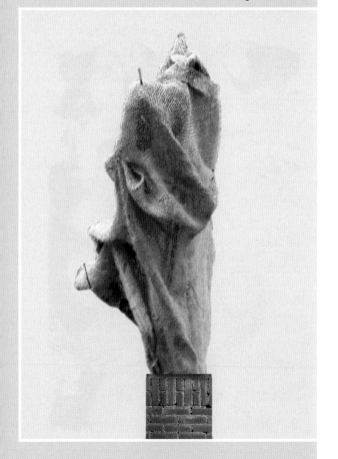

Anmerkungen

[1] Adorno-Vorlesungen „Theorie des Bildakts", Goethe-Universität Frankfurt am 8. und 9.11.2007

[2] Frankfurter Rundschau vom 12.7.2008

[3] Die Zeit, 9.8.2007, S. 30

[4] Hans L. C. Jaffe, Mondrian und De Stijl, Köln 1967, S. 38

[5] Ulrich Conrads (Hrsg.), Programme und Manifeste zur Architektur des 20. Jahrhunderts, Berlin/Frankfurt/Wien 1964, S. 75

[6] van Doesburg, Caminoscopie 1921, zit. n. ders., Das andere Gesicht, München 1983, S. 131

[7] Le Corbusier, Ausblick auf eine Architektur, Berlin/Frankfurt/Wien 1963, BWF 2, S. 38

[8] E. Bruce Goldstein, Wahrnehmungspsychologie, Kap. 6, Heidelberg/Berlin 2002

[9] Leonardo da Vinci, Sämtliche Gemälde und die Schriften zur Malerei, München 1990, S. 191

[10] Le Corbusier, Der Modulor 1, Stuttgart 1985, S. 55

[11] Biographische Notizen, In: Max Ernst Ausstellungskatalog, Köln/Zürich 1962/63

[12] Leonardo, a.a.O.,S. 385

[13] Conrads 1964 S. 47

[14] Im Interview mit Hanno Rauterberg in: Die Zeit, 21.2.2008, S. 45

[15] Briefwechsel zwischen Goethe und Zelter (Hrsg. v. Max Hecker), Bd.3, Frankfurt am Main 1987, S. 94

[16] s. a. Ulrich Schnabel, Im Labyrinth des Denkens, Die Zeit, 3.4.2008, S. 39

[17] Louis Kahn, Gespräche mit Studenten, Bauwelt 1971, Heft 1-2

[18] Bruno Reichlin in: Institut für Geschichte und Theorie der Architektur (Hrsg.), Alberto Sartoris, Ausstellungskatalog der ETH Zürich, Zürich 1978, S. 8

[19] Erwin Panofsky, Die Perspektive als „symbolische Form" (1927), in: Erwin Panofsky, Aufsätze zu Grundfragen der Kunstwissenschaft, Berlin 1974, S. 126

[20] Heinrich Wölfflin, Prolegomena zu einer Psychologie der Architektur, München 1886, S. 13

[21] ebd.

[22] Brief an Emile Bernard am 15. April 1904

[23] Literaturhinweis: Richard Sennett, Fleisch und Stein, Berlin 1995; Wolfgang Meisenheimer, Choreographie des architektonischen Raums, Düsseldorf 1999

[24] Lovis Corinth, Das Erlernen der Malerei, Berlin 1920, Witten 2008, S. 36f

[25] Conrads 1964, S. 93

[26] Literaturhinweis: Alexander Demandt, Über allen Wipfeln – Der Baum in der Kulturgeschichte, Köln 2002

[27] Paul Nizon, Hund. Beichte am Mittag, Frankfurt 1998, S. 17

[28] Lautréamont, Die Gesänge des Maldoror, Reinbek 1963, S. 144

[29] Jean Francois Lyotard, Immaterialität und Postmoderne, Berlin 1984, S. 67

[30] Eine graphische Technik, die zumindest in der Abbildung sich von der Federzeichnung kaum unterscheiden lässt und deshalb hier als solche durchgehen mag.

[31] Platon, Timaios, Kap. 16

[32] Josef Albers, Interaction of Colour, Köln 1970

[33] Zur Ergänzung: Selbstleuchtende Lichtfarben sind deren Primärfarben Rot, Gelb und Grün und die ihnen entgegengesetzten Komplementärfarben Cyan, Blau und Magenta.

[34] Laszlo Moholy-Nagy, Von Material zu Architektur, Berlin 2001 (Reprint von 1929), S. 7

[35] Werner Tübke, Ich fange mit dem Himmel an. Aquarelle und Texte, Frankfurt 1991, S. 39

[36] Johann Peter Eckermann, Gespräche mit Goethe (10. April 1829), München 1976, S. 355

[37] zit. n. Magdalena Droste, Bauhaus 1919 – 1933, Köln 1991, S. 18

[38] Ulf Jonak, Arche_tektur. Getarnte Häuser oder vom auffälligen Leben im Geheimen, Wien 2008, S. 34f

Danksagung

Ich danke den vielen studentischen Mitarbeitern, die mich in all den Jahren unterstützt haben, mich auch manches gelehrt haben, sei es der lockere Umgang mit Jüngeren, sei es der verständige Umgang mit dem Computer. Dass sie alle hervorragende Zeichner und Entwerfer waren, war für dies Fachgebiet fast selbstverständlich. Ein großer Teil der abgebildeten studentischen Arbeiten stammt von ihnen. Ich danke Florian Afflerbach, Christof Ahlers, Rainer Berg, Alex Görg, Arno Hartmann, Marcus Heider, Stephan Kurzinsky, Jürgen Opitz, Achim Schäfer, Martin Schäpers, Helga Schneider und Thilo Specht, aus deren Mappen und Skizzenbüchern (ausführlicher als aus anderen) ich Illustrationen für dieses Buch entnehmen konnte. Elke Wellhausen fotografierte einen großen Teil der hier gezeigten skulpturalen Arbeiten. Mein besonderer Dank gilt zudem Alex Görg, ohne dessen aufopfernde Hilfe und ohne dessen Layout-Kenntnisse das Buch in dieser Form nicht zustande gekommen wäre.

203

Literatur

Adelmann, Marianne (Hrsg.), Europäische Plastik der Gegenwart, Stuttgart 1966

Architektenzeichnungen 1479-1979, Katalog Kunstbibliothek Berlin 1979

Architektenzeichnungen heute, Separatdruck der Bauwelt, Berlin 1975

Bammes, Gottfried, Sehen und Verstehen, Ravensburg 1992

Bauakademie Berlin (Hrsg.), Die Hand des Architekten. Zeichnungen aus Berliner Architektursammlungen, Köln 2002

Bernstein, F.W., Bernsteins Buch der Zeichnerei, Zürich 1989

Corinth, Lovis, Das Erlernen der Malerei, Berlin 1920 (Witten 2008)

Decker, Elisabeth (Hrsg. u. a.), Skulptur, Köln 1996

Documenta 3, Katalog Handzeichnungen, Kassel 1964

Exner, Ulrich und Pressel, Dietrich, Raumgestaltung, Basel 2009

Feireiss, Kristin (Hrsg.), Handgezeichnete Welten, Berlin 2003

Idee und Anspruch der Architektur. Zeichnungen des 16. bis 20. Jahrhunderts aus dem Cooper-Hewitt Museum New York, Katalog Wallraf-Richartz-Museum Köln 1980

Internationale der Zeichnung, Kataloge Mathildenhöhe Darmstadt 1964/1967/1970

Janssen, Horst, Querbeet, München 1982

Ders., Die Kunst der Zeichnung. Sammlung Stefan Blessin, Oldenburg 2003

Jenny, Peter, Sign and Design. Zeichnen und Bezeichnen, Zürich 1981

Jonak, Ulf, Arche_tektur. Getarnte Häuser oder vom auffälligen Leben im Geheimen, Wien 2008

Jonak, Ulf / Kurzinsky, Stephan (Hrsg.), Siegener Skizzenbuch, Siegen 2005

Kemp, Wolfgang (Hrsg.), Der Betrachter ist im Bild, Köln 1985

Klee, Paul, Pädagogisches Skizzenbuch. Reprint, Mainz 1968

Koolhaas, Rem, Delirious New York. Ein retroaktives Manifest für Manhattan, Aachen 1999

Koschatzky, Walter, Die Kunst der Zeichnung, Salzburg 1977 (München 1981)

Koschatzky, Walter, Die Kunst des Aquarells, Salzburg 1982 (München 1985)

Küppers, Harald, Harmonielehre der Farben, Köln 1989

Kunstzeichen – Zeichenkunst, Zeitschrift du, Heft 2/1991

Lampugnani, V.M. (Hrsg.), Architektur unseres Jahrhunderts in Zeichnungen, Stuttgart 1982

Linfert, Carl, Die Grundlagen der Architekturzeichnung. Sonderdruck aus dem ersten Band der kunstwissenschaftlichen Forschungen, Berlin 1931

Matthaei, J. Michael, Grundfragen des Grafik – Design. Wahrnehmen und Gestalten, Augsburg 1988

McQuaid, Matilda (Hrsg.), Visionen und Utopien. Architekturzeichnungen aus dem Museum of Modern Art, Katalog der Kunsthalle Schirn, München 2003

Meisenheimer, Wolfgang, Choreografie des architektonischen Raumes, Düsseldorf 1999

Nerdinger, Winfried (Hrsg.), Die Architekturzeichnung. Vom barocken Idealplan zur Axonometrie, München 1986

Stiebner, Erhardt D. und Leonhard, Walter, Bruckmanns Handbuch der Schrift, München 1977

Trier, Eduard, Moderne Plastik, Frankfurt am Main 1955

Vollmer, Klausbernd, Das große Handbuch der Farben, Krummwisch 2008

Vom Zeichnen, Aspekte der Zeichnung 1960-1985, Katalog Frankfurter Kunstverein 1986

Wehlte, Kurt, Werkstoffe und Techniken der Malerei, Ravensburg 1967 und 1985

Wölfflin, Heinrich, Prolegomena zu einer Psychologie der Architektur, München 1886 (Berlin 1999)

Zeichnungen, Beispiele aus dem Fach ‚Grundlagen der Gestaltung' (Universität Siegen,
 FB Architektur und Städtebau), Beispielheft 10, Siegen 1989/1999

Bildnachweis

Wenn nicht anders erwähnt, stammt der überwiegende Anteil der Abbildungen aus der Lehre im Fach Grundlagen der Gestaltung des Fachbereichs Architektur und Städtebau der Universität Siegen bzw. aus dem Fotoarchiv Ulf Jonak.

Sach- und Personenregister